DORI HADAR With a preface by Neil Strauss and an afterword by Jane Livingston

# Mingering Mike

© 2007 Princeton Architectural Press, New York

# Mingering Mike

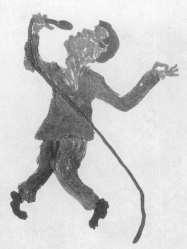

**DORI HADAR**

With a preface by Neil Strauss and

an afterword by Jane Livingston

Published by
Princeton Architectural Press
37 East Seventh Street
New York, New York 10003

For a free catalog of books, call 1.800.722.6657.
Visit our web site at www.papress.com.

Library of Congress Cataloging-in-Publication Data

Hadar, Dori.
Mingering Mike / Dori Hadar ; with a preface by Neil Strauss and
essay by Jane Livingston. — 1st ed.
p.  cm.
Includes bibliographical references.
ISBN-13: 978-1-56898-569-5 (alk. paper)
ISBN-10: 1-56898-569-X (alk. paper)
1.  Mingering Mike. 2.  Sound recordings—Album covers—
Washington (D.C.) 3.  Outsider art—Washington (D.C.)—History—
20th century.  I. Strauss, Neil. II. Livingston, Jane. III. Title.
NC1883.3.M56H33 2007
741.6'6092—dc22
[B]
2006016177

Portions of Dori Hadar's text originally appeared in his 2004 article
for *Wax Poetics* magazine and a 2004 interview conducted by Erica
Magrey for *Swingset* magazine. Some quotations in Neil Strauss's
preface originally appeared in his February 2, 2004, *New York Times*
article "A Well-Imagined Star."

Editor: Scott Tennent
Designer: Jan Haux
Photography: Nicola Bednarek

Special thanks to: Nettie Aljian, Sara Bader, Dorothy Ball, Janet
Behning, Becca Casbon, Penny (Yuen Pik) Chu, Russell Fernandez,
Sara Hart, Clare Jacobson, John King, Mark Lamster, Nancy
Eklund Later, Linda Lee, Katharine Myers, Lauren Nelson Packard,
Jennifer Thompson, Paul Wagner, Joseph Weston, and Deb Wood of
Princeton Architectural Press —Kevin C. Lippert, publisher

# Table of Contents

# Acknowledgments

**DORI HADAR** would like to thank Mike, for just being you; Joseph War, Cathy, and Agnes, for so graciously reminiscing over Mingering Mike's golden years; Frank Beylotte, for everything—you're the dude; everyone at Soul Strut for all of your support, advice, and encouragement. None of this could have happened without you.

Thanks also to George Hemphill and Hemphill Fine Arts, Jane Livingston, Neil Strauss, David Brown and SECCA, and Scott Tennent and Jan Haux at Princeton Architectural Press; Brian Digenti, Oliver Wang, and Andre Torres at *Wax Poetics*, Erica Magrey at *Swingset*, and Tanya Heinrich and Tom Patterson at *Folk Art* magazine.

To my family and friends: Neevy Hadar, Mary Hadar, Robert Martin, Amy Larkin, Yossi and Carmen Hadar, Susan Raines, Thomas Shiner, The Vanguard Squad, Brian Liu and Nick Pimentel at Toolbox DC, Jaime Wolf, JoAnn Lewis, Hollie West, everyone at Roberts & Wood, Harry Dixon, Neal Becton, Anna Salajegheh, Maija Fiebig, the crew at Roadhouse Oldies, and Adolph (if you only knew).

**MINGERING MIKE** would like to thank Nana, Daddy, Momma Reese, Cat, Theresa (my sister who died months after her birth), Carl, Steverino (discovered me, "ha!"), LaDosca, Janet, Big "D", Joseph War, Ramblin' Ralph Montgomery, Jane and her hubby, all of my other friends and family (too many to mention), and hugs and kisses to Jean (even though she don't play that).

**Neil Strauss**

HERE'S A HELPFUL tip, so you can't claim you didn't learn anything from this book: always say, "I'll check it out," to life.

As a music critic at the *New York Times* for a decade, that was always my credo, along with its close corollary, John Cage's "Be open to whatever comes next." I bought every obscure CD someone recommended, saw any movie a friend raved about, and met with anyone who seemed interesting. And to tell the truth, most of the time I wasted my time or money. But every once in a while that CD, movie, or person changed my life, and it was worth every failure.

That's why I've always enjoyed interviewing David Bowie. Whenever I've talked to him, he's turned me on to something new. The first time, he recommended an art exhibit by a guy named Henry Darger. "No one had even heard of him until he died," Bowie said. "His landlord came up to his apartment and discovered the entire place was covered with these fantastic drawings."

"I'll check it out," I replied.

That was how I discovered what are known as outsider artists—creators who work isolated from the art world, generally making pieces for personal gratification (or obsession or neurosis) rather than sharing them with critics, gallery owners, and the public.

And so it went. Every time I interviewed Bowie, he turned me onto something cool on the fringes of the art world—until, one day, I discovered something I could turn him onto.

It began when my brother called and suggested I take a look at a discussion forum on a website called Soul Strut, where a group of record collectors known as diggers—so named for their obsessive habit of digging through record crates wherever secondhand ephemera is sold—gather to discuss obscure funk recordings, recipes for repairing warped vinyl, and other arcane matters. "You may find it interesting," my brother said.

"I'll check it out."

On the Soul Strut forums, I discovered that Dori Hadar, along with fellow digger Frank Beylotte, had accidentally discovered what seemed to be an outsider artist a couple of weeks before. At a flea market in Washington, D.C.—location not disclosed for fear of competition from other diggers—Hadar had come across thirty-eight albums by a character known as Mingering Mike. And Beylotte had discovered a

handful of seven-inch singles and eight-track tapes. However, when they pulled the records out of the sleeves to check for scratches, they discovered that there was no vinyl inside the hand-painted covers. What appeared to be records were actually round cardboard cutouts with grooves drawn in marker; their protective sleeves were simply taped-together grocery bags. Each album was elaborately detailed with fake liner notes, copyright information, and on the spine, catalog numbers. A few of the albums were even covered in shrinkwrap, affixed with price stickers, and labeled with apocryphal quotes from luminaries like James Brown. There were even double-albums with gatefold sleeves.

There were soundtracks to films that didn't exist; instrumental albums; a benefit recording for sickle cell anemia; a tribute to Bruce Lee; a triple-record disc titled *Live from Paris*; songs protesting the Vietnam War and promoting racial unity; and records of Christmas, Easter, and bicentennial music. For just under a hundred dollars (two bucks an album), Hadar had unwittingly bought the oeuvre of an outsider artist.

I knew what I had to do.

The great thing about writing for the *New York Times* is that the editors trust their writers. Unlike working for mainstream magazines, where publishers need famous faces to fill their pages, or for film production companies, where producers need to know the ending of a story before committing to it, all it takes is a good idea to get an assignment at the *Times*. They allow their writers to check things out, even if they don't know exactly what they're getting themselves into.

Two days later, I sat in Hadar's living room, examining the album covers. They truly were objects of beauty. The drawings, the lettering, the phrasing, the details seemed more authentic in many ways than the actual mass-replicated artifacts of the early '70s. I had a feeling that it was the last time I'd hold them in my hands: this was their age of innocence. Soon, they'd belong to the world outside Hadar's basement apartment. They'd be insured, photographed, preserved, hung in galleries, acclaimed, imitated, and critiqued. They'd be no longer mysterious, but iconic.

At 5 p.m., the doorbell rang. A large, good-humored, round-faced man entered, wearing a black work jacket. He smiled shyly and then, when he saw his covers lined up on a mantle, more broadly. He grabbed *The Two Sides of Mingering Mike*, clasped it to his bosom, and exclaimed, "My babies!" Then he pretended to cry. We were now guests in his fantasy.

Then, with more apprehension than excitement, Mingering Mike sat down for the first interview of his thirty-five year career. He didn't want his real name to be used—and still doesn't—and refused to let a photographer take any photos that would identify him.

"It would have been a dream come true if it happened twenty years ago," he said of the newfound attention. "But now it's strange—overwhelming."

As a teenager, Mingering Mike dreamed of becoming a musician. He claims to have written four thousand songs on everything from matchbooks to diaper boxes, though only a small fraction were recorded. More important than music to Mingering Mike, it seemed, was packaging. Like Hadar and Beylotte, he was an avid digger himself—or a "record-aholic," as he put it on

one album. Except he outdid them by not just collecting but also creating. This is so, he explained, "If it all came together one day, I'd be ready."

He would spend as long as a week designing, painting, and lettering his album jackets. Then he began adding fake promotional stickers, seven-inch singles, lyric sheets, gatefold sleeves, fan club information, shrinkwrap (which took him an hour to slide on without tearing), and nearly every other detail imaginable.

"I used to come in from work," he said, "and I'd have the albums and 45s on the wall. I liked to think that they were real. They were finished products in my mind."

But, outside of performing a few shows at St. Elizabeth's, a mental hospital, in an act with his brother, he never played live or seriously attempted to release his music.

Mingering Mike's lack of an actual career, or even an attempt to have one, has unexpectedly become the crux of his appeal. He has taken the bedroom dreams of every eight-year-old—the ones dashed against the rocks of reality when homework, social hierarchies, and premature pick-a-job-or-starve pressures set in—and extended them into adulthood. He has made a classic childhood pop-star fantasy real and tangible, yet almost entirely inaudible. It is a world as fragile and transitory as the cardboard and marker it was built with. By neither shedding his youthful dreams nor taking any steps to actualize them, his mock albums stand as a triumph of the imagination over reality, rationality, and responsibility. He is Peter Pan to the record industry's Captain Hook.

On the liner notes to one of his albums, Mingering Mike writes about himself and his cousins, "If we named all their hits, it would take up all the space available on this album."

When I picked up the album and laughed at the grandiosity of the statement, Mingering Mike snatched it back. "Hey," he said, with a smile. "It's my fantasy!"

Shortly afterward, I was able to tell Bowie about Mingering Mike. He pledged to check out the album covers online. In return, he suggested I visit a place in Los Angeles called the Museum of Jurassic Technology, a gallery that exists on the border of reality and fiction.

"I'll check it out," I told him.

But that's another story. It just has the same beginning.

They all do.

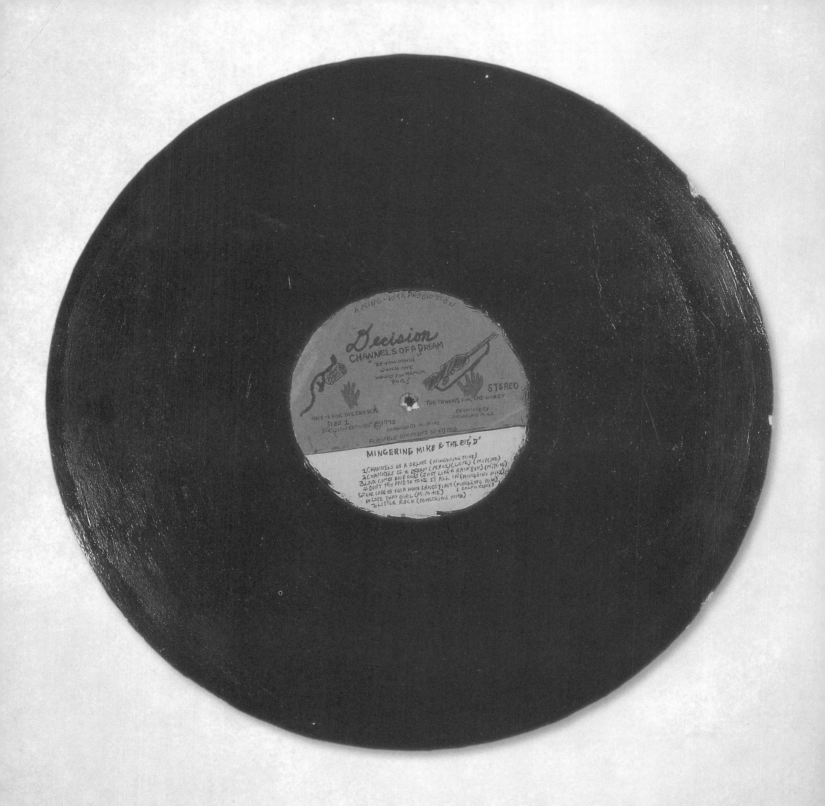

**MINGERING MIKE & THE BIG "D"**
Channels of a Dream (record)

# A Star is Reborn

It was an unprecedented career. His first album, *Sit'tin by the Window*, like the countless releases that would soon follow, was a chartbuster, catapulting him to unparalleled heights. For ten years, beginning in the late 1960s, he unleashed a storm of albums, hit singles, and motion pictures that would ultimately establish him as one of the era's most prolific and awe-inspiring artists. By 1977, when he bowed out of the music scene, he had released over fifty LPs and at least as many hit 45s, all on record labels that he founded and managed himself. In 1972 alone he produced fifteen full-length albums and over twenty singles, and his traveling revue performed for sold-out crowds the world over. And if that weren't enough, he wrote and starred in nine films, all of which he directed.

His name was Mingering Mike. And in his imagination, he was unrivaled. His career was nothing less than legendary—and nothing more than a box of painted cardboard in a Washington, D.C., flea market.

THE THRILL OF rummaging through old junk lies in the chance of finding something rare and extraordinary. For a music fan, it's a relentless quest for that obscure recording that slipped through the cracks and is waiting to be rediscovered and appreciated years later. The obsessed crate digger will do just about anything to feed his insatiable appetite for records, including getting up at ungodly hours to be the early bird at a flea market or yard sale. It was at just such a market in Washington, D.C., that I stumbled into the fantastic world of Mingering Mike.

I was one of the first to arrive on that cold December morning, and I was thrilled to see that a vendor was unloading box after box of records from the back of his truck. I dug in and was delighted to discover a great collection of hard-to-find soul albums and soundtracks—Kool and the Gang's *Live at the Sex Machine*, Melvin van Peebles's *Sweet Sweetback's Baadasssss Song*, and Lalo Schifrin's soundtrack to the television show *Mannix*, to name a few. Dragging myself out of bed suddenly seemed well worth it.

The last box, however, held the real gems. I pulled out a curious album titled *The Mingering Mike Show— Live from the Howard Theater*. I knew of the legendary but now defunct Howard Theater, the premier venue in D.C. for black performers back in the day, but I had never before heard the name Mingering Mike. And for an obsessive music collector like myself, it wasn't a name I would have forgotten. The back cover stated that it was a June 1969 release, on a label called Nation's Capitol Records.

Immediately a few things struck me as odd. For one, the album was hand-painted. When I opened the gatefold cover I was baffled to find that the record inside was made of cardboard. The grooves were actually drawn on with a glossy paint, and a handmade label had been applied with glue. From a distance the record looked real, but up close the brushstrokes and handwritten lettering were obvious.

The cover art had to have been inspired by one of James Brown's live albums. It showcased portraits of various soul groups I had never heard of—the Monitors, the Colts Band, Mike & the Minutes, the Mailavar Dancers, Miss Linda Landtree, and Miss Lora Little. There was a typewritten track listing for what was apparently a double album—the Colts started off the show with an instrumental tune called "Sucked You In," followed by the Mailavar Dancers, who—according to the track listing—danced to the tune of James Brown's "I Got the Feeling." Other performances included Miss Lora Little singing "While You're Out Look'n 4 Suga," and Mingering Mike's renditions of "Spinning Wheel," "Murder (In the First Degree)," and "What I Go'in ta Do."

I assumed the album was a high school student's art project, and I set it aside, mildly annoyed at the idea of a record that wasn't really a record. But as I pulled the other albums out one after another it became clear that what I was looking at was something far more elaborate: a career that wasn't really a career.

The name "Mingering Mike" kept flashing before my eyes: *The Mingering Mike Revue—Live from Paris*; *Minger's Gold Supersonic Greatest Hits*; *Can Minger Mike Stevens Really Sing*; *Mingering Mike and The Big "D" Boogie Down at the White House*. And it looked as though Mike also produced albums by other artists,

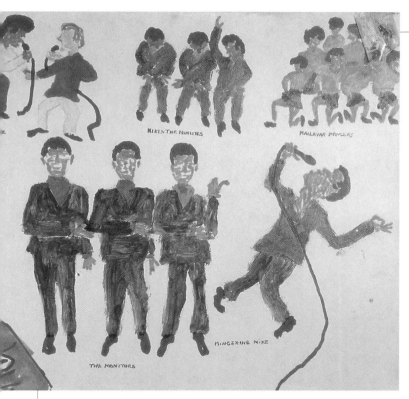

**VARIOUS ARTISTS**

*The Mingering Mike Show—Live from the Howard Theater*
(detail)

with names such as Joseph War, Audio Andre, and the Outsiders. I had no idea what to make of this, no clue who this Mingering Mike was, or why he created this enormous collection of fake records. The whole thing was bizarre.

When I removed all of the "records" from the box, there lay before me approximately forty albums that were written, produced, and arranged by the omnipresent "Mingering Mike." All of them had intricate artwork, were on labels I had never heard of, and many even had liner notes. Incredibly, some had the titles written on the spines and were wrapped in cellophane with price tags on them, as if they had been sold in a store.

I marveled over the album and song titles— *3 Footsteps Away From The Altar*, Original Music from *Brother of the Dragon*, *Fractured Soul*, *The Drug Store*. These were the sort of titles that a soul and funk collector dreamt of finding, yet they consisted of nothing but paint and cardboard. I studied them there in the parking lot for close to an hour until I finally added them to the stack of real records I'd found, paid the vendor two bucks for each of them, and headed to work, my mind spinning.

Over the course of the next week I pored over the albums, drawn into their fascinating world. Just what were these things? Who was Mingering Mike? Was he a real *musician*? Were these concepts for the actual albums? And just what does "mingering" mean, anyway?

Stumped, I took some pictures and posted them on Soulstrut.com, a website devoted to record digging. Mingering Mike immediately became the focus of all Soul Strut discussion. Even without knowing what the albums were, everyone seemed to fall in love with Mike right away.

"Mingering Mike seems to be a real noble soul," wrote one person, "and I really hope the best for him wherever he is at this moment." Another said that it reminded him of "the time when we were all kids and wanted to be the people we saw on the record covers." Others were so awestruck by the huge body of work that they crowned him "the patron saint of crate digging."

It wasn't long before people were referring to the albums as outsider art.

"This collection belongs in a museum somewhere," posted one Soul-Strutter. Others suggested that I take

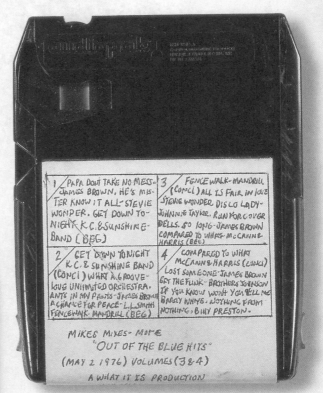

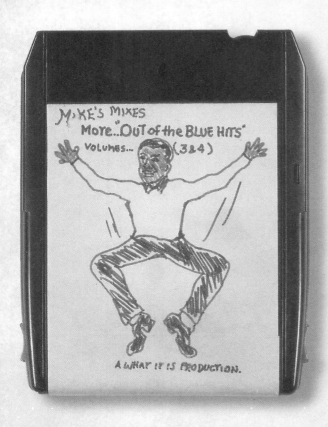

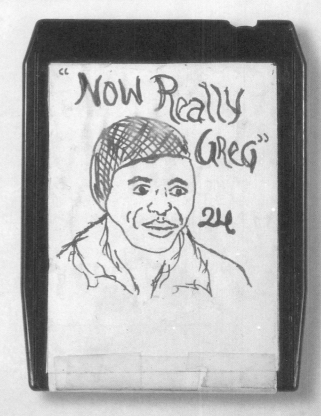

**VARIOUS ARTISTS**

**Above**: *Mike's Mixes: More…"Out of the Blue Hits"* Volumes 3 & 4

  8-track (front and back)

**Right**: *"Now Really Greg"* 8-track

the artwork to places like the Visionary Art Museum in Baltimore and the Smithsonian.

One reply was more to the point: Frank Beylotte, a fellow digger in D.C., wrote that he too had seen some similar "records" at the flea market. After reading my post he rushed back and bought fifteen of Mingering Mike's cardboard 45s that I had missed. He mentioned in another posting that there were a number of other Mingering Mike items there, including boxes of reel-to-reel recordings, 8-tracks, videotapes, and boxes of letters. I sped back to the flea market, fearful that what was left of Mingering Mike's stuff was either sold or trashed by now. But to my relief it was all there, seemingly untouched. Correspondence, recordings, pictures—I bought it all.

What had started out as curious interest on a website had now become clamorous excitement. The story quickly spread over the internet, appearing on countless blogs and message boards. A search for Mingering Mike on the web suddenly turned up over two hundred results—and the Soul Strut thread reached an unprecedented 8,000 hits within a couple of days. Various media outlets, including the *New York Times*, the *Washington Post*, the *Fader*, *Spin*, and NPR began to contact Frank and me, interested in reporting the discovery.

The next step was obvious—to find Mingering Mike, assuming he was still alive some thirty years later. Luckily I work as a criminal investigator, and tracking people down is what I do.

Using clues from personal letters I had found tucked into the albums, I was able to narrow my search to an address in Landover, Maryland. When I knocked on the door and asked for Mingering Mike the man laughed at hearing the name and explained that he was Mike's cousin. I would later find out that I had been talking to Audio Andre, one of Mike's many imaginary side acts. He took my phone number and said he'd pass it on.

Days passed and no one called, so I did a little more digging and came up with an address in southeast D.C. Frank and I jumped into my car and headed out to find Mike on a Sunday afternoon.

We pulled into the parking lot of an apartment complex just a mile and a half from the flea market where this story began. We knocked on the door, and after a minute or two, it cracked open and an eye peered out suspiciously.

"Mingering Mike?" I asked.

The eyes continued to stare.

"We're sorry to bother you. This might sound kind of strange, but we found your art at a flea market, and we think it's incredible. We'd love to talk to you about it," I said.

At the mention of the art, the eyes quickly brightened up. The door opened a bit more, and we could see the man's face. There was no doubt that this was Mingering Mike himself—his photograph was pasted on the inside of one his albums.

"Now's not really a good time," he said, apprehensively. We said we'd come back at the same time the next day, but when we did there was no answer. (Later, Mike told us that he suspected we were cops or, worse, bill collectors). I left a note with my phone number, and a couple of days later he called. We agreed to meet for lunch at Denny's.

Mike was sitting at a booth at the far end of the restaurant with his cousin Warren, aka Joseph War. After we introduced ourselves, there was a long silence. They both seemed wary and uncomfortable. I can't say I blamed them. Here we were, two strange white guys coming out of nowhere and asking them about personal details of their lives. All this time, combing through lost minutiae, I had imagined people's lives—and now here I was barging right into one.

I brought printouts of some of Mike's album covers, and I laid them out on the table. Frank and I began to let loose with all of the questions we had been agonizing over for the past few days. During the months that followed, as we became friends, Mike answered them all.

Mike was clearly heartbroken at the loss of his "babies," as he referred to his albums. For close to ten years he had kept many of his belongings in a storage unit in Maryland where he had a longstanding relationship with the owners. When he occasionally fell behind on his monthly payments the management always cut him some slack. At some point the business was sold, though, and when Mike failed to pay his rent in late 2003, the new owners simply sent him a bill and a warning. Unaware of the change, Mike assumed it wouldn't be a problem if he paid a few days late. A couple of weeks later he was devastated to discover that his belongings had been auctioned off.

Not only had Mike lost his handmade albums, but he had also lost a substantial part of his enormous music collection. A couple thousand of his records were put out for sale at the market that week, and diggers such as Frank and myself had thinned them out

considerably. Later, we were able to buy back what remained of Mike's incredibly diverse collection. His tastes varied from the Temptations to Frank Sinatra to Barbra Streisand to the Beatles. It was a vast library of popular American music from the past forty years.

Fortunately, while loading the records into the car, Frank and I discovered even more Mingering Mike creations. A zip lock bag stuck in a box contained sixty-five 45 and LP labels that he never got around to gluing onto cardboard records. Later, Warren added more albums to the collection. They had been sitting in his basement, forgotten for the past twenty years.

**MIKE & THE MONITORS/MINGERING MIKE**
"Don't Try and Take it All In" b/w "Love Comes and Goes
(Just Like a Rainbow)"
(Green & Brown, year unknown)

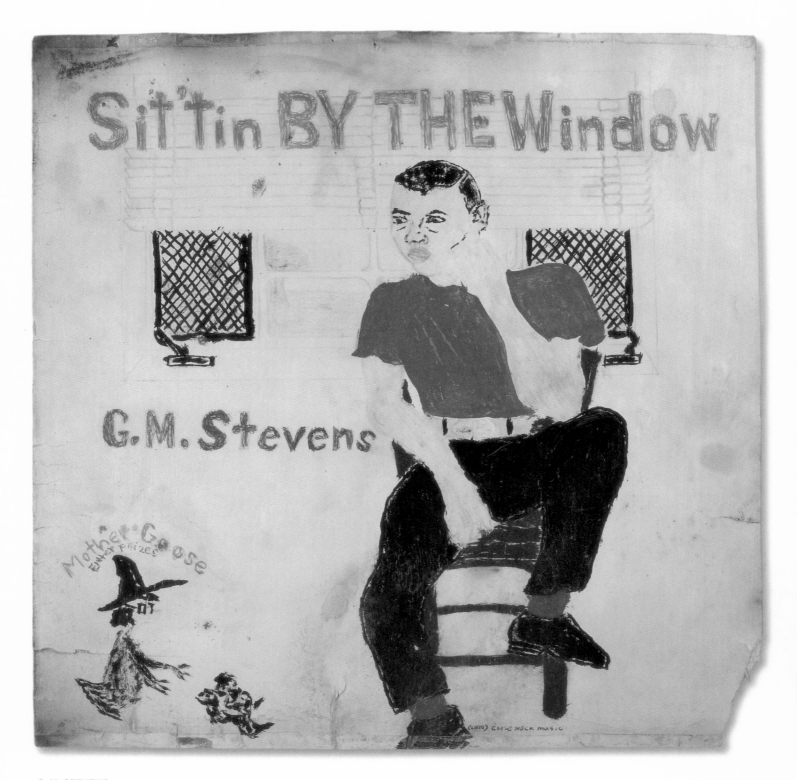

**G. M. STEVENS**

Sit'tin by the Window

(Mother Goose Enterprises, June 1968)

# Introduction

**G. S. Stevens** is a bright and intelligent young man with a great, excitting future waiting him. ("Only if he could find it because if it takes money you can count me out"), but I hope he can make it in show Biss so he can pay me for this fine, out standing introduction if I do say so my self.

**P.S.**

**HE'S** played all the little clip joints this side of 16<sup>th</sup> and 17<sup>th</sup> street not where the White house is, he's bend kick out of there three threes and told never to come back, and Johnson **meant** it yesterday I            n throw away five boxes of Uncle Ben's rice he started to throw away the watermelo            stopped him so he threw away bird and the water melon the flys ate the watermelon            back bird any why he's played such places such as "The Crooks Place, "The Ash car            ney maker's club, and "the No Sympathy Gunman's Union. in witch he was kicked out of al of the above clubs, Lady's and Gentlement give you or introduces you to G. M. Stevens

Yours truly
*Jack Benny*

## Side 1

* Sittin by the window.
  I'm lost (without you by my side").
  I Love you.
* Everybody's goin somewhere except me.
  I found me a Love.

## Side 2

"People Say" (its wrong for us to fall in Love.
* It's a boy's Life ('but a mans world).
  Angec.
* What kind of a girl are you.
* Your change is my gane.

**THis recod was** recorded in a damp house this side 5<sup>th</sup> street where crowds of drunks hang around quite often.

a Production of Mother Goose

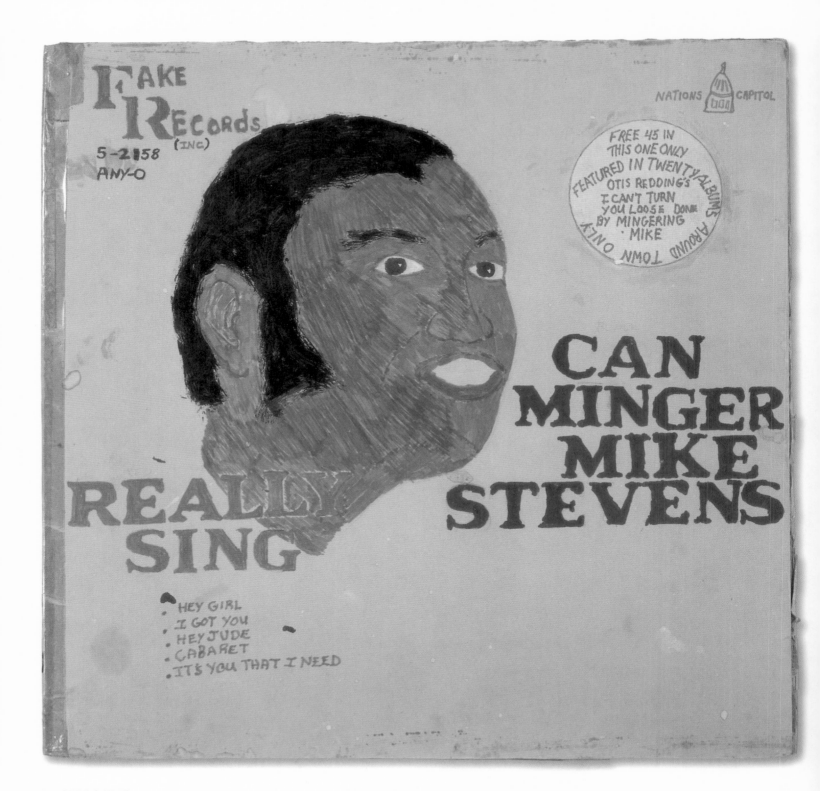

**MINGERING MIKE**

Can Minger Mike Stevens Really Sing

(Fake Records/Nations Capitol, Mar. 1969)

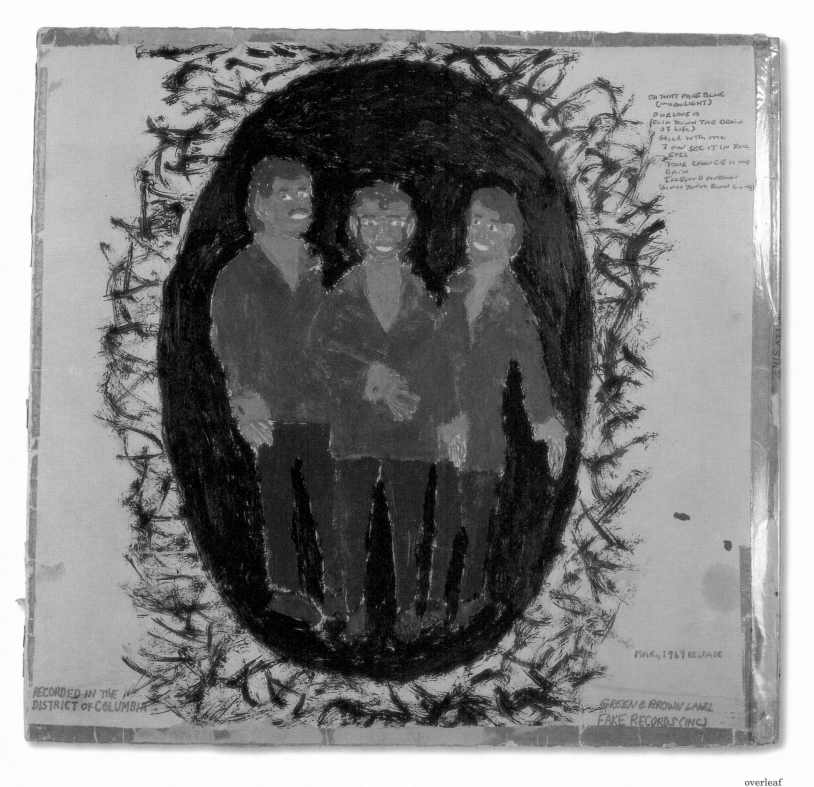

overleaf
**MINGERING MIKE**
Can Minger Mike Stevens Really Sing (gatefold w/ record)

PICTURE ME

F.R.
CAN MINGERING
MIKE STEVENS REALLY SING

Side 2    ANY-0    —    ANY-0

1. OH THAT PALE BLUE MOONLIGHT (G. STEVENS)
2. OUR LOVE IS (GOING DOWN THE DRAIN OF life LESS)
   (GREGORY STEVENSON)
3. STICK WITH ME (GREGORY STEVENSON)
4. I CAN SEE IT IN YOUR EYE (G. STEVENSON)
5. YOUR CHANGE IS MY GAME (G. STEVENSON)
6. I'VE FOUND ANOTHER, SINCE YOU BEEN GONE
   (G. STEVENSON)

LONG 33 PLAY

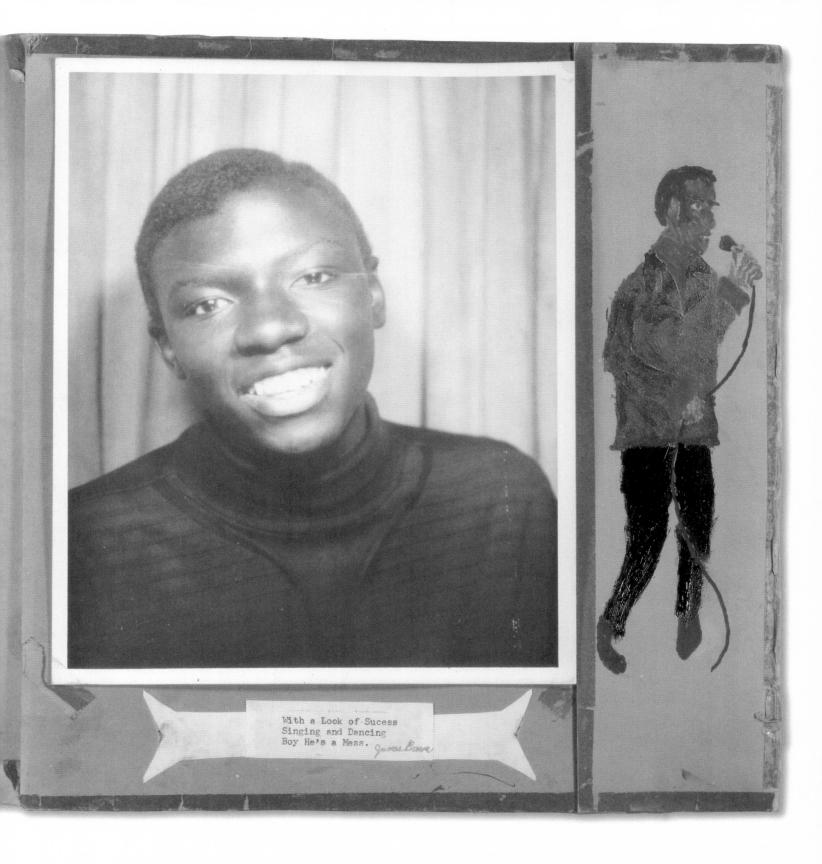

With a Look of Sucess
Singing and Dancing
Boy He's a Mess. James Brown

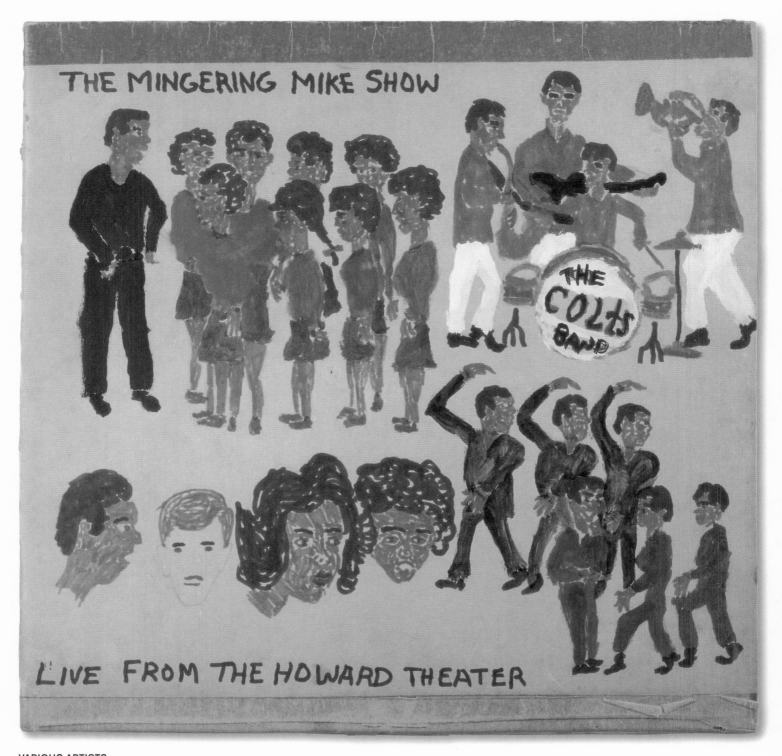

**VARIOUS ARTISTS**

The Mingering Mike Show—
Live from the Howard Theater

(Nations Capitol, June 1969)

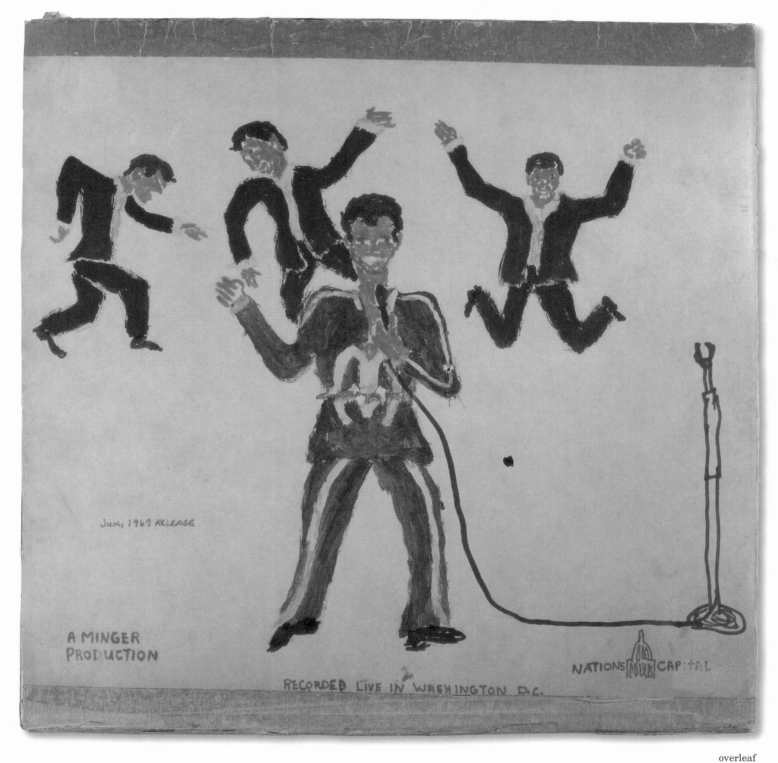

overleaf
**VARIOUS ARTISTS**
The Mingering Mike Show—
Live from the Howard Theater (gatefold)

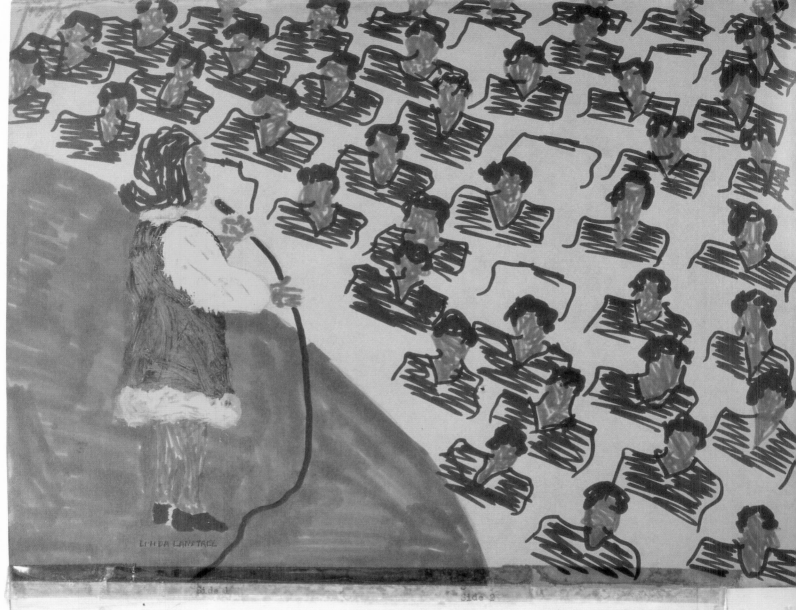

LINDA LANDTREE

Side 1            Side 2

Mike, Jeff and Don- introduce
    THE COLTS BAND
(instr.,) sucked you in.
(instr.,) mabel, mabel, mabel.
(instr.,) soul in the sea.
the colts introduce
    MIKE & THE MINUTES
. sweet and tender me (lovable you)
. is the sun still shinning(for me)
. if you can want.
    THE MAILAVAR DANCERS
. (dance to the tune of)i got the feeling.
      Part 1

    THE MAILAVAR DANCERS
i got the feeling (part 2 )
    MINGERING MIKE
there was a time.
    MISS LINDA LANDTREE
my song.
baby, baby sweet baby.
it's too late.
duet with mike(not made 4 one anoth

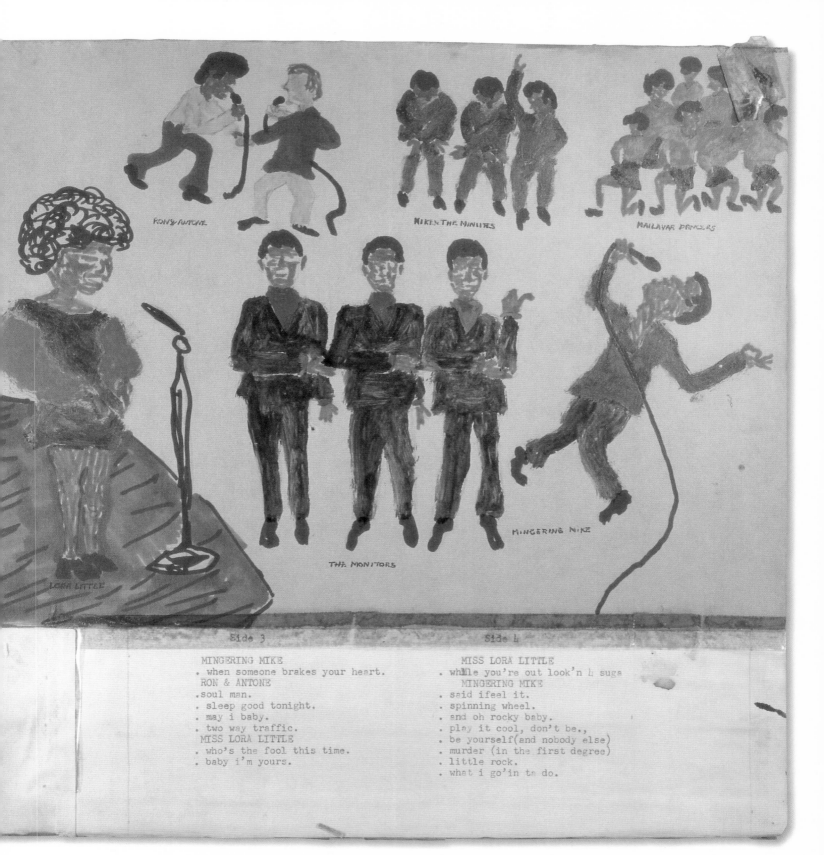

RON & ANTONE

NIKEN THE MINUTES

MAILAVAR DANCERS

LORA LITTLE

THE MONITORS

MINGERING MIKE

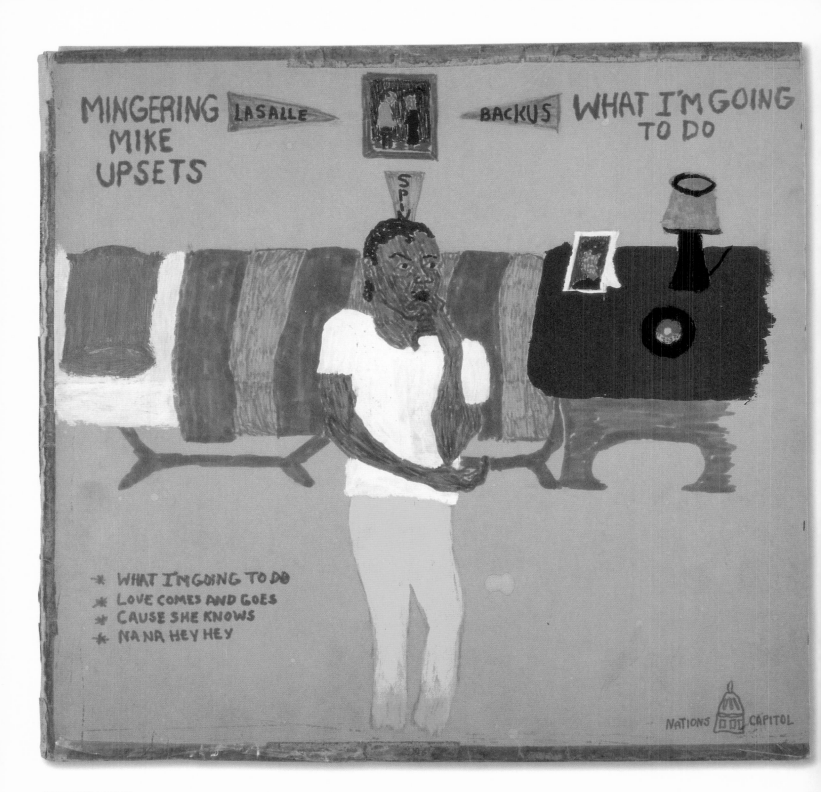

**MINGERING MIKE**

What I'm Going to Do

(Nations Capitol, Nov. 1969)

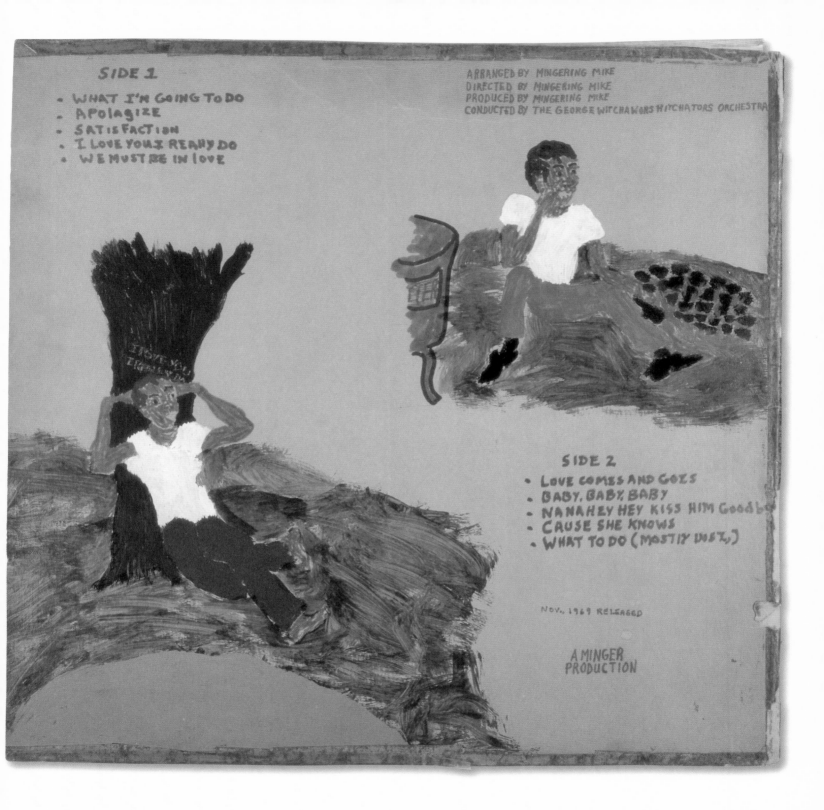

SIDE 1

- WHAT I'M GOING TO DO
- APOLAGIZE
- SATISFACTION
- I LOVE YOU I REAHY DO
- WE MUST BE IN love

ARRANGED BY MINGERING MIKE
DIRECTED BY MINGERING MIKE
PRODUCED BY MINGERING MIKE
CONDUCTED BY THE GEORGE WITCHAWORSHITCHATORS ORCHESTRA

SIDE 2

- LOVE COMES AND GOES
- BABY, BABY, BABY
- NANAHEY HEY KISS HIM Goodbye
- CAUSE SHE KNOWS
- WHAT TO DO (MOSTIY INST,)

NOV., 1969 RELEASED

A MINGER
PRODUCTION

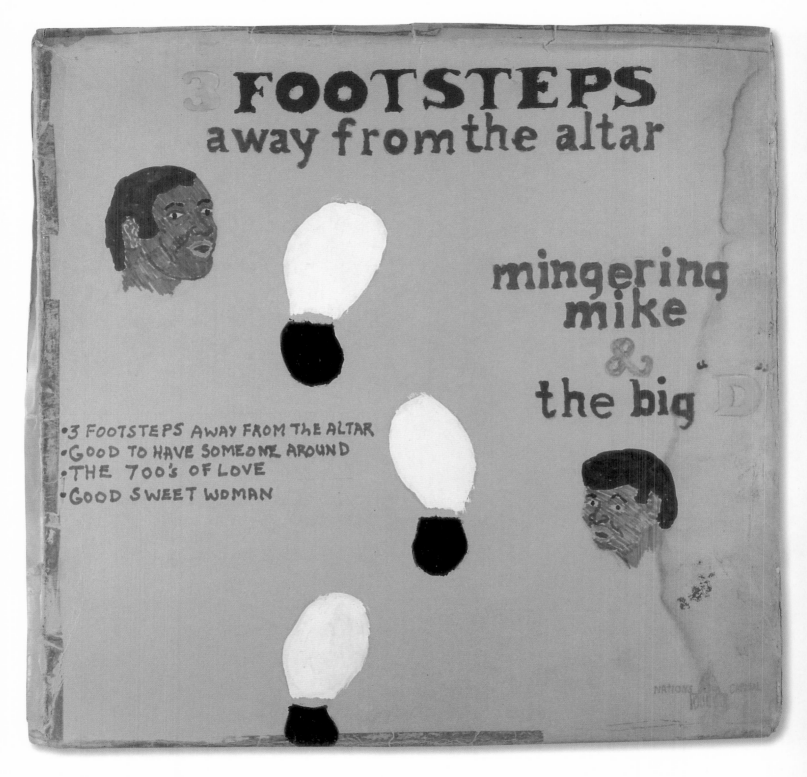

**MINGERING MIKE & THE BIG "D"**

3 Footsteps Away from the Altar

(Nations Capitol, Dec. 1969)

ALBUMS AVAILABLE
MINGERING MIKE

JUNE 1968

MARCH 1969

JUNE 1969

NOV., 1969

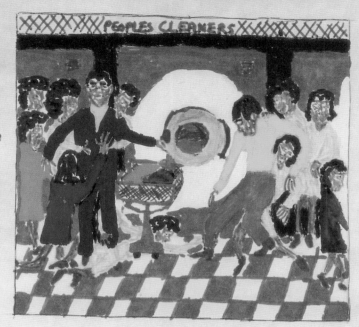

PEOPLES CLEANERS

ALBUMS AVAILABLE
THE BIG "D"

RUN FOR MY LIFE THE BIG "D"

JUNE 1968

FEB., 1968          NOV., 1969

## SIDE 1

• 3 FOOT STEPS
• DON'T GO
• I CAN SEE N YOUR EYES
• CAUSE SHE KNOWS
• I'M IN LOVE WITH YOU

DEC., 1969 RELEASE

## COMMENTS FROM
MINGERING MIKE          &          THE BIG "D"

THE BIG "D" IS A FIND, FIND TALENT
AND I BELIEVE HE WOULD FURTHER HIS
EDUCATION, WOULD MAKE HIM EVEN
A BETTER SINGER and SONG WRITER, HE'S
JUST ABOUT THE BEST, YOU SEE, HIS
NAME THE BIG "D".

*Mingering Mike*

MINGER is a Good singer and
dancer and a find song writer
but as you know it's hard for a singer
to make hits after hits, And MINGER
has just about did this with his singing
and writing, I may not like one, some
records and if he knows that he'll try
his best to do another one that haves me
wishing I wrote it.

*The Big "D"*

## SIDE 2

• SHAME OF THE WORLD
• TO THE REAL THING
• THE 7 00's OF LOVE
• LET ME TRIK TO YOU
• SOME ONE AROUND
• GOOD SWEET WOMAN
• VERY FIND XMAS

A MINGER
PRODUCTION

RECORDED IN MINGER STUDIO   WASHINGTON D.C. 11100

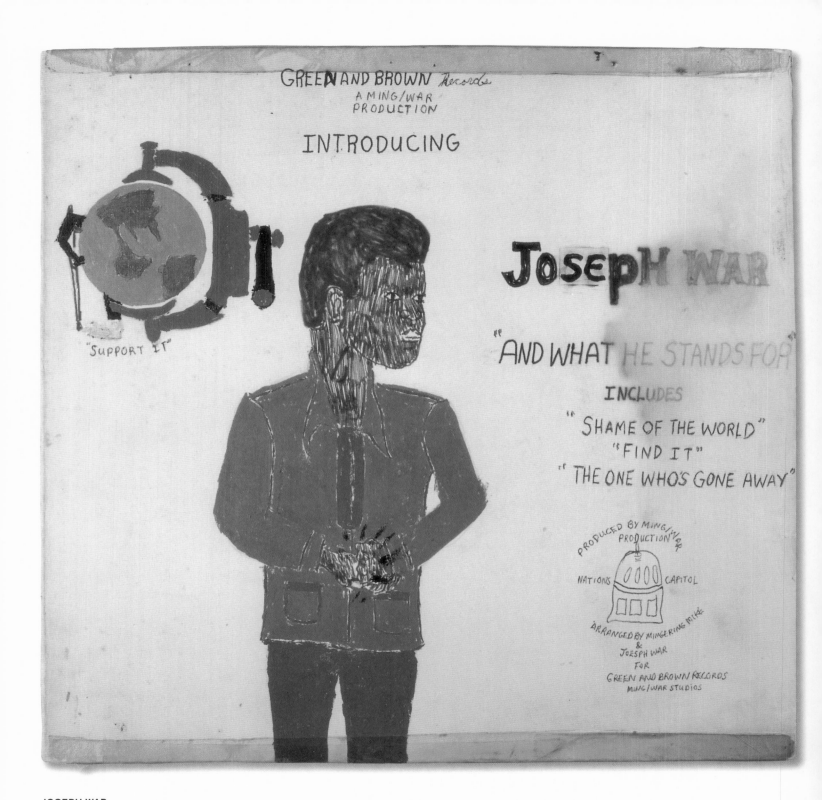

**JOSEPH WAR**

Introducing Joseph War "and What He Stands For"

(Green & Brown, 1970)

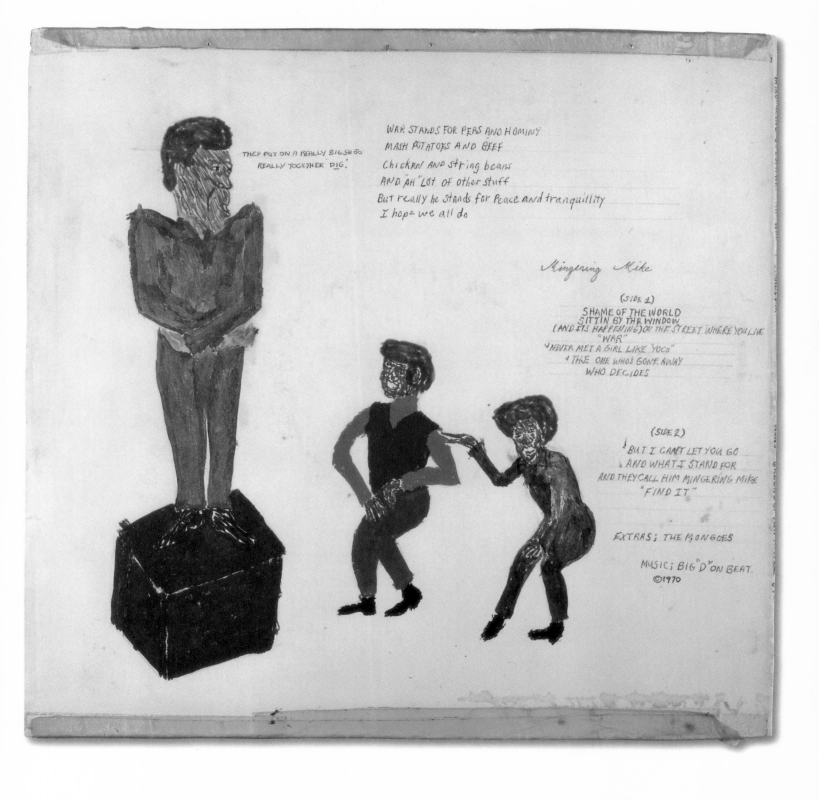

THEY PUT ON A REALLY BIG SHOO
REALLY TOGETHER DIG.

WAR STANDS FOR PEAS AND HOMINY
MASH POTATOES AND BEEF
Chicken AND string beans
AND "AH" Lot of other stuff
But really he stands for Peace and tranquillity
I hope we all do

Mingering Mike

(SIDE 1)
SHAME OF THE WORLD
SITTIN BY THE WINDOW
(AND ITS HAPPENING) ON THE STREET WHERE YOU LIVE
"WAR"
NEVER MET A GIRL LIKE "YOCO"
THE ONE WHO'S GONE AWAY
WHO DECIDES

(SIDE 2)
BUT I CANT LET YOU GO
AND WHAT I STAND FOR
AND THEY CALL HIM MINGERING MIKE
"FIND IT"

EXTRAS; THE MONGOES

MUSIC; BIG "D" ON BEAT.
©1970

This is Mingers eigth album and
He has had his shares of ups and down
His share of loosing like anyone else,
But he doesn't quit, he just keeps
Going because he feels he must,
And thats a sign of pride and determination
What the world's people needs a little
More of.

—Stevarino & Richard, gig agent

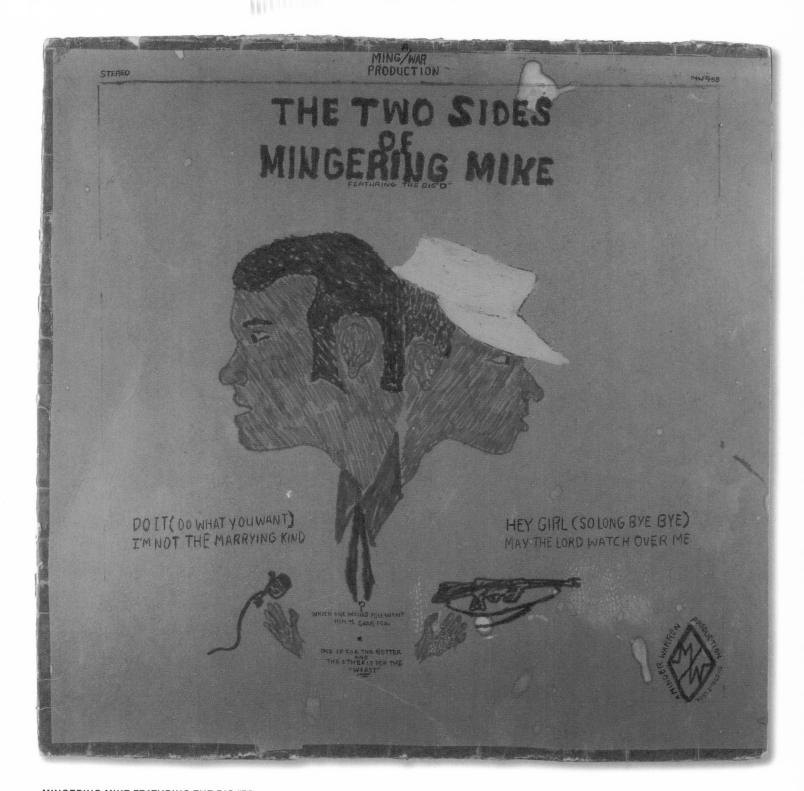

**MINGERING MIKE FEATURING THE BIG "D"**

The Two Sides of Mingering Mike

(Ming/War, July 1970)

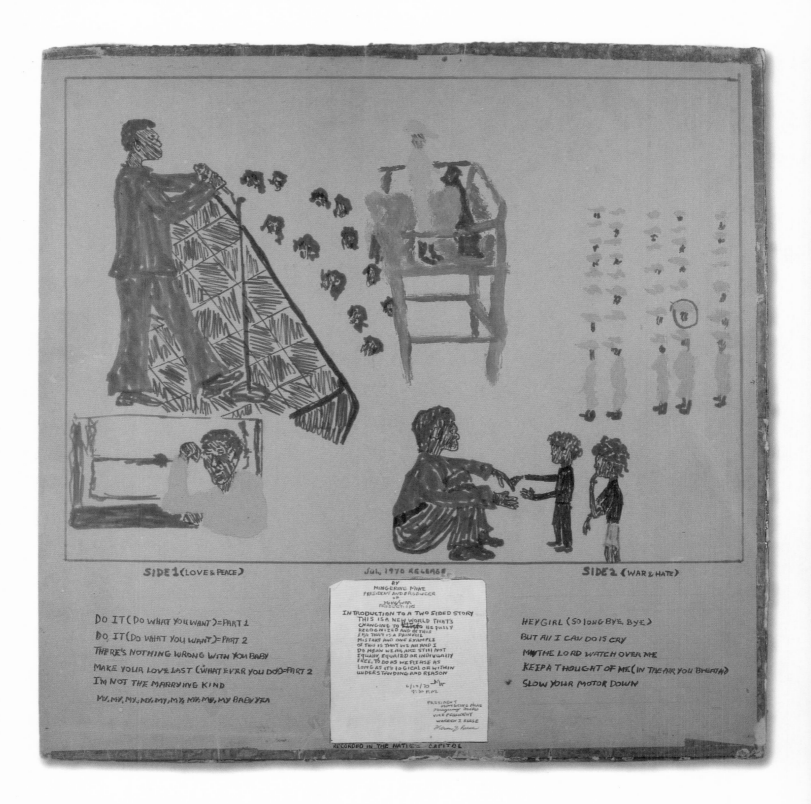

SIDE 1 (LOVE & PEACE)    Jul, 1970 RELEASE    SIDE 2 (WAR & HATE)

BY
MINGERING MIKE
PRESIDENT AND PRODUCER
OF
MING/WAR
PRODUCTIONS

INTRODUCTION TO A TWO SIDED STORY
THIS IS A NEW WORLD THAT'S
CHANGING TO ~~~~~ BE FULLY
RECOGNIZED AND IN THIS
ERA THAT IS A PAINFUL
MISTAKE AND ONE EXAMPLE
OF THIS IS THAT WE ALL AND I
DO MEAN WEAK AND STILL NOT
EQUALLY, EQUALED OR INDIVIDUALLY
FREE, TO DO AS WE PLEASE AS
LONG AS IT'S LOGICAL OR WITHIN
UNDERSTANDING AND REASON

6/10/70 -Mr
9:30 P.M.

PRESIDENT
MINGERING MIKE
VICE PRESIDENT
WARREN J. REESE

RECORDED IN THE NATI~~ CAPITOL

DO IT (DO WHAT YOU WANT) = PART 1

DO IT (DO WHAT YOU WANT) = PART 2

THERE'S NOTHING WRONG WITH YOU BABY

MAKE YOUR LOVE LAST (WHAT EVER YOU DO) = PART 2

I'M NOT THE MARRYING KIND

MY, MY, MY, MY, MY, MY, MY, MY, MY BABY YEA

HEY GIRL (SO LONG BYE BYE)

BUT ALL I CAN DO IS CRY

MAY THE LORD WATCH OVER ME

KEEP A THOUGHT OF ME (IN THE AIR YOU BREATH)

SLOW YOUR MOTOR DOWN

**MINGERING MIKE FEATURING THE BIG "D"**
The Two Sides of Mingering Mike (back cover)

BY
MINGERING MIKE
PRESIDENT AND PRODUCER
OF
MINE/WAR
PRODUCTIONS

INTRODUCTION TO A TWO SIDED STORY
THIS IS A NEW WORLD THAT'S
CHANGING TO ~~FAST TO~~ BE FULLY
RECOGNIZED AND IN THIS
ERA THAT IS A PAINFUL
MISTAKE AND ONE EXAMPLE
OF THIS IS THAT WE AH AND I
DO MEAN WE AH, ARE STILL NOT
EQUALLY EQUALED OR INDIVUALLY
FREE, TO DO AS WE PLEASE AS
LONG AS IT'S LOGICAL OR WITHIN
UNDERSTANDING AND REASON

6/10/70 —MW
9:30 P.M.

PRESIDENT
MINGERING MIKE
Mingering Mike
VICE PRESIDENT
WARREN J. REESE
Warren J. Reese

**MINGERING MIKE FEATURING THE BIG "D"**
The Two Sides of Mingering Mike (detail)          37

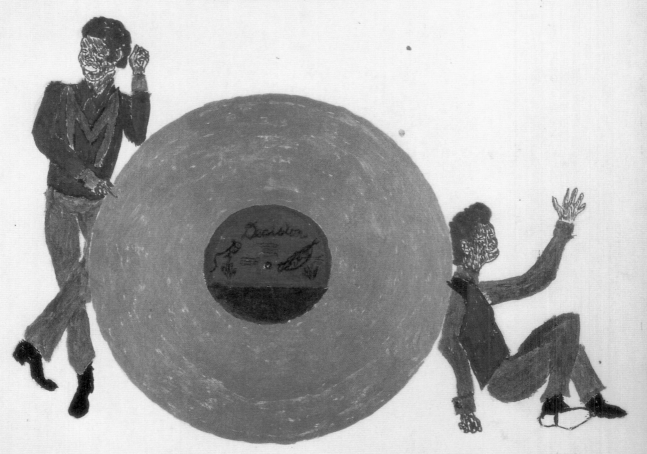

THE
HIP CORNER
SHOWS LATEST
THINGS HAPPENING
SINCE RELEARSEAL
OF THIS ALBUM.

The FOLLOWING ARE
45 RPM SU ER

MIKE (TOGETHER JERRICK
BABY IN LOVE 3 FOOTSTEPS DONT GO
BECAUSE SHE ME 7 OB's OF LOVE TALK TO YOU
I CAN SEE IN EYES NOTHING WRONG REAL THING
WHAT TO DO WOMAN THAT LEAVED
ALL I CAN DO CRY MINGEE ING MHE
LOVE HE R I WANT OUT GET THRILL
SHE LOOKED

ETC. ETC.
ETC ETC

IF WE NAMED All THERR
HITS IT WOULD TAKE UP
All THE SPACE AVAILIBE ON
THIS ALBUM.

MONEY HAENT GONE TO OUR HEADS.

JUST OUR HATS,

PART PRODUCER JOESPH WAR
HAS A SINGLE & ALBUM TO BE
RELEASED IN THE NEAR FUTURE.

MIKE AND DEE ON VACATION
AFTER WARS LAST CONCERT
OF 1970 - 25 ONE NIGHTERS.

BIG "D" JUST COLLETED A GOLD RECORD FOR
I GET A THRILL FROM EVERY TOUCH.

MIKE JUST COLLECTED A GOLD RECORD FOR
BUT SAMS GOING TO TAKE IT ALL AWAY.

SONG OF 3/4/70
(MINGER PUB)
TITTLE BUT ALL I CAN DO IS CRY     WRITTEN
MING

SONG OF 1969
(JERRICK PUB)
TITLE     LET ME TALK TO YOU     WRITTEN BY
THE BIG "D"

JULY 1970

THIS RECORD HAS BEEN SPECIA     TO GIVE AN STEREO AFFIX.

SIDE 1
WHAT I'M GOIN TA DO
NOTHING WRONG WITH YOU BABY (PART ONE)
NOTHING WRONG WITH YOU BABY (PART TWO)
LET ME TALK TO YOU
THE ONE WHO'S GONE AWAY (J.WAR-M.MILLS)
BUT ALL I CAN DO IS CRY
THREE FOOTSTEP (PART 1)

EXTRAS, THE MONGOES &
THE OUTSIDERS

SIDE 2
GOT TA GET NEXT TO THE REAL THING
WE'VE GOT SOMETHING THAT WE NEED
GOOD TO HAVE SOMEONE AROUND LIKE YOU
WHY YOU WANT TO DO THIS TO ME (ETC.)
GOOD SWEET WOMAN
LA LA, IS All I KNOW SEVEN OB's
THREE FOOTSTEPS (PART 2)

© 1970

PRODUCED BY MING WAR
PRODUCTIONS
NATIONS CAPITOL
ARRANGED BY MINGER MIKE
THE BIG "D"s
FOR DECISION RECORD
MINGER STUDIOS

39

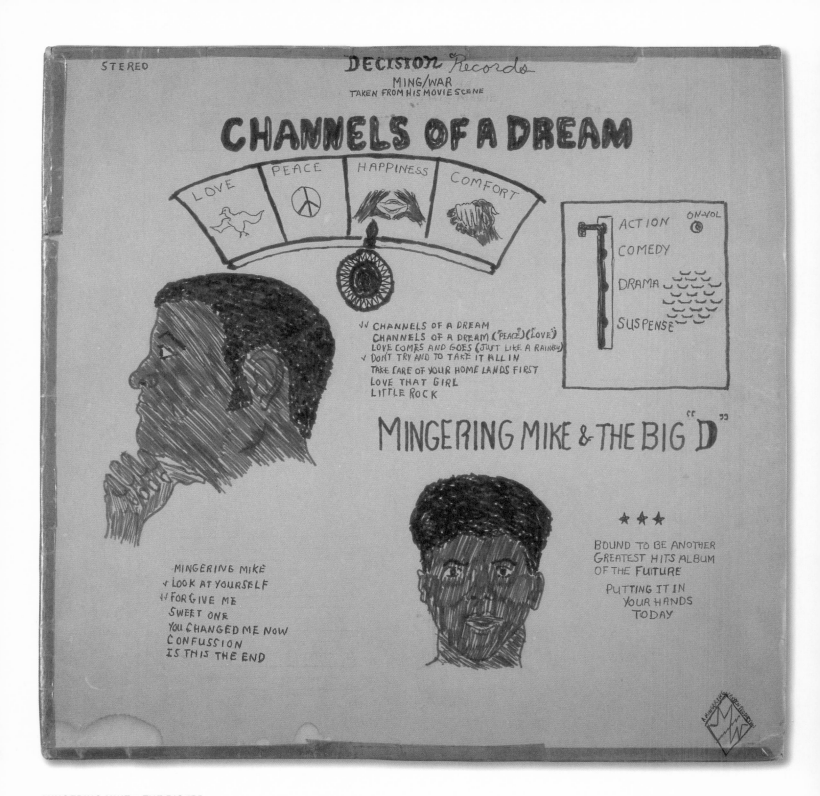

**MINGERING MIKE & THE BIG "D"**
Channels of a Dream
(Decision, Sept. 1970)

# The HIP CORNER

SHOWS LATEST
THINGS HAPPENING
SINCE RELEASEAL
OF THIS ALBUM
SELECTIONS

FOR THE SECOND
TIME THE USE TOBE
COLTS, WHICH WAS CHANGED TO
THE MONITORS ARE
NOW CALLED
THE MONGOES.

A HIP NEW HIT
SINGLE, TWO SIDED
HIT AS ALWAYS

I'll GET IT TOGETHER

LOOK AT YOURSELF

All SELECTIONS WRITTEN AND ARRANGED BY
MINGERING MIKE AND THE BIG "D"

MUSIC BY;
THE COLTS BAND &
THE GEORGE-WITCHAWORS, HITCHATORS ORCHESTRA

EXTRAS;
THE OUTSIDERS &
THE MONGOES

| THE BIG "D" | MINGERING MIKE |
|---|---|
| SING AS SOLOIST | SING AS SOLOIST |
| SINGS AS DUET | SINGS AS DUET |
| SINGS AS GROUP | SINGS AS GROUP |
| STARTED WRITTING IN 1967 | STARTED WRITTING IN 1967 |

LISTEN TO THE WARREN AL        REED SHOW   MAIL IT TO MING-WAR PRO.
IN WASHINGTON D.C.                              WASH. D.C.
"ON WAR RADIO DIAL 1820                    STOP THE WAR
                                                          PETITION
                                                      To the President inside
                                                      Sign it, Pass it on
"Will I MARRY, Will I DINN"                  A TOTAL OF 25 Names
                                                      ON SCRIP IN EACH ALBUM
"I'll GET IT TOGETHER"
TO THE MANY, MANY FRIENDS OF MINE.
                                    Mingering Mike

IF YOU DON'T FEEL OR SEE
THE LOVE THAT'S IN WE
WELL THEN JUST TAKE A
LOOK AT YOURSELF:
AND SEE WHAT LIFE WOULD BE, TO US
WITHOUT YOU OR ME.
                                    The Big "D"

I DON'T WANT THIS TO BECOME
FOR THE LURDS SAKE
"SHAME OF THE WORLD"          I HATE WAR, NOW TELL ME
                                            WHAT ITS FOR
SEPT 5 1970                         IS IT FOR PEASE
                                            IS it FOR HATE,
                          WHY CANT WE LOVE THE PEOPLE OF HERE
                          AND OTHER LANDS, WHY DON'T WE ALL GIVE
                          LOVE AND KINDNESS A CHANCE.

NATIONS CAPITOL

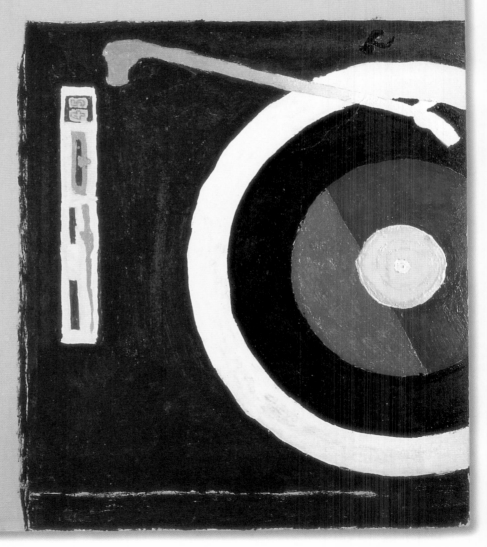

# GROOVING WITH MIKE

## MINGERING MIKE

STEREO AE,
N⁰ 893

"INCLUDES"

222 LOVE AVENUE.

SITTIN IN THE MOVIES ALONE.

"I DON'T KNOW, HOW I'M GOING
TO DO IT.

("YOU'RE PLAYING) "PLAY IT COOL
DON'T BE NO FOOL, GET YOUR THING
TOGETHER AND GO BACK TO SCHOOL"

**MINGERING MIKE**
Grooving with Mike
(Minger, Oct. 1970)

42

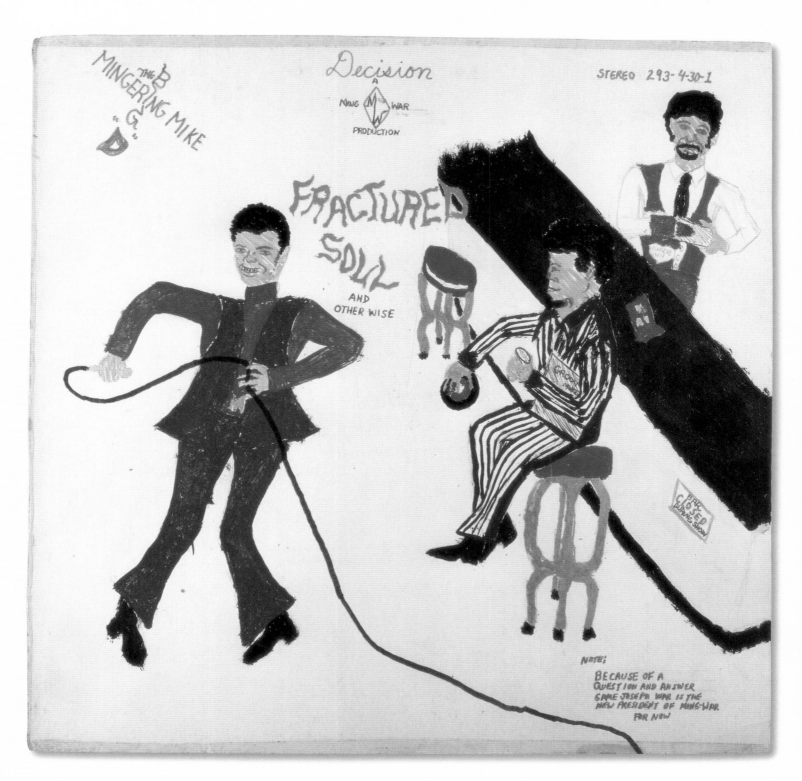

**MINGERING MIKE & THE BIG "D"**
Fractured Soul and Other Wise
(Decision, Apr. 1971)

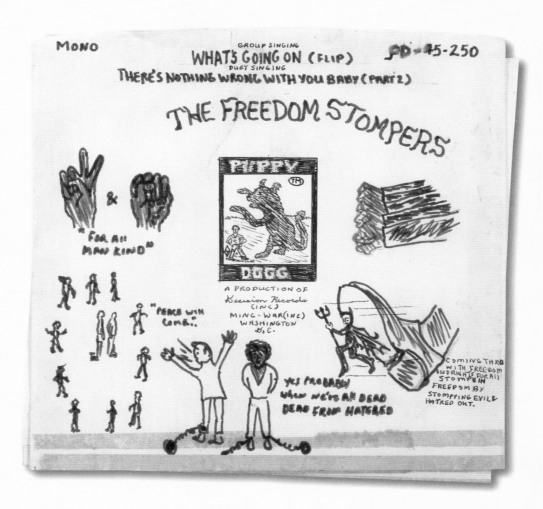

**THE FREEDOM STOMPERS/MINGERING MIKE & THE BIG "D"**

"What's Going On"

b/w "There's Nothing Wrong With You Baby (Part 2)"

(Puppy Dog/Green & Brown, first copyright Nov. 1969, renewed 1971)

44

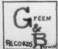

**MINGERING MIKE**

Minger's Gold Supersonic Greatest Hits (Vol. 3)

(Minger, May 20, 1971)

## SIDE 1

1. BECAUSE SHE KNOWS
2. FIND IT (PART ONE)
3. FIND IT (PART TWO)
4. DON'T TRY AND TA TAKE IT ALL IN
5. I CAN SEE IT IN YOUR EYES
6. I'LL GET IT TOGETHER
7. LOVE COMES AND GOES

## SIDE 2

1. TUFF KIDS
2. WHAT I'M GOIN TA DO
3. SHE LOOKED INTO MY EYES
4. CHANNELS OF A DREAM
5. I LIKE DOING THINGS NOT RIGHT
6. LET'S NOT FIGHT

"JUST COOLING IT AT HOME"

ALL OF THE ABOVE LISTED WERE WRITTEN AND COMPOSED
BY MINGERING MIKE
PUBLISHED BY
CRYSTAL BALL MUSIC (INC,)
Decision
Ming WAR Production
Washington D.C.

ALL OF THE ABOVE RECORDINGS HAVE EXCEEDED
THE THREE MILLION MARK,
IN RECORD SALES.

MINGERING MIKE HAS SHOWN YOU MILLIONS AND MILLIONS
OF TIMES OF HIS CAPABILITYS
AS A SUCESSFUL SONG WRITTER COMPOSER
AND LAST BUT NOT LEASE SINGER
A TRUE ARTIST IN EVERY SENSE OF THE WORD.

MINGER RECORDS DISTRIBUTED BY DECISION RECORDS WASH., DC. 20005

**MINGERING MIKE**

Get'tin to the Roots of All Evils

(Minger, Aug. 1971)

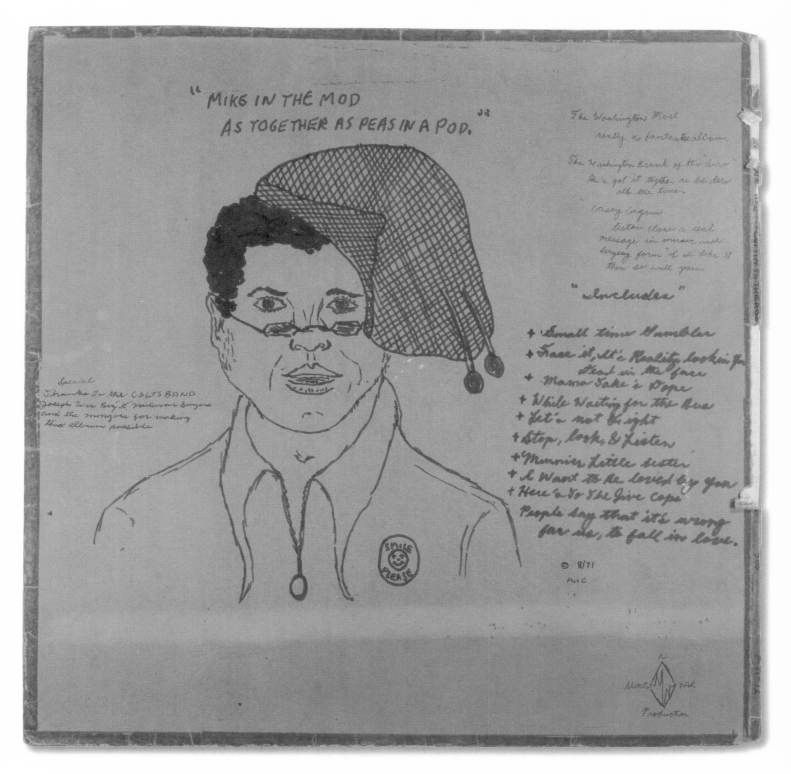

overleaf
**MINGERING MIKE**
Get'tin to the Roots of All Evils (gatefold)

EXPRESSIONS OF HAPPINESS
RECIEVING HIS GOLD
RECORDS FOR

LETS NOT FIGHT.
WHO'S WAITING FOR
THE BUS.
HERE'S TO THE
JIVE COPS.
WE'VE GOT TO GET
IT TOGETHER.
FACE IT, IT'S REALITY.
MAMA TAKES DOPE
THESE ARE MY PEOPLE
RIGHT OR WRONG.
WEAK AND STRONG.
SMALL TIME GAMBLER
SHE'S MY MAIN HUBBA-HUBBA.

I'M VERY CONCERN WITH THE GROWING RATES
OF SUICIDES, THIEFTS KILLINGS, ALCOHALISM, ADDICTS
PROSITUTES, FAKES, FRAUDS, HIGH COST OF LIVING
HIGH COST FOR BEING SICK, DEATH ARRANGEMENTS
CHILD EDUCATION, ADULT EDUCATION, POVERTY
PREJUDICE, BIGATRY, THE WAR, AND THE SUCCESS
OF THIS ALBUM

Mingلering Mike

IS THE WORLD GOING MAD
HERE IS WHERE ONCE LIED
THE WORLD AND IT'S GODS
I I HAPPENED ALL OF A SUDDEN
AND NOBODY WAS TOLD... "REST IN PEACE"

PEACE AND POWER
TO ALL MAN
KIND
AND ME TOO

BIG D., M. MIKE, R. RALPH

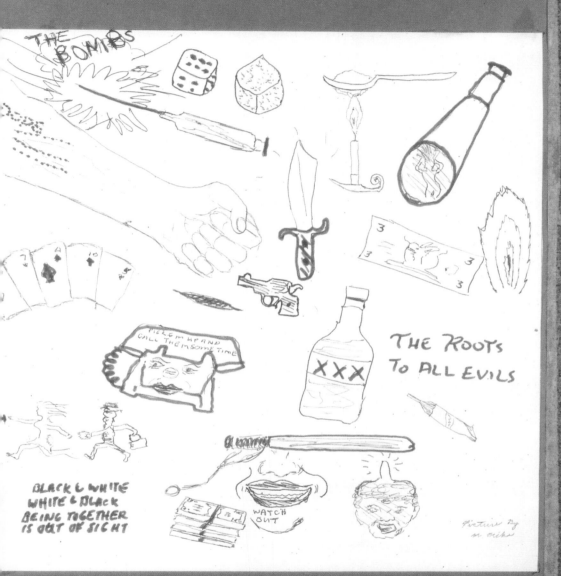

THE BOMBS

MIX EM UP AND
CALL THEM SOME TIME

THE ROOTS
TO ALL EVILS

BLACK & WHITE
WHITE & BLACK
BEING TOGETHER
IS OUT OF SIGHT

WATCH
OUT

XXX

Picture By
m mike

ALL SONGS WRITTEN, PUBLISHED AND
PRODUCED BY MINGERING MIKE

### SIDE 1

SMALL TIME GAMBLER
FACE IT, IT'S REALITY (PART 1)
FACE IT, IT'S REALITY (PART 2)
MAMA TAKES DOPE
HERE'S TO THE JIVE COPS
WHILE WAITING FOR THE BUS

### SIDE 2

PEOPLE SAY IT'S WRONG FOR US
MINNIE'S LITTLE SISTER
I WANT TO BE LOVED BY YOU
IF MY MIND DOES, MY HANDS DON'T
STOP, LOOK & LISTEN
LET'S NOT FIGHT

## The Hit Corner

CONTAINED IN THIS ALBUM
ONLY IN EVERY THIRTY ALBUM
ANOTHER SURE HIT FOR MINGER
A TWO SIDED MONSTER.

## "FOR FAN'S ONLY"

IF YOU WOULD LIKE TO
ENTER MINGERING MIKE'S
FAN CLUB SEND A
DOLLAR, FOR TWO PICTURE A
BUTTON, A PEN 2 BOOKCOVERS
AND A NOTE OF THANK
PERSONALLY FROM MIKE

SEND TO:
THE MINGERING MIKE
FAN CLUB P.O. 10100
WASHINGTON D.C. 200000000

JUST ONE
DOLLAR

MW-NO-575

**INSTRUMENTALS**
AND ONE VOCAL

ARRANGES AND DIRECTS

STEREO

THE
MINGERING
SINGE
INC

LOOK AND LISTEN FOR
NEW SINGLES BY
THE FREEDOM STOMPERS
AND ONE FROM MINGERING
MIKE, AND THE BIG D"
SOON TO BE RELEASED.

ITS A REMARKABLE WORLD

LOOK AT YOURSELF

ME AND YOU AND A DOG NAMED BOO

DO I LOVE YOU

IF A BLIND MAN COULD SEE

FOR THE SUMMER OF (?)

THERES WAS A TIME

BUT A GIRL CAN MAKE YOU CHANGE

BUT ALL I CAN DO IS CRY

DONT TRY AND TA TAKE IT ALL IN

DEDICATED TO THE ONE OUT OF A MILLION
THAT WONDERS CAN HE DO ANYTHING
OTHER THAN SINGING

THE ANSWER IS "WELL, WE'll LET YOU
BE THE JUDGE OF THAT

WITH THE EXCEPTION OF 5 SONGS, ALL THE REST ARE WRITTEN AND COMPOSED
"BY HISSELF"

**THE MINGERING MIKE SINGERS & ORCHESTRA**
Instrumentals and One Vocal
(Ming/War, Aug. 1971)

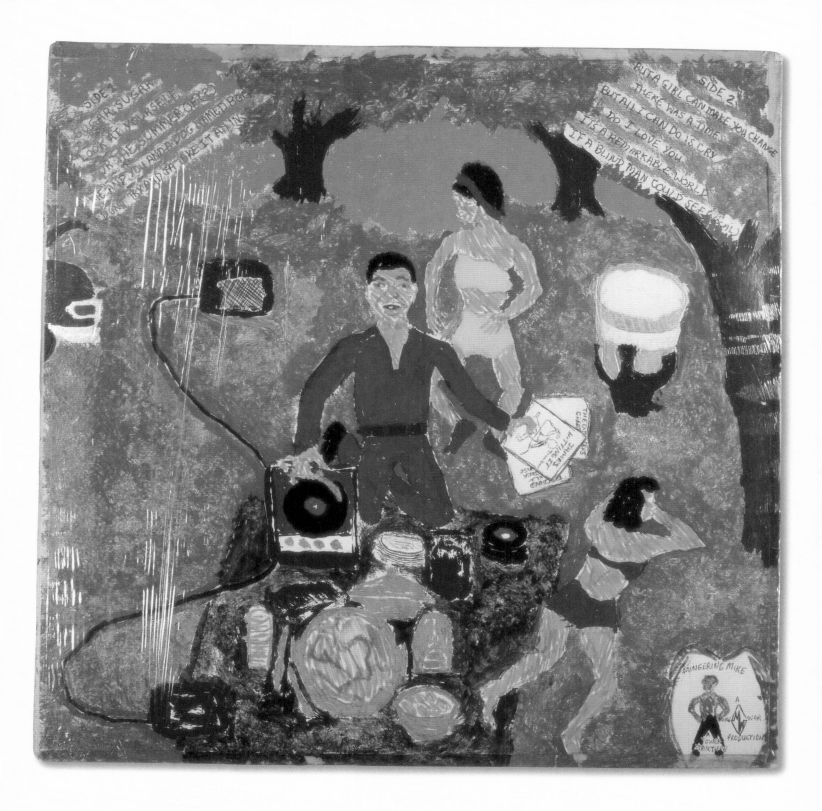

I know that this album
Is nice, but the only
Way that "you out there"
Can tell this as a fact
That if you hear it somewhere
Or if you just plain right out
And buy it, and I don't collect
Too many albums so' if you're
Like me than I know you'll enjoy it.

—Mingering Mike

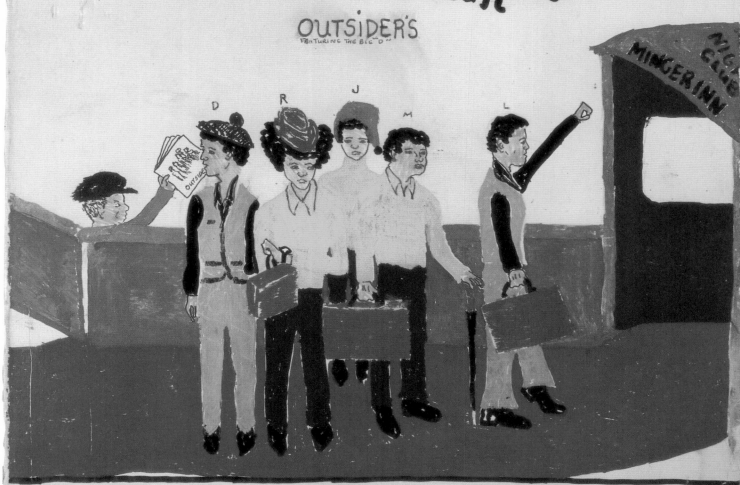

**THE OUTSIDER'S FEATURING THE BIG "D"**
The Outsider's Are Back
(Sex, 1971)

**Top-left record (partial):**
ME
AND
INSTRUMENTAL FROM THE MOVIE "BROTHER OF THE DRAGON" Time 2:45
45-61974
UDID'S

**Top-right record:**
WAR RECORDS DISTRIBUTORS
GEMS
STEREO GS-456
PRODUCED & ARRANGED BY JOSEPH WAR & MINGERING MIKE
45 R.P.M.
STONE PUB BMI
GS 10734
WAR STUDIO RECORDED
VOCAL TIME 3:05
I'VE FORT BATTLES IN SAIGON NOW I'VE GOT TO FIGHT IN WASHINGTON (G. STEVENSON, W. REESE)
MINGERING
IN ALBUM 3407 1972 RELEASE

**Bottom-left record:**
(M. MIKE)
YOU KNOW ONLY WHAT "THEY TELL YOU"
MINGERING MIKE
ARRANGED & PRODUCED BY M MIKE 45-19502
VOCAL TIME MONO CRYSTAL BALL MUSIC RECORDED AT WAR STUDIO
FROM THE MOVIE & ALBUM, YOU KNOW ONLY WHAT THEY TELL YOU. 45 RPM WASHINGTON D.C.
RELAYSONS
A TRADE MARK OF REGISON PLUS WAR (INC)

**Bottom-right record (partial):**
BANGL...
(GEORGE HARRISON)
HOTTIFONES MUSICING BMC TOTAL-4:00
RECORDED AT WAR STUDIO WASHINGTON D.C.
MIN...
DISTR...

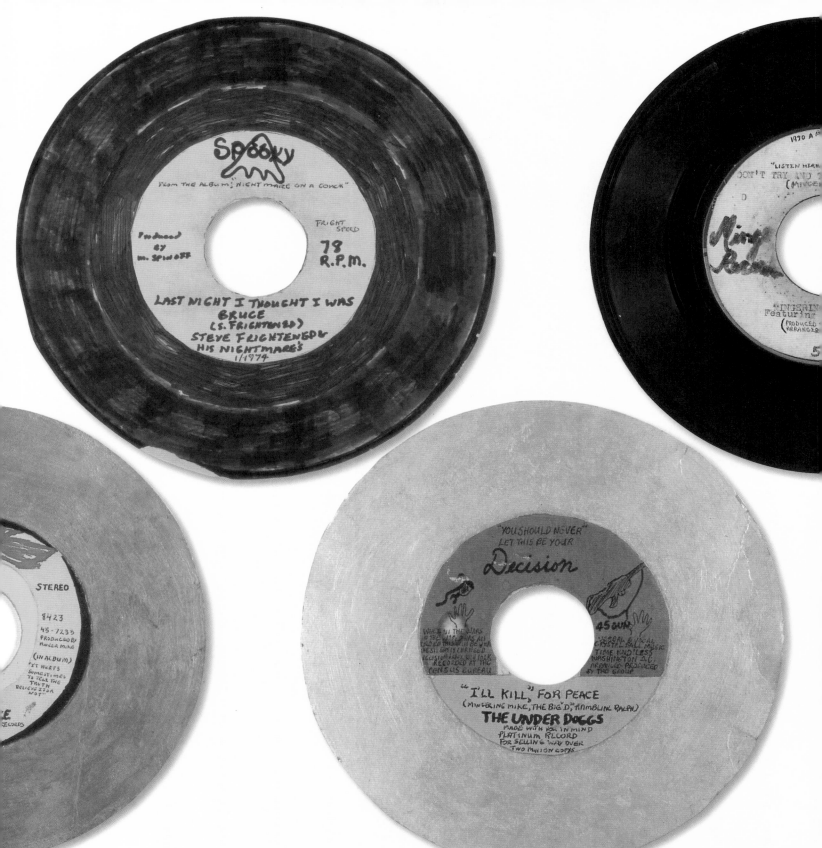

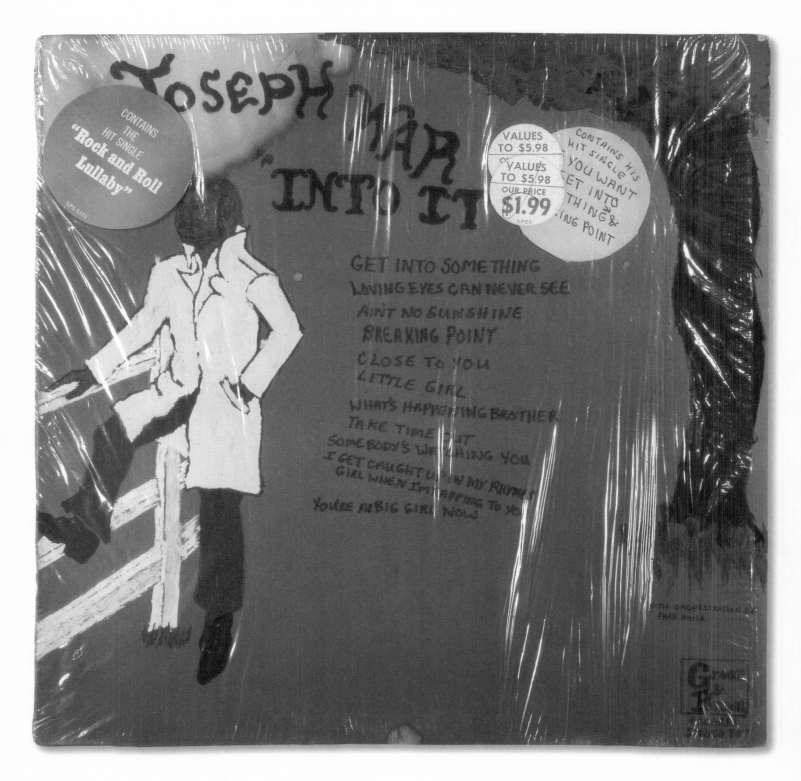

**JOSEPH WAR**

"Into It"

(Green & Brown, Oct. 1971)

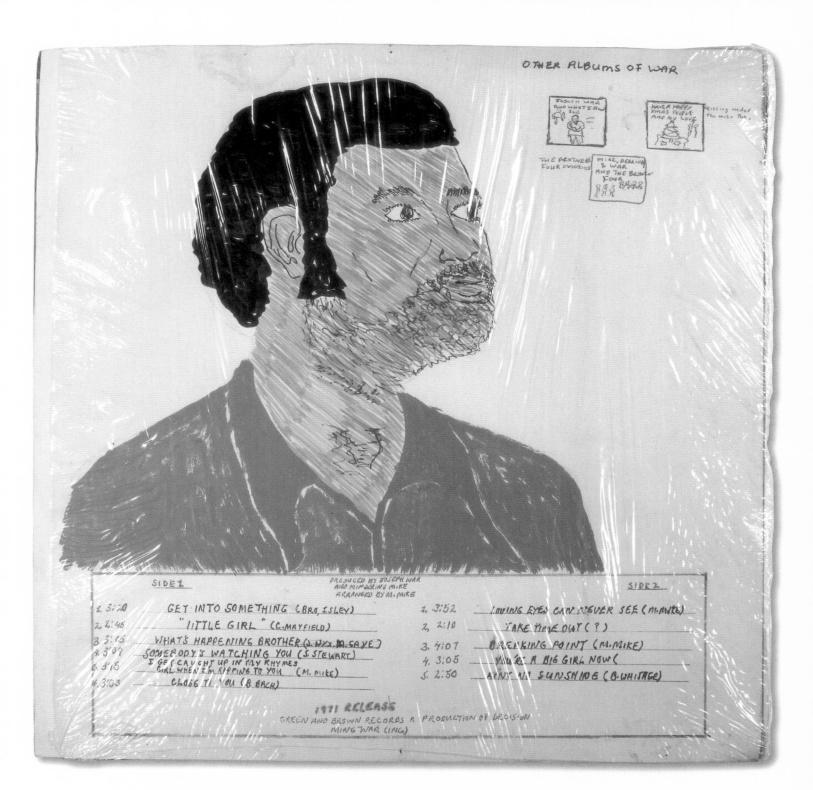

OTHER ALBUMS OF WAR

SIDE 1

PRODUCED BY JOSEPH WAR
AND MIXED BY MIKE
ARRANGED BY M. MIKE

SIDE 2

| | | SIDE 1 | | | SIDE 2 |
|---|---|---|---|---|---|
| 1. 3:20 | GET INTO SOMETHING (BRO. ISLEY) | | 1. 3:52 | LOVING EYES CAN NEVER SEE (M. MIKE) | |
| 2. 2:45 | "LITTLE GIRL" (C. MAYFIELD) | | 2. 2:10 | TAKE TIME OUT (?) | |
| 3. 3:15 | WHAT'S HAPPENING BROTHER (J. NYX M. GAYE) | | 3. 4:07 | BREAKING POINT (M. MIKE) | |
| 4. 3:07 | SOMEBODY'S WATCHING YOU (S. STEWART) | | 4. 3:05 | YOU'RE A BIG GIRL NOW ( | |
| 5. 3:15 | I GET CAUGHT UP IN MY RHYMES | | 5. 2:30 | AINT NO SUNSHINE (B. WHITHER) | |
| | GIRL WHEN I'M RAPPING TO YOU (M. MIKE) | | | | |
| 6. 3:03 | CLOSE TO YOU (B. BACH) | | | | |

1971 RELEASE
GREEN AND BROWN RECORDS A PRODUCTION OF DECISION
MING WAR (ING)

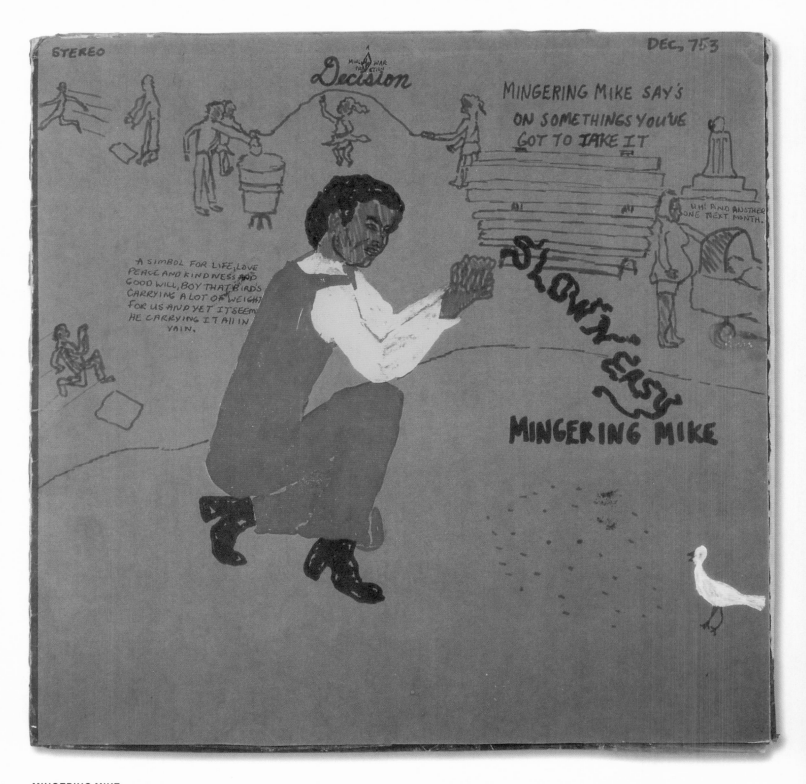

**MINGERING MIKE**
Slow "N" Easy
(Decision, Oct. 1971)

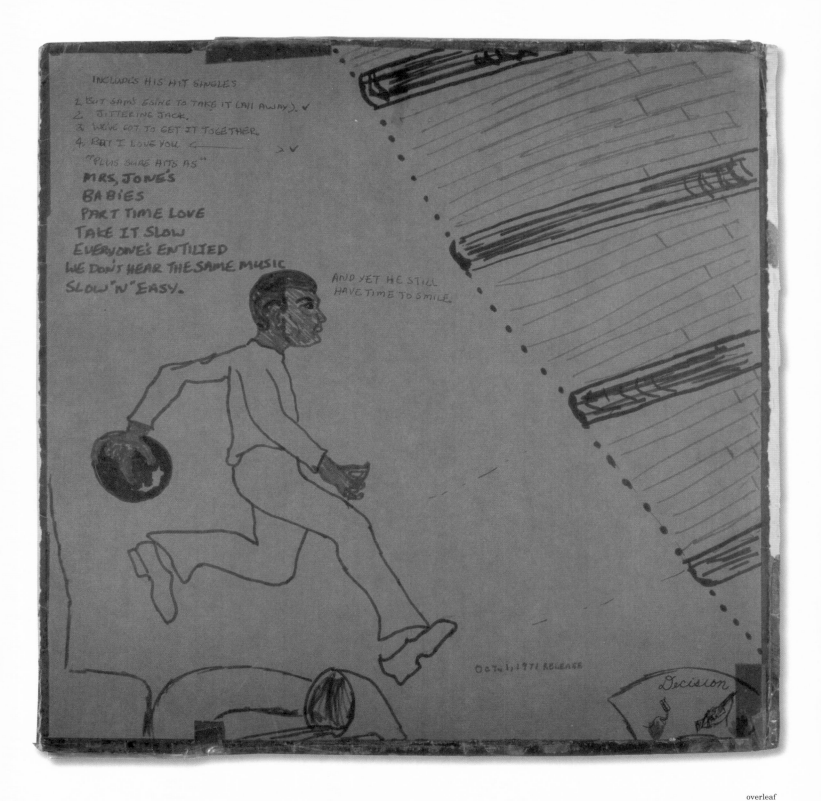

overleaf
**MINGERING MIKE**
Slow "N" Easy (gatefold)

"BUT SAM" HE'S GOING TA TAKE IT ALL AWAY

You're Living HIGH ON TOP TODAY
But SAM- HE'S GOING TA "TAKE IT (ALL AWAY)
NOT BY FORCE, BUT BY JUST PLAIN OLD HERE SAY

Now WHAT I SAY, You're Living REALLY living it up (TODAY)
"HA" BUT SAM HE GOING TA TAKE IT (ALL AWAY)
"HA" THEIR TRYING TO STOP PEOPLE FROM SMOKING TODAY

I AIN'T FOR IT BUT ANYWAY, WHICH WOULD YOU WANT
A SLOW LINGERING DEATH
OR SECOND BY SECOND LIVING IN DEATH

"WAR" THE KING OF USELESS, FOOLISH, UNREST
THINK ABOUT IT NOW
WHICH ONE WOULD BE YOUR BEST
IF YOU HAD TO PUT UP A FIGHT AND TA PROTEST.

"HA" You're LIVING REALLY LIVING HIGH ON TOP TODAY
AND AGAIN I SAY, But SAM? HE'S GOING TA TAKE IT
(ALL AWAY) PUT UP A FIGHT AND STOP THIS TODAY

IF YOU WANT YOUR YOUNG IN TO LIVE TOMORROW
"AH" AS THEY LIVE TODAY ("DON'T FIGHT")
USE YOUR MINDS AND SIGNS
AND TA KEEP THAT BOTTLE OF IODINE AT HOME
TO HEAL THAT EAR FROM TALKIN ON THE TELEPHONE

---

WE'VE GOT TO GET IT TOGETHER

WE'VE GOT TO GET IT TOGETHER
WE'VE GOT TO GET IT TOGETHER
WE'VE GOT TO GET IT TOGETHER

WHEN EVER YOU'RE FEELING DOWN
AND A, AND A WEARING A FROWN
BECAUSE OF SOMETHING THAT SOMEBODY SAID

AND THEY, AND THEY GOT YOU MAD
BECAUSE THEY CALLED YOU ALL SORTS OF NAMES
AND IN THE BRAIN IT LEAVES A CONFUSSING PAIN

KEEPPING TO YOURSELF CAN MAKE YOU GO INSANE

AND YOU ASK YOURSELF WHY THEY TREAT ME
DIFFERENT CAUSE "AH, I THOUGHT BASICLY AIN'T WE
ALL THE SAME, JUST DIFFERENT IN NAMES

HAIR, VIEWS AND OTHER THINGS
WELL, DON'T YOU THINK IT'S TIME
CAUSE IT'S BLOWING IN THE HEARTS AND MINDS
CAUSE "PEOPLE" DON'T YOU WANT PEACE SOMETIMES

WELL DON'T YOU KNOW
WE'VE GOT TO GET IT TOGETHER
WE'VE GOT TO GET IT TOGETHER

WE'VE GOT TO GET IT TOGETHER
RIGHT ON, RIGHT AWAY "HO, COME ON
COME ON AND LET LOVE BE STRONG
HEY, HEY, HEY "AH" YEAH COME ON

---

"JITTERING JACK"

AH SAY JUNKIE, YOU WANT SOME DOPE
You WANT the needle or the Kind You Smoke,
Now listen here Junkie

The pusher don't care about you,
cause he meets million a day,
Jim, Ah Just like you,

AND I Don't even Know YOU NAME
but it's obvious you're a Custame
that'll come back agin and again

WANTING the goods and Jack, Jack'S "Shaken"
AND HA "Shimmering "Hey, AH" I think I'll
Call YOU HA, AH Jittering Jack "Hey"

Jittering Jack hurry, hurry on Back
Cause we've got some business to uh, ah trans act.

AND HA I Know You Can't ABUSE
with the stuff I give you to use,

Will help You continue your habit
But You won't be too far gone
Even though your patients and will powers

Just about all Gone, So Come on
and leave some help to get You some
And may be when you get too sick or even

I'm a lg from it, maybe Just then your death
Will bring another to quit.

---

IF I NEVER PERSONALLY MENTION
THE GUYS WHO MADE ME COME
THROUGH WELL AS I THINK I DID
THEY KNOW I APPRECIATE IT.
MAN ON FRONT COVER
JASON LEE JONES.

ORCHESTRATION BY: FRED MUSE
COMBO'S = THE BIG "D"
FLUTE = JOSEPH WAR
DRUMS = LEE SAVERS
VIOLINS = TOM Aders, MARRY BOOTHE
SUGAR ROBERTS and Lang BOWS.
LEAD GUITAR; MARGRET Pirers
BASS Guitar; Susan PAYNE
TRUMPETS; JACK NACKS, TIM ADAMS,
ALBERT DATON;
CLARINET; BOB TAMS
PIANO; SAM LANCE
ORGAN; JIM HICKS

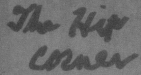

The Hip Corner

## SIDE (1)

*1 BUT SAM'S GOING TO TAKE IT ("ALL AWAY")

2. MRS, JONES

3. BABIES (THOUSANDS OF BABY'S")

4. YOUR PART TIME LOVE

*5. JITTERING JACK

*6. TAKE IT SLOW

JUST WHERE DO YOU STAND
OR DO YOU GIVE A "DAMN"

THE FOLLOWING SONGS ABOVE
AND BELOW WERE WRITTEN
BY MINGERING MIKE,

PUBLISHED BY
CRYSTAL BALL MUSIC
© 1971

MUSIC APPLIED BY
MING-WAR
ORCHESTRA & SINGERS

BLAB, BLAB.

BOOM!

YEAH LAY IT
ON ME

HERE'S THE
STUFF

## SIDE (2)

*1. SLOW AND EASY (INSTRUMENTAL)

2. WE'VE GOT TO GET IT TOGETHER

*3. EVERYONE'S ENTITLED

4. WE DON'T HEAR THE SAME MUSIC

*5. BUT I LOVE YOU

WE ALL STAND ON SOMETHINGS
THEN AGAIN THE OTHER'S
NEED REARRANGE, WHICH
IS CERTAIN TO COME
LIKE THE NIGHT WHEN THE
MORNING COMES.

TODAY WE DEMAND A CHANGE
TO SOME PEOPLE, THEY LIKE IT
THE WAY IT IS, AND THEY CALL
US STRANGE, LET'S GET IT TOGETHER
FOR TOMORROW IS PROMISED TO NO ONE
AND FROM THE END OF LIFE YOU JUST
CAN'T ESCAPE NOR RUN
WHERE CAN YOU? FROM A DARKENED SUN.

Mingering Mike
10/1/71

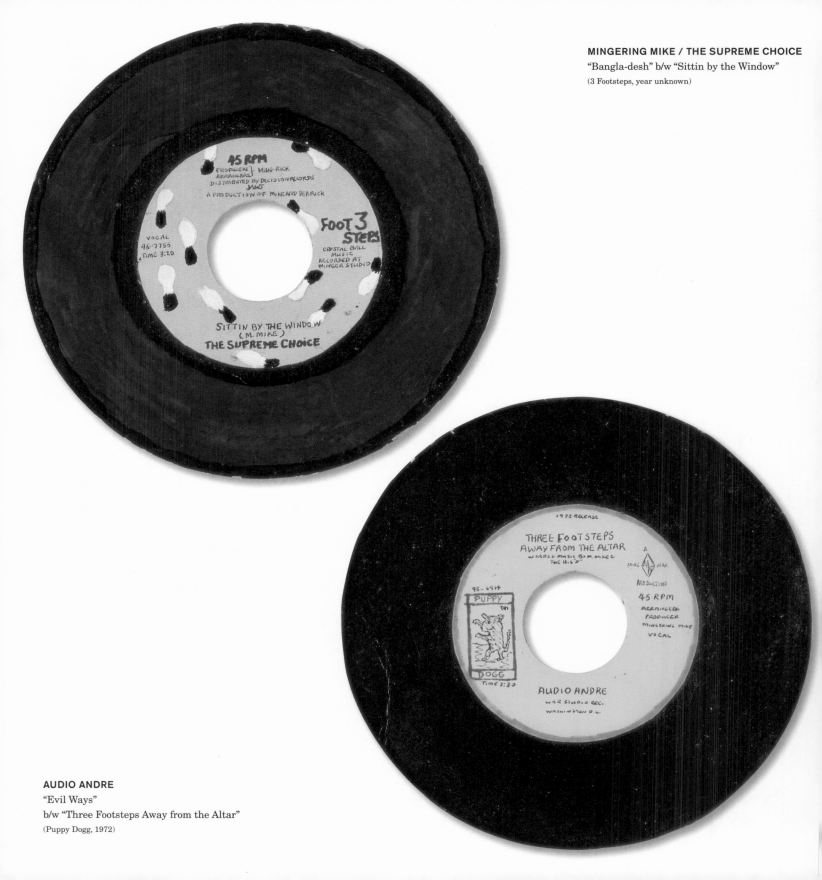

**MINGERING MIKE / THE SUPREME CHOICE**
"Bangla-desh" b/w "Sittin by the Window"
(3 Footsteps, year unknown)

**AUDIO ANDRE**
"Evil Ways"
b/w "Three Footsteps Away from the Altar"
(Puppy Dogg, 1972)

**THE BIG "D" & MINGERING MIKE**

(You Keep Asking Me) "Do I Love You"

(Hypnotic, Dec. 1971)

SIDE A

DO I LOVE YOU (D)(WD) 3:00      GROOVING WITH SOMEBODY          IT'S A REMARKABLE WORLD (WM)(M) 3:50
                                           YOU LOVE
                                        (PART ONE & TWO) 5:00
WE'VE GOT SOMETHING THAT                 (+)(WD)          A BABY IS TO BE LOVED (WM)(M) 3:35
         WE NEED
     (INSTRUMENTAL)
     (D)(WD) 2:47              SIDE B

IT FEELS GOOD (PART ONE & TWO)(+)(D) 5:20  SHE'S BACK (WM)(M) 3:01

           KATHY CALLED (D) 3:02

"WHAT WOULD YOU DO IF"?(M)(WM) 3:10  SUNGLASSES MARGRET (WM)(M) 2:38

    "DO YOU LOVE ME OR DON'T YOU"? (D)(WM) 3:40

"A BABY IS TO BE LOVED"

MEANS WRITTEN BY
     MINGERING MIKE (WM)
MEANS WRITTEN BY
     THE BIG D (WD)
MEANS SUNG BY
     THE BIG D (D)
MEANS SUNG BY
     MINGERING MIKE (M)
MEANS SUNG TOGETHER (+)

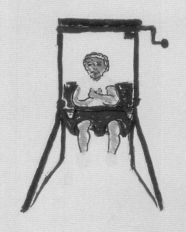

DISTRIBUTED BY DECISION RECORDS
       1971 RELEASE
   A MING-WDR PRODUCTION
      DEC. (10) 1971

**THE BIG "D" & MINGERING MIKE**
(You Keep Asking Me) "Do I Love You" (back cover)          66

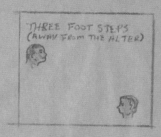

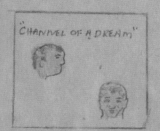

THIS IS THEIR THIRD
ALBUM TOGETHER
AND LIKE THE PREVIOUS
TWO ALBUMS, WILL
PROBABLY MAKE IT
BIG TOO.

**THE BIG "D" & MINGERING MIKE**

(You Keep Asking Me) "Do I Love You" (inner sleeve)　　67

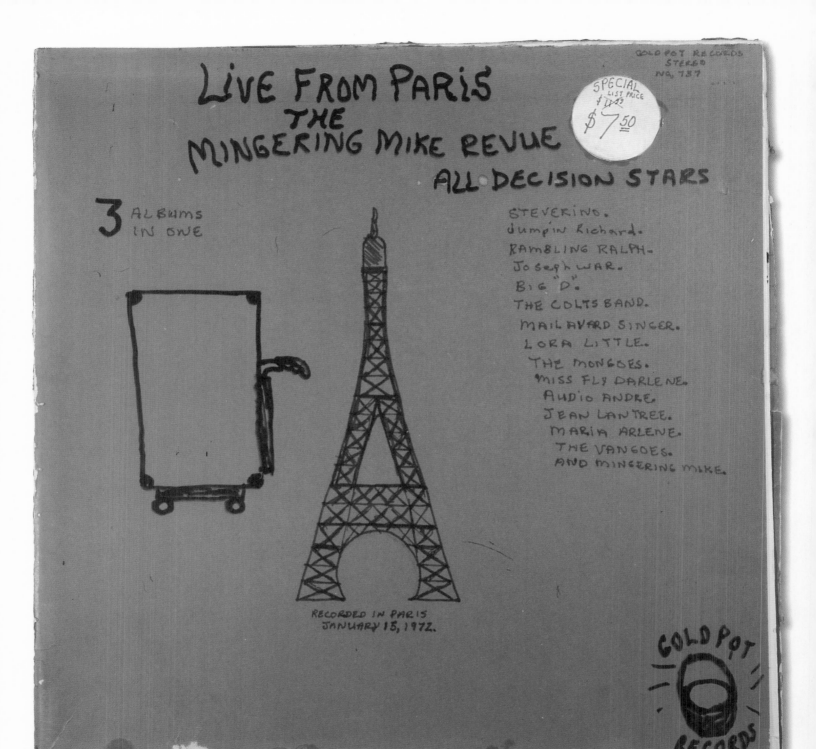

**VARIOUS ARTISTS**

The Mingering Mike Revue All Decision Stars—
Live from Paris

(Goldpot, Jan. 1972)

68

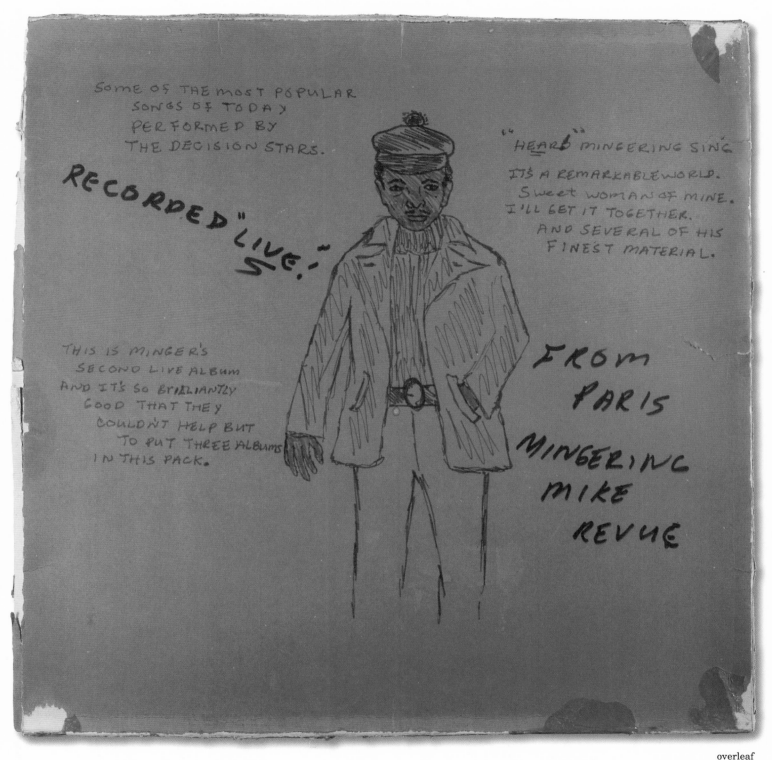

SOME OF THE MOST POPULAR
SONGS OF TODAY
PERFORMED BY
THE DECISION STARS.

RECORDED "LIVE."

THIS IS MINGER'S
SECOND LIVE ALBUM
AND IT'S SO BRILLIANTLY
GOOD THAT THEY
COULDN'T HELP BUT
TO PUT THREE ALBUMS
IN THIS PACK.

"HEARD" MINGERING SING
IT'S A REMARKABLE WORLD.
SWEET WOMAN OF MINE.
I'LL GET IT TOGETHER.
AND SEVERAL OF HIS
FINEST MATERIAL.

FROM
PARIS
MINGERING
MIKE
REVUE

overleaf
**VARIOUS ARTISTS**
The Mingering Mike Revue All Decision Stars—
Live from Paris (gatefold)

EACH STAR HAS A LIVE ALBUM
EITHER TO BE RELEASED
OR HAS ALREADY BEEN RELEASED
IF YOU NEVER SEEN THEM
INPERSON HEAR THEM ON
RECORD LIVE, "OUT OF SIGHT."

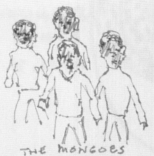

MISS MARIA ARLENE

BIG "D"

THE VANGOES
(J. WAR, J. LANTREE, R. RALPH, M. MIKE, BIG "D")
TOGETHER

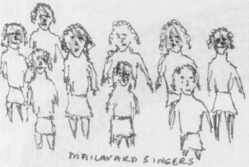

MAILAVARD SINGERS

Jumpin Richard

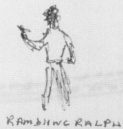

Joseph WAR

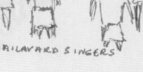

THE MONGOES

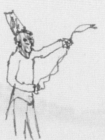

STEVEKIND

RAMBLING RALPH

34
PERFORMERS
THEIR BIGGEST
SHOW EVER.

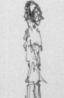

SUGAR MILLER

MISS FLY DARLENE

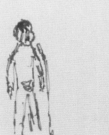

AUDIO ANDRE

LORA LITTLE

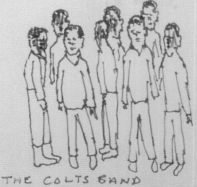

THE COLTS BAND

CRYSTAL BALL MUSIC
ARRANGED BY THE GROUP
PRODUCED BY MINGERING MIKE
RELEASED FEBURARY 10, 1972

JUST A HOUR AND 35 MINUTES OF EXCITEMENT IN THIS ALBUM, A VERY SMALL PORTION OF THIS DYNAMITE SHOW

## SONGS ON THE (A) SIDE OF THE THREE ALBUMS

| | | |
|---|---|---|
| GIVE IT TO ME (m. mike) | SINCE I LOST MY BABY (?) | BUT I LOVE YOU MORE (?) |
| LET ME GO TO HIM (B. BACH, H. DAV) | WHATS GOING ON (LOAPO, CLEWAL) | FUNNY TO REMEMBER (m. mike) |
| EVERYBODYS OUT OF TOWN (B. BACH, H. DAV) | I THINK I'M FALLEN IN LOVE AGAIN (B&D) | LOVE THAT GIRL (m. mike) |
| SPELLBINDER (?) | ARE YOU HAPPY (GAMBLE, HUFF) | WE CAN WORK IT OUT (J. LIMP, INC) |
| TRACKS OF MY TEARS (W. ROBINSON) | ONE MONKEY DON'T STOP NO SHOW (?) | TAKE IT OFF HIM (B. MILES) |
| WHERE DID OUR LOVE GO (HOS, DOZ, HOL) | | BREAKING POINT (m. mike) |
| SUB TOTAL (6) SIX | SUB. TOTAL (5) FIVE | SUB. TOTAL (6) SIX |

# WHEN PLAYING AT HIS HOME TOWN

WASHINGTON D.C. A UNEXPECTED AND UNPREDICTABLE CROWD OF 100,000 STANDING ROOM ONLY

WHAT A NIGHT THAT WAS.

4.50 A TICKET   $600,000

## SONGS ON THE (B) SIDE OF THE THREE ALBUMS

| | | |
|---|---|---|
| LOVE IS A HURTIN' THING (?) | WE'VE GOT TO HAVE PEACE (C. MAYFIELD) | A BABY IS TO BE LOVED (m. mike) |
| ARE YOU MY WOMAN (E. RECORD) | I'LL GET IT TOGETHER (m. mike) | I LIKE DOING THINGS NOT RIGHT (m. mike) |
| CHANNELS OF A DREAM (m. mike) | BUT DO YOU LOVE HIM (m. mike) | I CAN SEE YOUR PHILOSOPHY (m. mike) |
| BUT I LOVE YOU (m. mike) | DON'T TRY AND TA TAKE IT ALL IN (m. mike) | AND I LOVE HER AND I WANT HER BACK (m. mike) |
| BUT ALL I CAN DO IS CRY (m. mike) | FIND IT (m. mike) | IT'S A REMARKABLE WORLD (m. mike) |
| | A BABY IS TO BE LOVED (m. mike) | SWEET WOMAN OF MINE (m. mike) |
| SUB. TOTAL (5) FIVE | SUB. TOTAL (6) SIX | COMPLETE TOTAL (33) |

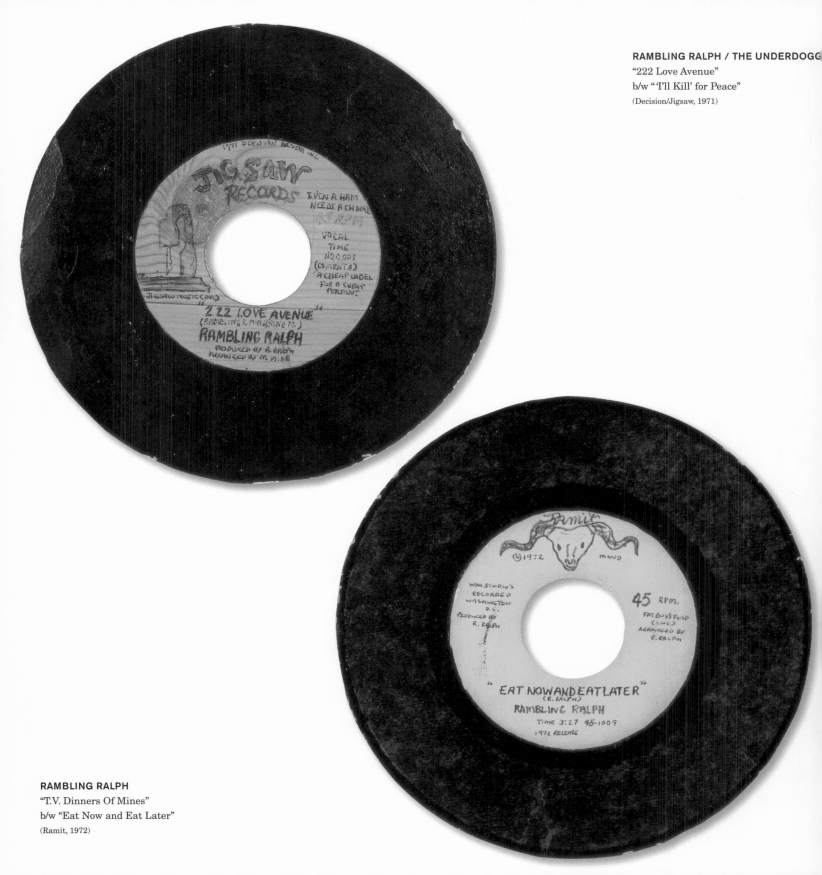

**RAMBLING RALPH / THE UNDERDOGG**
"222 Love Avenue"
b/w "I'll Kill' for Peace"
(Decision/Jigsaw, 1971)

**RAMBLING RALPH**
"T.V. Dinners Of Mines"
b/w "Eat Now and Eat Later"
(Ramit, 1972)

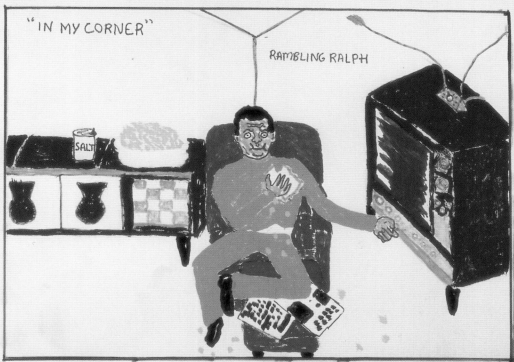

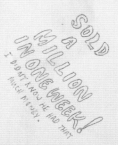

**RAMBLING RALPH**

"In My Corner"

(Ramit, Jan. 1972)

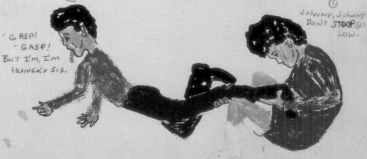

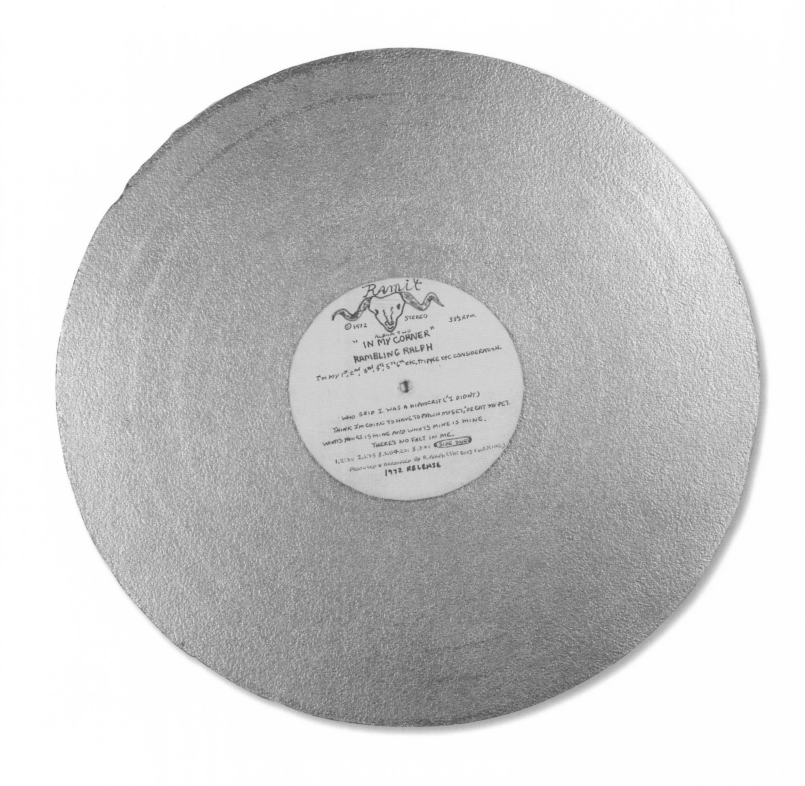

**RAMBLING RALPH**

"In My Corner" (record)

# HOME COMING/"BUT WHEN YOU DRINK"

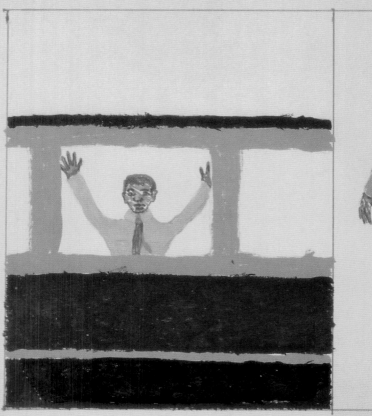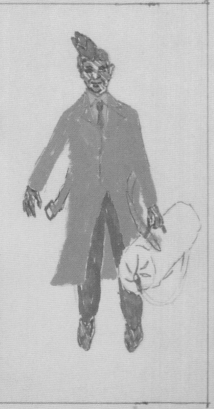

THIS ALBUM CONTAINS;
& **8 MORE.**

{
1. SHE'S NOT A ONE GUY GIRL.
2. "COME ON BACK".
3. "TISK", "TISK", FRUSTRATIONS.

T.T.H.

**MINGERING MIKE**
Homecoming / "But When You Drink"
(Tip of the Hat, Feb. 1972)

76

(SIDE 2 HOME COMING;)

HOME COMING.
° IF YOU KNEW SUEY.
                    AND NOW I'M A DROP OUT.
DON'T STEAL MY LOVE.
                    COME ON BACK.
  I LIKE DOING THINGS NOT RIGHT/ I CAN SEE—
    = INSTRUMENTAL = YOUR PHILOSOPHY.

T.T.H.
Records
ARE Really together.

(SIDE 2 BUT WHEN YOU DRINK;)
BUT WHEN YOU DRINK ( YOU DRINK ALONE).
          DON'T TAKE THE LOVE THAT YOU GAVE ME.
     SHE'S NOT A ONE GUY GIRL.
               TISK, TISK, (FRUSTRATIONS OF AN ANGRY YOUNG MAN)
      THAT'S THE WAY LOVE IS. (INSTRUMENTAL.)

          WAR STUDIO'S RECORDED
              WASH., D.C.
          PRODUCED BY: MINGERING
          1972 RELEASE   2/5/72

overleaf
**MINGERING MIKE**
Homecoming / "But When You Drink" (gatefold)

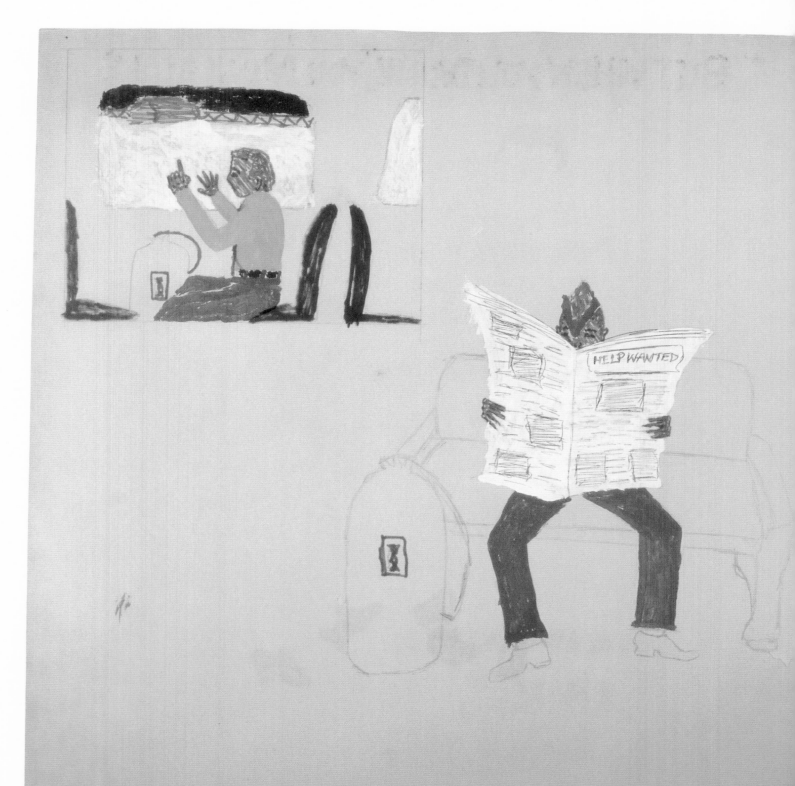

# " BUT WHEN YOU DRINK, YOU DRINK ALONE"

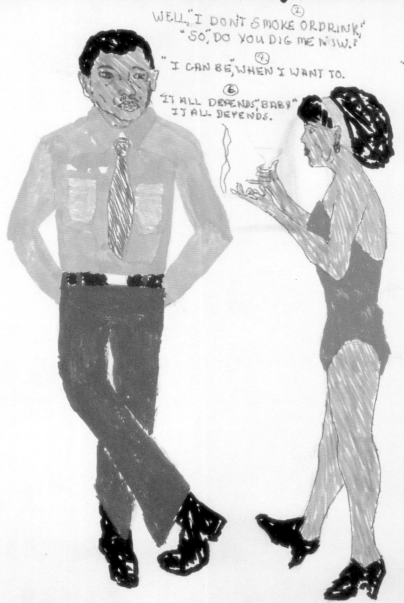

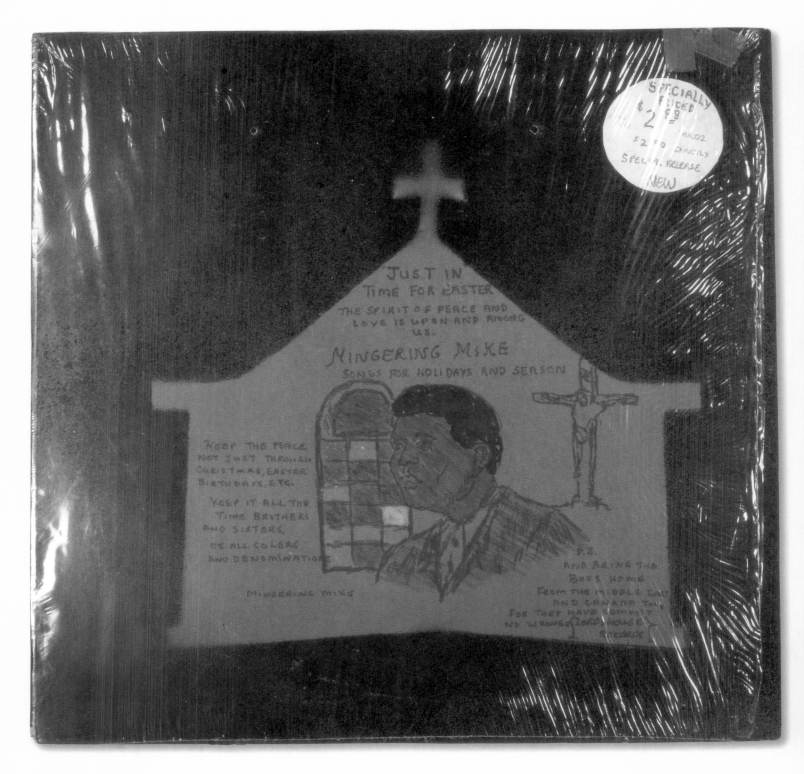

**MINGERING MIKE**

Just in Time for Easter

(Lord's House, Mar. 1972)

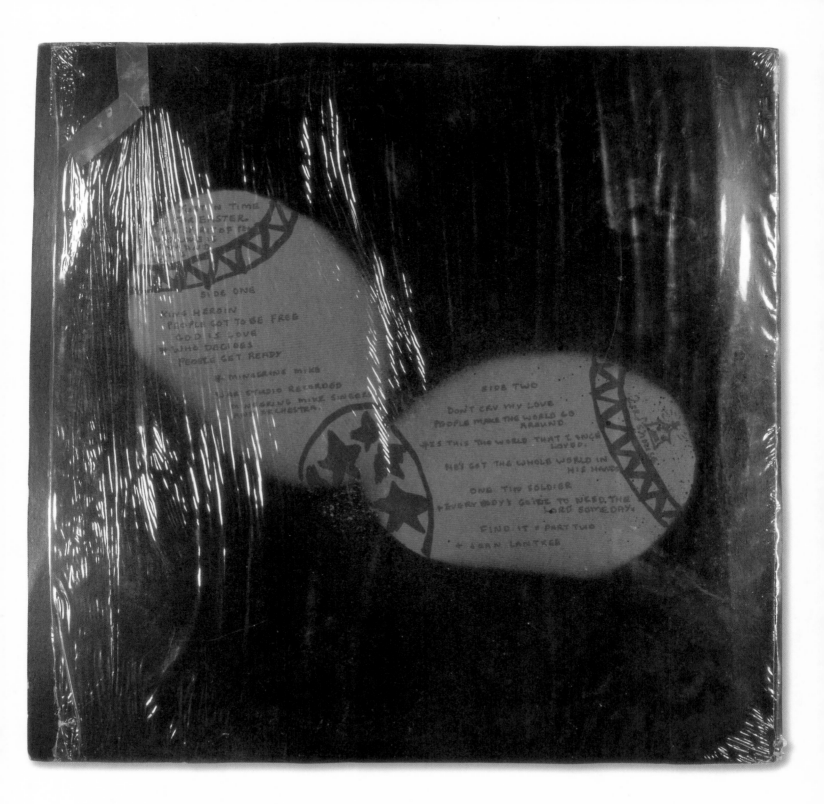

This album I think is one, "and mind you only one of the best albums put together by Mingering Mike," and the way he can pick out of the air songs and make them all hits is one to me. I like this album very much and if you like or getting into his kind of thing then I know you'll agree with me too that this album is out of sight.

—Flem Dims, WGGE

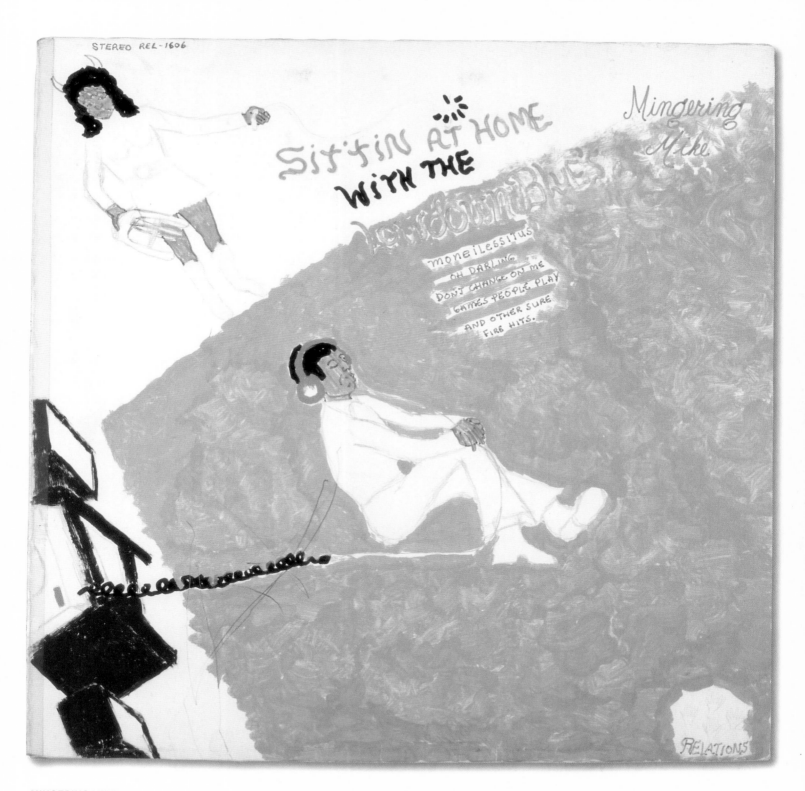

**MINGERING MIKE**

Sit'tin at Home with the Lowdown Blues

(Relations, Apr. 1972)

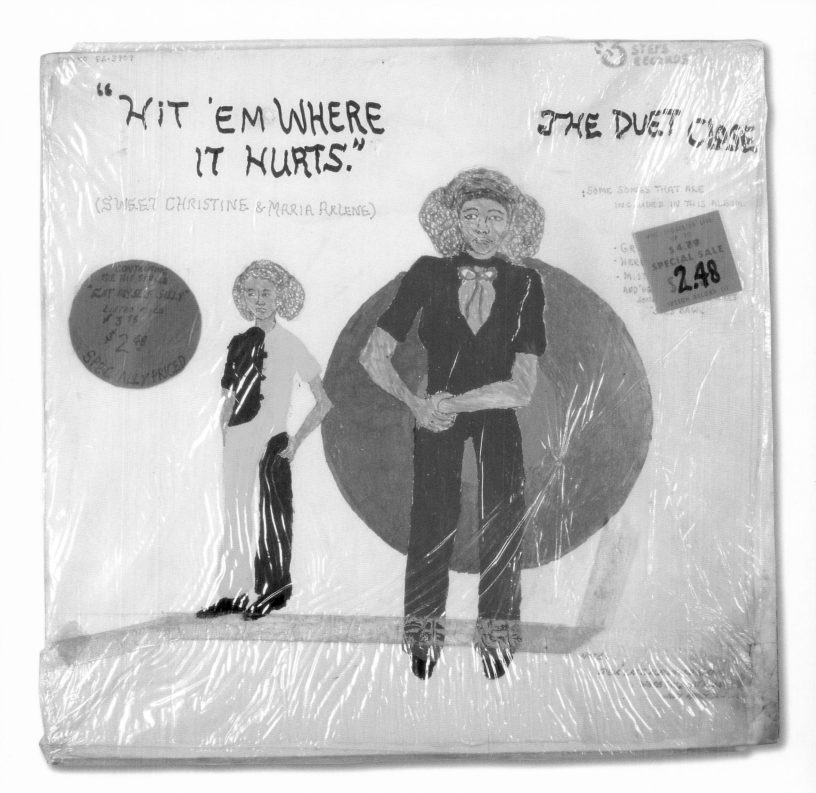

**THE DUET CLOSE**
Hit 'Em Where it Hurts
(3 Footsteps, 1972)

84

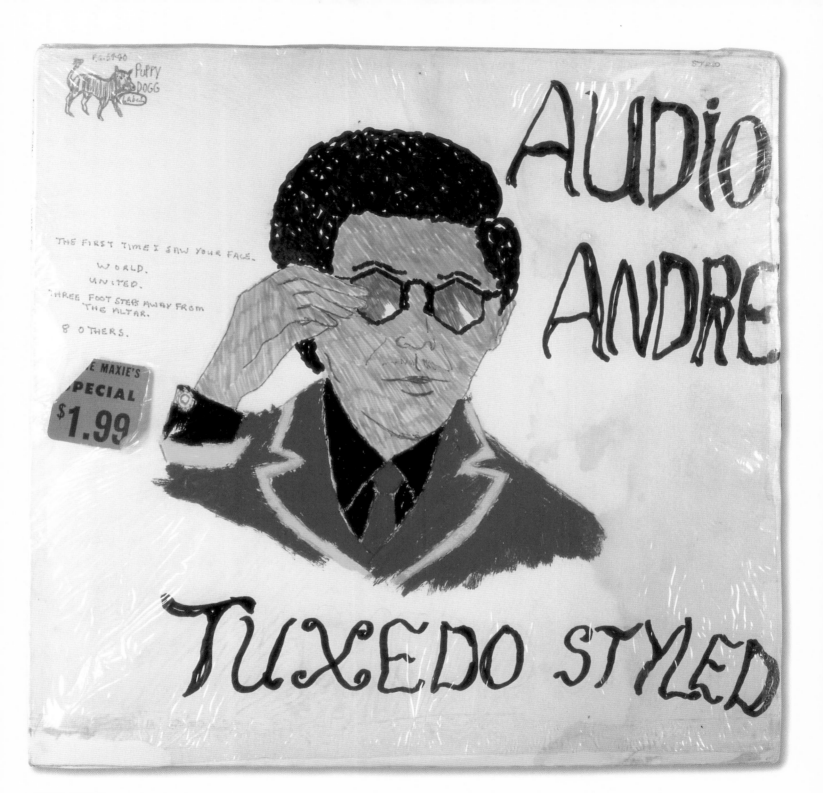

**AUDIO ANDRE**
Tuxedo Styled
(Puppy Dogg, Apr. 1972)

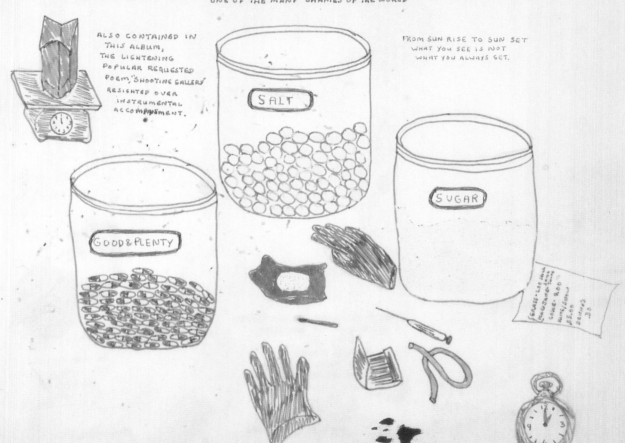

**MINGERING MIKE**
The Drug Store
(Minger, May 1972)

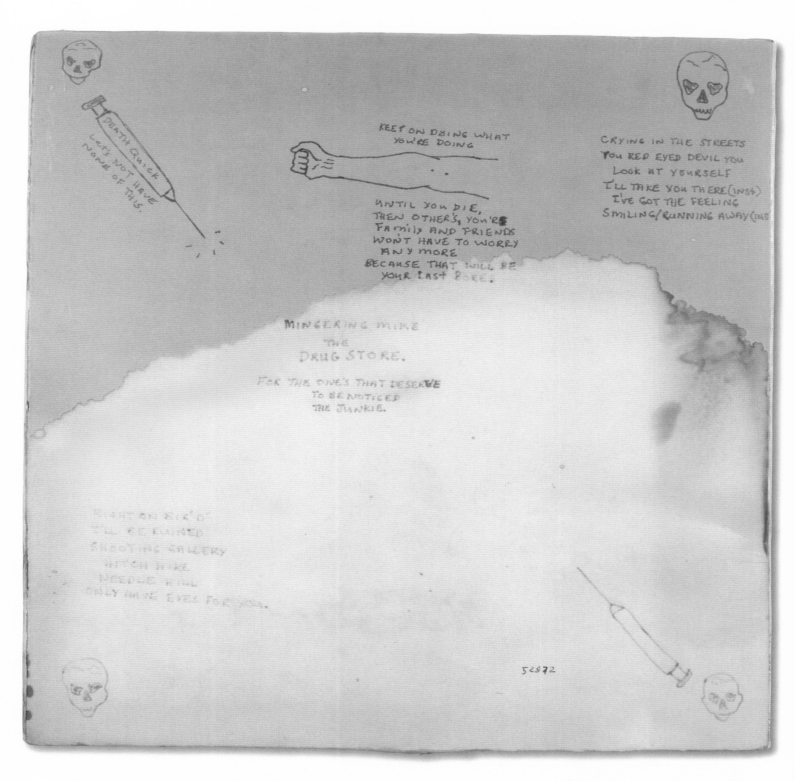

overleaf
**MINGERING MIKE**
The Drug Store (gatefold)

DRUGS AND YOU, I WISH I COULD
HELP SOMEBODY
IF I, I COULD JUST REACH
YOU, SURE I HAVE
HANG UPS "TOO"
BUT I HOPE I WILL
NEVER EVER DEPEND ON
DRUGS AS YOU DO,
JUST FOR A WHILE OF MY
LIFE TIME TO PULL
ME THROUGH.
1:42-1:50 Am. 5/13/72

TO BREAK AWAY FOR A WHILE OF
THE MISERY THAT SOMETIMES
OR ALL THE TIME, THAT FOLLOWS
DRUG ADDICTION, I'VE ADDED
A FEW CHEERFUL & TEARFUL TUNES.

MINGERING MIKE

BACKGROUND VOCALS BY
THE MONGOES
BACKGROUND MUSIC BY
THE DECISION
ORCHESTRA, MAIN OR
FRONT GROUND MUSIC BY
THE COLTS BAND.

SELECTIONS FROM
SIDE ONE & TWO

ALL SONGS WERE ARRANGED BY
MIKE EXCEPT FOR SIDE
ONE & AND TWO BANDS
1 (1) & (2 - (4-6)
THEY WERE DONE BY
JAMES JAMRAD

CRYING IN THE STREETS
YOU RED EYED DEVIL YOU
LOOK AT YOURSELF
I'LL TAKE YOU THERE (INST.)
I'VE GOT THE FEELING
SMILIN/RUN'IN AWAY

PRODUCTION BY JOSEPH W

MINGER RECORDS INC
A BRANCH OF
DECISION MING/WAR
PRODUCTION
WASHINGTON D.C.

RIGHT ON BIG "D"
I'LL BE RUIN
THE SHOOTING GALLERY
HITCH HIKE
NEEDLE HILL
ONLY HAVE EYES FOR YOU

LET'S PUT THE SMOKE
ON DRUGS
BEFORE MILLIONS OF
OTHERS BE COVERED
THE EARTHS RUG.

WRITE US ANYTIME YOU THINK
ON ANY OF THE DECISION
MING/WAR
RECORD STARS IF
A 45 FROM ANY ALBUM
SHOULD BE RELEASED
THAT'S FROM THE PAST
TO THE PRESENT
AND THE FUTURE
EITHER AS THE A OR B
SIDE OF THE RECORD

RECORDED AT
MINGLE STUDIO'S

STEREO - 85073

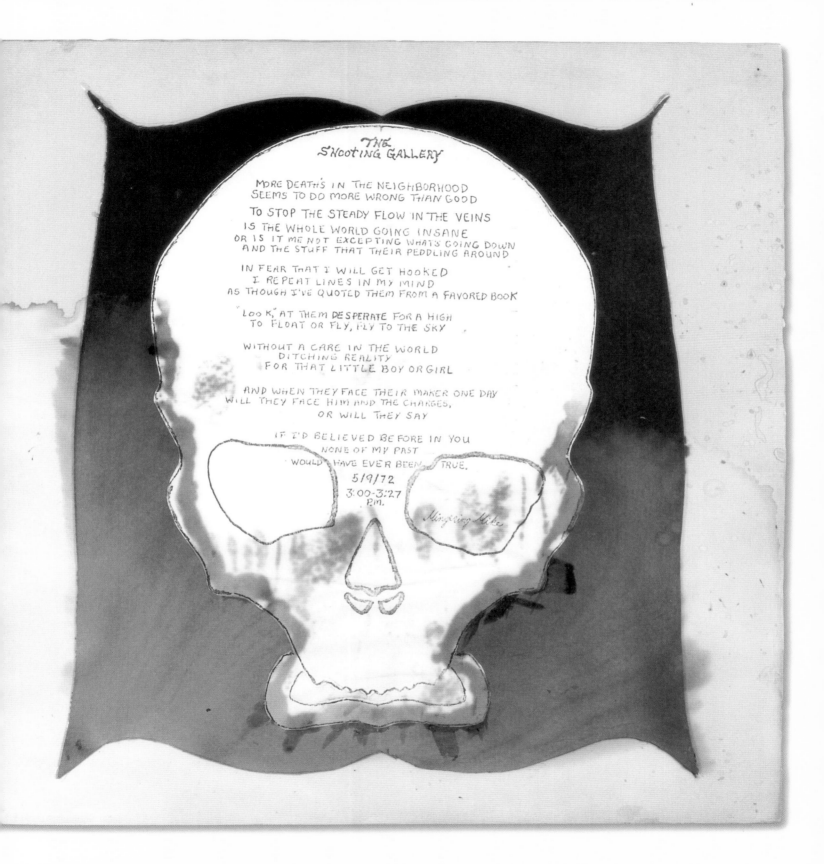

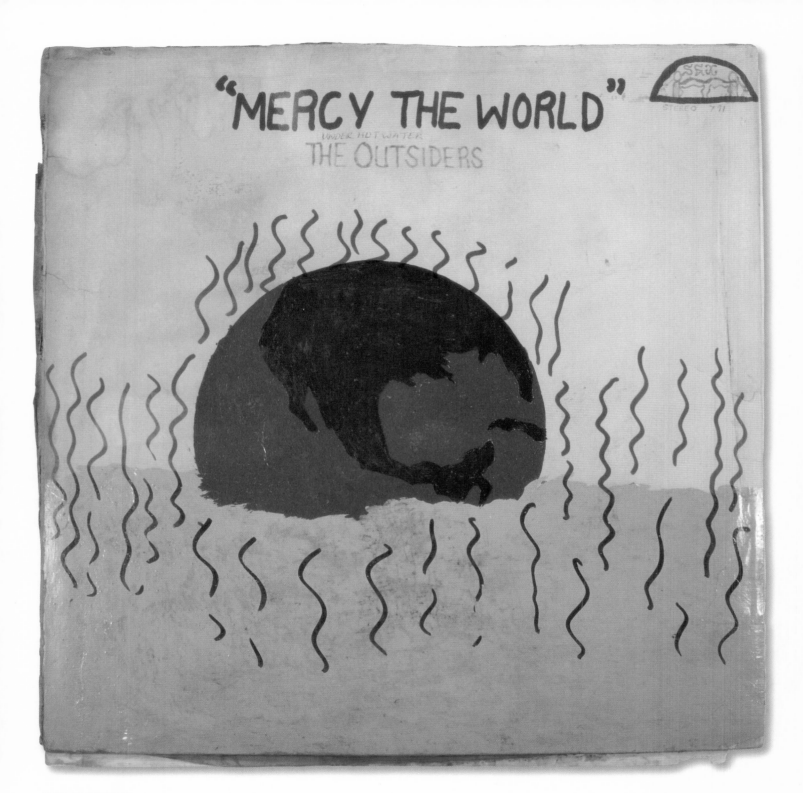

**THE OUTSIDERS**
"Mercy the World"
(Sex, year unknown)

(SIDE 1)

I FEEL HIGH   4:00
THE WORLD IS JUST A BIG BALL OF AIR   3:14
          PEACE   3:58
    CAN WE COME TOGETHER   3:55
  I FEEL THE PAIN   3:00
      WE ARE NEIGHBORS   3:30

(SIDE 2)

" DAMN IT, DAMN IT"   6:11
WE MERCY THE WORLD   5:00
AIN'T IT TOGETHER   7:00

ALL SONGS ARRANGED BY
  "THE OUTSIDERS"
CONDUCTED BY
  NEIL PETERS
PRODUCED BY
  THE BIG "D"
EXCEPT FOR
"WE ARE NEIGHBORS"
  ALL THE REST
  WERE WRITTEN
  BY THE BIG "D"
FRONT & BACK COVER
  BY "MIKE"

(RICKY, JAMES, MIKE, DERRICK & LARRY)
  MAKES UP THE OUTSIDERS

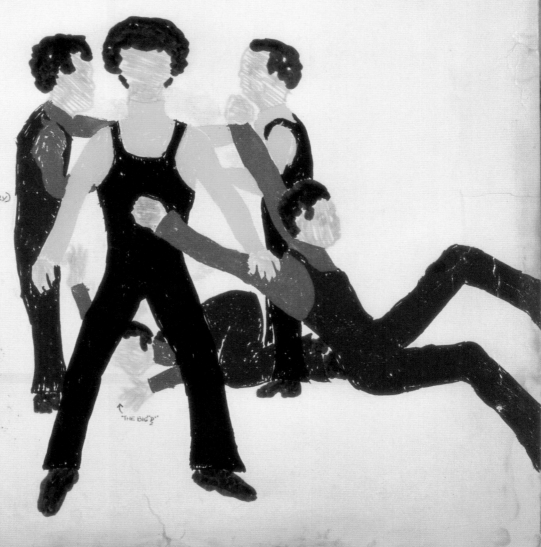

SEX

STEREO 791
SEX RECORDS (INC.)
WASHINGTON D.C.
SEX STUDIO'S

"THE BIG "D""

91

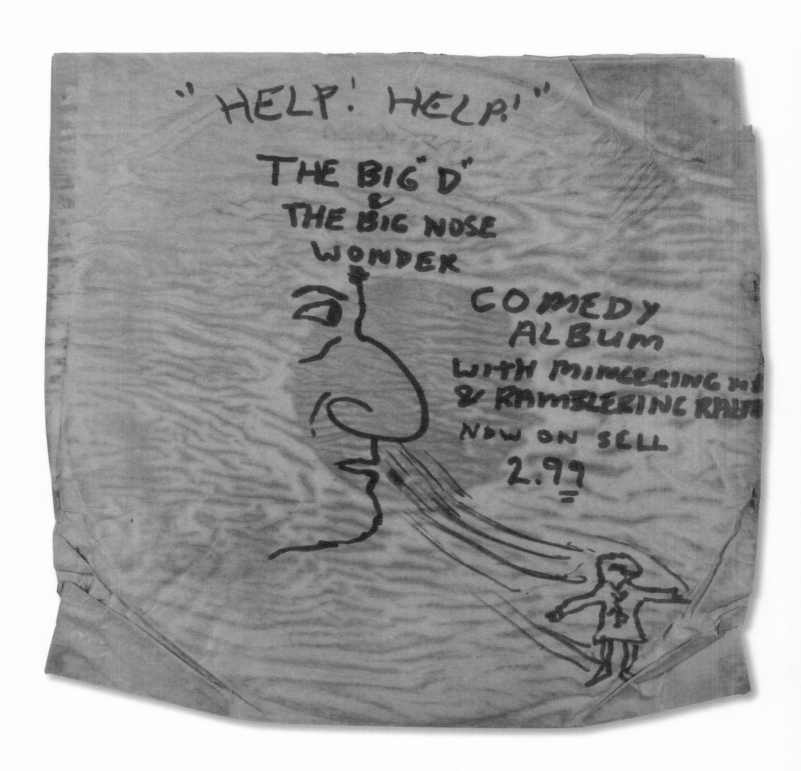

**THE OUTSIDERS**
"Mercy the World" (inner sleeve)

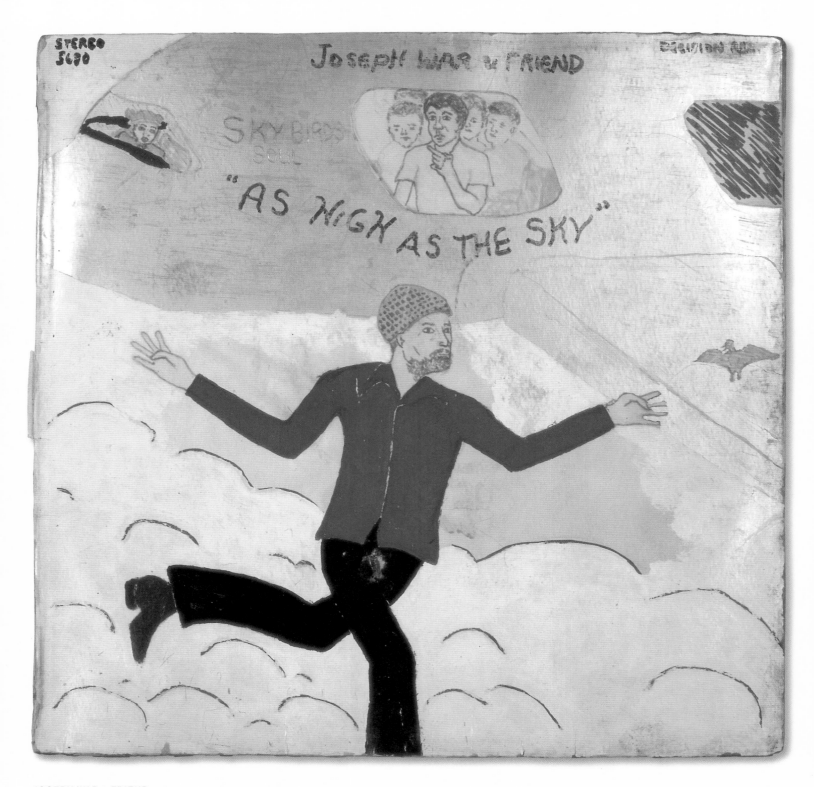

**JOSEPH WAR & FRIEND**

"As High as the Sky"

(Decision, June 1972)

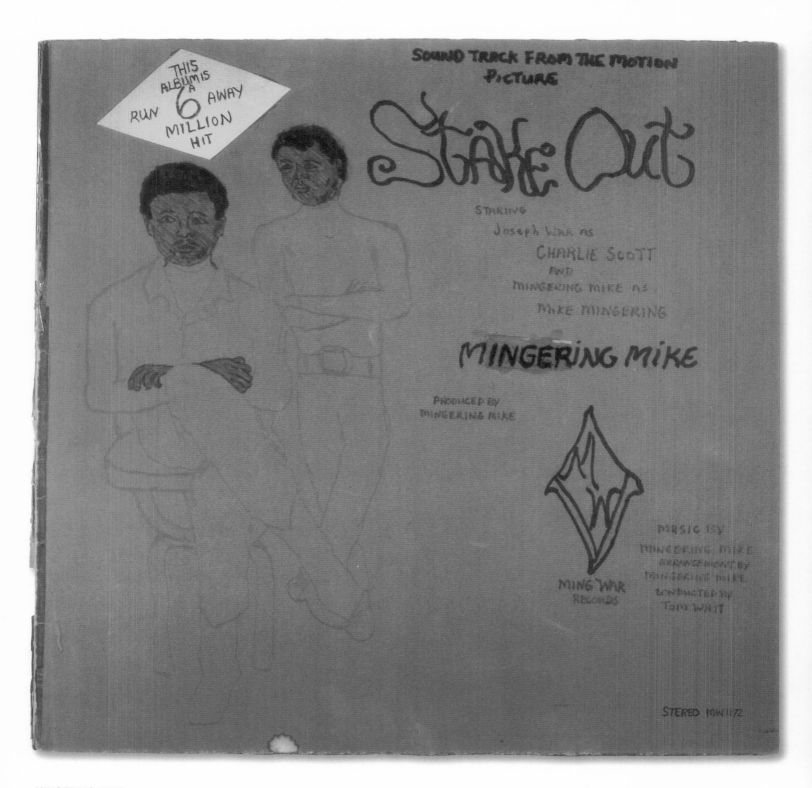

**MINGERING MIKE**

Soundtrack from the Motion Picture *Stake Out*

(Ming/War, Nov. 1972)

# "STAKE OUT"

THEME FROM;
CHARLIE SCOTT 4:10
MIKE MINGERING 3:03

"LOOKIN OUT THE-
WINDOWS OF A GHETTO"
4:36
"ARE YOU GOING TO
3:55 LEAVE ME?"

"FINAL TRIP" 4:13
THE HOOKER'S-
SPOT CHECK WALK.
3:40

RECORDED AT;
RHONDA'S SUITE
(THE HOOKER'S SPOT CHECK WALK)
BIG D SOUND STUDIO
(WHAT WONDERFUL EXPERIENCE)
ALL OTHER SONGS
WERE RECORDED AT
MINGER
STUDIO

(P) 1972
PUBLISHED AT
CRYSTAL BALL MUSIC
MING WAR
RECORDS
DISTRIBUTED BY DECISION
MING WAR
WORLD WIDE
MW 1127 STEREO

THEME FROM
"STAKE OUT" 3:04
PARTY MUSIC 2:23

AIN'T THE WAY IT SUPPOSE TO
BE
"(GHETTO SONG) 3:20
"UPLIFTED
THEME

(UPLIFT OF)
"STAKE OUT" 1:57

WHAT A WONDERFUL
EXPERIENCE
(LOVE SONG) 9:00

"AIN'T THE WAY IT SUPPOSE TO BE"
(UPLIFTED END THEME)
2:25

## MUSIC BY
## MINGERING MIKE

PRIVATE EYE
I.D. CARD

1972 RELEASE
PRODUCED BY MINGERING
11072

95

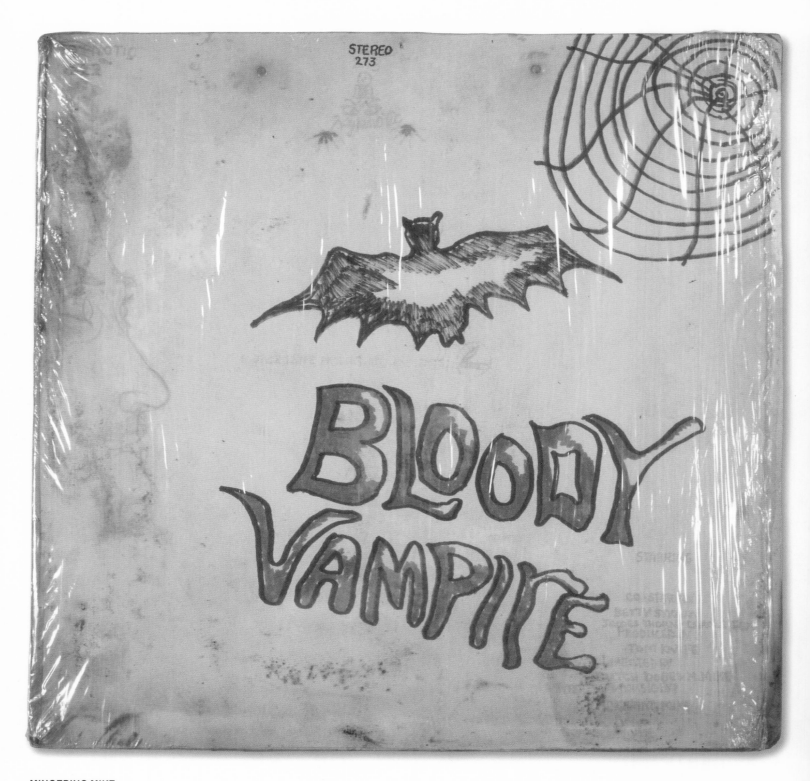

**MINGERING MIKE**

Original Soundtrack to *Bloody Vampire*

(Hypnotic, Feb. 1973)

# THE SILENT OBSERVER

**THE YOUNGEST OF** five brothers and sisters, Mike was the quiet one in the family. His mother Mary, who worked as a baker at a local restaurant, was stricken with leukemia and died at the age of forty-six, when Mike was just six years old. With their father essentially out of the picture, Cathy, the oldest sister, took on the colossal task of raising the family at the age of seventeen.

"Mike was always sort of a weird kid," she explained. "He was always doing his own thing, whatever that might be. He did a lot of drawing. He pretty much kept to himself and was kind of in his own world. But we were all sort of in our own worlds, really."

The family was tight knit. His brothers, sisters, and many cousins made up his close circle of friends.

"I couldn't even tell you who our neighbors were when I grew up," recalls Mike. This may be because his family bounced around among more than ten different homes during his childhood. "I was content doing my own thing, and I stayed in the house most of the time. I was the shy, sensitive one. You could say anything to me and I might start crying."

As a kid, Mike was surrounded by music. Cathy sang in two spirituals groups—the Spiritual Songs of Joy and the Pentecostal Specials—and she sang at the Holy Redeemer Church in northeast Washington. Occasionally she toured the country, sometimes playing on the same bill as the legendary gospel singer James Cleveland.

"Cathy used to sing in the house, and it was enchanting to me as a kid. Like they say, music soothes the savage beast. It was like the movie *Young Frankenstein*, where Gene Wilder is playing the violin and Frankenstein is completely mesmerized. She was a great singer and was very inspiring to me. There was a piano in the basement, and she would play the boogie-woogie. I had never heard that before, and it sounded great to me. I thought, 'Wow, she can sing, and she can play!'"

Mike, however, never learned to play an instrument. Singing and songwriting was his thing. "A lot of music was like noise to me at first when I'd hear it on the radio as a kid," he admits. "I was really into TV. When I saw how they danced and stuff... the performance side of it really opened my eyes to music a lot more. It wasn't until I saw people performing on television and in concert that I really became captivated.... A lot of people had such great showmanship to them."

Before black radio stations began to emerge in the late 1960s, stations played a mix of everything, though it was mostly white pop music. Mike grew up listening to Frank Sinatra, Mel Tormé, and Nat King Cole. His taste was broad and varied, and his record collection steadily grew as the years passed.

He was a part of the new TV generation. It was in the 1960s that advertisers began to target youth through the relatively new medium. Snazzy new products were showcased in commercials, and the world was beamed into the living room of all who owned a television set.

From the age of six he watched variety shows such as *Hit Parade*, where he saw Rosemary Clooney, Dinah Shore, and Patti Page perform. In the late '60s, *American Bandstand* and *Soul Train*, where artists performed their hits before a live, dancing audience, became the hot new programs. Mike studied them closely, absorbing all the details.

"I think it was Elvis that really got me in the beginning, though. He was such a performer. His phrasing, and the great background singers, the Jordanaires gospel group... It seemed like gospel added real body and flavor to the song. And when he blended standard songs with gospel they were really fantastic. Elvis was real popular with the kids back then, and he really took it to another level. He was around black people a lot. And he just made it his own. That really intrigued me.

"Once I got hooked into music, then I really started listening to the radio and buying records. I think the first record I bought was the Flamingos' *I Know Better*. I used to go to Circle Music, a local record shop. That's when I started getting into the soul stuff. They used to have the album covers in the window. And you'd see Little Anthony with the crown and the cape, and they'd always be playing something brand new in the store. I remember hearing Curtis Mayfield singing his song "Never Could You Be." I thought it sounded so nice with the trumpets and everything, and his high-pitched voice. It wasn't until I was eighteen and had a job as an administrative assistant at the Justice Department that I was able to really start buying music, though."

Mike quickly became an obsessed record collector, drawn to the fantastic worlds portrayed on their covers. "Everybody had a nice big smile on their face. It was like they were saying, 'Hey y'all, this is it! If you get to have your own album you'll be smiling and having a wonderful time just like me! It was so intriguing to me. In real life you have your ups and downs, but that album cover will always be smiling."

Around this time, the Washington, D.C. music scene was thriving. It was home to a host of soon-to-be stars such as Marvin Gaye, Harvey Fuqua, Van McCoy, and Billy Stewart, just to name a few. A regular stop on the chitlin' circuit for just about all of the major black artists at the time, D.C. hosted shows by James Brown, the Motown revues, and regularly touring artists such as Joe Tex and Jackie Wilson.

The hub of black music in D.C. was the famous Howard Theater in the hip U-Street district. Before closing its doors in 1970, the Howard showcased the premier musical acts in the city as far back as the 1920s, when local jazz legend Duke Ellington and others appeared there regularly. One of the first all-

black venues of its kind, the Howard inspired numerous other theaters on the East Coast, including the Apollo Theater in Harlem, the Uptown in Philadelphia, and the Royal in Baltimore.

Luckily for Mike, his older brother, Carl, was a manager at the Howard, which meant that Mike could go to as many shows as he wanted to for free. At fourteen he saw his first concert—Junior Walker and the All Stars. After that, he was hooked.

In his definitive biography, *Divided Soul*, Marvin Gaye described the Howard as his "real high school." "I studied the singers like my life depended on it," he said. "When I saw Sam Cooke and Jesse Belvin I'd try to avoid my friends and family for days. I didn't want to talk or be talked to 'cause I was busy practicing and memorizing everything I saw those singers do. The shows were knockouts." Not long afterward, Mike followed in Gaye's footsteps, attending so many shows that he can barely differentiate among them now.

He wasn't the only one. The rich mix of performers inspired plenty of neighborhood wannabes.

"It was commonplace to see guys hanging out on the corner singing," Mike recalls. "Especially in front of the Coco Club. That was a nightclub on 8th and H Street NE. They'd be out there hoping that a scout would come along or something. Everybody seemed to want to be a musician back then. It was like the less strenuous thing out there to do. It didn't take much effort to open your mouth up and sing if you knew how to do it. So maybe you'd make some money from people walking by, or maybe a talent scout might come by."

"Roland [one of Mike's brothers] used to go out and try to sing on the corner," Cathy remembers. "A lot of people were trying to sing back then. I remember him standing out there on the corner singing with Marvin Gaye before he was discovered. Now *that* boy could sing."

At other smaller clubs, such as the Cellar Door and the Psychedelic Room, where Joseph War held a social club that featured live bands, Mike caught local groups like the Jaguars, Experience Unlimited, Trouble Funk, and the Young Senators, who later became Eddie Kendricks's backing band. Like Marvin Gaye a few years earlier, Mike would rush home after the shows to practice his singing and hone his songwriting skills. Soon he had so many songs in his head, he felt the need to put them on record.

# Sit'tin by the Window

**THE 1960S WERE** some of the most turbulent years this country has ever known. The nightly news was filled with stories about the civil rights movement and the conflict in Vietnam, and drug and hippie cultures were prevalent on the streets. And the music scene was flourishing—Motown had established itself as a powerful empire, the Beatles were taking the U.S. by storm, and black radio had just made itself a permanent fixture on the dial.

Living in the nation's capital, Mike was right in the middle of it. The March on Washington in 1963 and Martin Luther King, Jr.'s "I have a dream" speech, the war protests, the riots that followed King's assassination in 1968—all of these pivotal historic events took place within just a couple of miles from where he lived. An introvert, Mike took it all in and reflected on it through his music, the only way he knew how. Appropriately, he titled his first record *Sit'tin by the Window*.

Mike slaved over his debut. A stickler for details, he spent hours in front of the mirror perfecting his self-portrait, which truly resembles a young Mingering Mike. Like all of his projects, everything had to be as close to the real thing as possible. At that point, in 1968,

Mike hadn't fully developed his stage name—he varied his moniker on his early albums, referring to himself as "G. M. Stevens," "Minger Mike Stevens," and sometimes simply "Mingering."

A young Mike with his records, June 1969

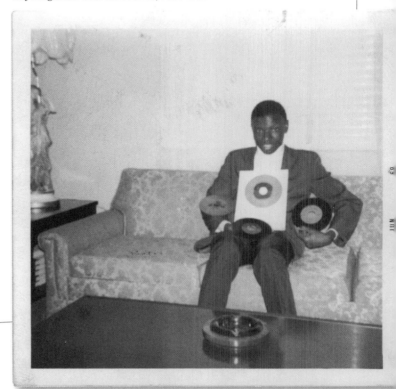

The liner notes on the back cover are attributed to none other than comedian Jack Benny, who lavished Mike with praise:

G. M. Stevens is a bright and intelligent young man with a great, exciting future waiting him. ("Only if he could find it because if it takes money you can count me out"), but I hope he can make it in show biss so he can pay me for this fine, outstanding introduction if I do say so myself.

The album was purportedly released on Mother Goose Records in 1968. When asked how he came up with the idea for the label, Mike said, "Everything was make believe anyway, so why not make it like a fairy tale?" He would follow suit on his next album, *Can Minger Mike Stevens Really Sing* on Fake Records, again a play within a play. On that album, in which he mostly performs covers of some of his favorite tunes, a quote from James Brown is typed underneath a photograph of a beaming Mike: "With a look of success, Singing and Dancing, Boy He's a Mess. —James Brown."

The songs on *Sit'tin by the Window* were all originals. The title track was a reflection on himself, taking in whatever was going on around him, while "Everybody's Go'in Somewhere Except Me" referred to the self-absorption that kept him at home, developing his imaginary career.

"When I was young my creative juices were just flowing out of me," Mike says. "But I was real shy, and I thought of myself as a kind of silent observer. I'd absorb everything around me and try to express it however I could. Ideas would pop into my head from different situations I was in and the things I'd see. But there was nowhere for me to say it. So I guess that's why I took to music and everything."

Mike's first musical concepts were born as simple song titles, and the music, lyrics, and album art usually came later. In many cases, the track listings on his albums were filler—he would come up with titles that fit the general concept of the album and set them aside to work on later.

"With writers and things, sometimes you might get a melody before you get the lyrics and this was vice versa. I just had words to work with.

"I used to always think of titles, but I could never come up with the words to go with them. I used to go in the bathroom for the good acoustics; it kind of helped me get creative. My family would be like, 'Hey, what you doin' in there?!' But I just couldn't come up with nothing. And then one day something just popped into my head. And then I got myself a tape recorder and started recording myself and listening to it. The beats were kinda stale, but the words were pretty good, and I executed them pretty good, so I said, 'Hey, this is pretty good!' So then after I got inspired by that, I got even more inspired and started coming up with more songs."

Mike wrote his first song when he was seventeen. Though he can't remember it, he does remember the name of another early composition. "It's a Boy's Life (But a Man's World)" was written from the perspective of an adult who longs to be a kid again.

It was around this time that Mike discovered that his second cousin, nicknamed "The Big 'D,'" shared his passion for singing and songwriting. "[The Big "D"]

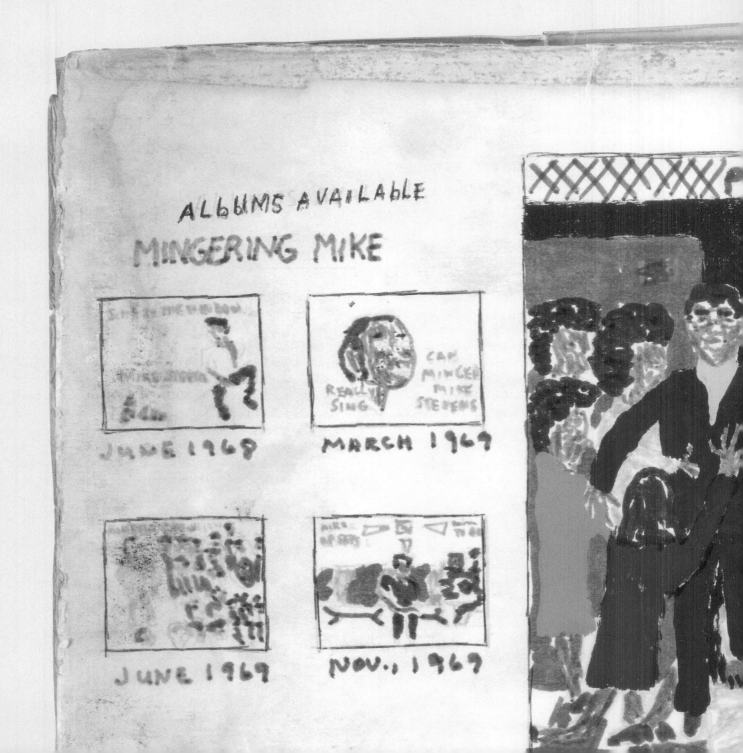

wrote some songs and sang them to me one time, and I thought they were really good," Mike recalled. "He could really sing, it was amazing." Pretty soon the two were a duo, building off each other's creative energy.

While Mike sang his newly written lyrics, The Big "D" would sing backup while pounding out a steady percussion on a mattress or phone book with an afro-pick. Eventually the two recorded their lyrics at home on a reel-to-reel recorder and occasionally overdubbed themselves singing and humming the music on top of that. Some tracks were impromptu, improvised jam sessions that lasted well over ten minutes. At the beginning of "Coffee Cake," one of their funniest (and longest) songs, Mike begins by declaring "I wrote this song...uh, right now!!"

Mike and The Big "D"'s recordings were passionate and heartfelt. Their soft young voices resonate with feeling and paint a picture of two young men completely immersed in their music. Occasionally the sounds of children playing outside make their way onto the recordings, giving them the feeling of time capsules. You can't help but visualize the two as they sang to each other in their isolated fantasy while the sounds of the real world seeped in from outside. Mike estimates that he and The Big "D" recorded over two hundred songs. Many, though, along with some of his album covers, were lost when they were put up for sale at the flea market.

Occasionally the two would go to Union Station, where they could record themselves singing for a minute and a half in a booth and receive a small playable cardboard record coated with a thin layer of vinyl. Because neither of them played any instruments or had any musical training, they sang the music as well as the lyrics.

• AUG • 69

Mike and The Big "D" get do

Mike took things a step further when he sent some of his favorite reels to a local studio to have acetate 45s pressed. Much like an actual vinyl LP or 45, acetates are aluminum discs coated with a special lacquer that are typically used as test pressings during the mastering process.

"I thought about [going into a recording studio], but [eventually] I had to concentrate on work, so that kinda killed it before I could do that. I did send some of my

reels to U.S. Recordings, which I just found out is still in business in Virginia, and had some 45 acetates made up. It cost $2.99 to have a single one made. It was cool to be able to listen to myself on a record like that. I put my own labels on those, too. I think I made nine or ten of those."

While his dream was completely private, Mike still clung to the fantasy that he might be discovered. He even had a couple of his songs transcribed, in anticipation of his future career.

"I wanted to make everything as real as possible in case that opportunity came," he says. "I was looking in the *Yellow Pages* and they had a local musician that could put [your lyrics] to piano music. I said 'lemme try that guy.' And that was only twenty bucks, so it looked real professional with the lyrics and the music. I said 'boy this would be fantastic but I can't read it. I don't know all these symbols up there, G clef and all that.' But I said, 'man that's fantastic.' Most musicians out there, they don't read music, but after a while they might pick it up because they've been in the business awhile."

Mike would often think of song ideas while watching TV, running into the kitchen during commercials to write them down before he forgot them. Just about anything could inspire a song idea—he says he came up with four or five each day. His country-western song "I Like Doing Things Not Right," which appears on a couple of his albums, was inspired by *Hee Haw*. To give me an idea of how the song went, he sang some of the lyrics to me, following them up with a toot from an invisible jar of moonshine.

"[We] got together and just started doing ad-libs. We turned something on, might have had a thought or idea, then bing! Then we listened to it after and said, 'Hey, that's pretty good!' I came up with a song one day called 'I Need Your Soul' and I just happened to be riding my bike around the city, and a tune just came in my head. I just ran over to his house and recorded. I said 'Hey, I just thought of a brand new song.' I said, 'I don't know what I'm gonna say or anything, but we gonna do it right now.'

"We'd try to improvise as much as we could and incorporate what was going on around us into the songs. There was this one time that Big "D"'s sister was knocking on the door while we were recording and he incorporated the knocking into the song. We both amazed each other and built off each other like that."

In "Stars in the Eyes of Men," Mike and The Big "D" rap back and forth about their dream of becoming stars.

I dreamed I've been to Paris and Rome
Throwin' shows for people.
I been everywhere
And I ain't been nowhere.
And every year I'm getting a little older
I want a gold record, you know?
I wanna do movies, musical movies and stuff,
Maybe star in 'em.

Toward the end, they pay homage to some of their greatest inspirations—Frank Sinatra, Bruce Lee, and

Right: Lyrics to "Hold it Right There if You Care Because My Footsteps are on the Way"

HOLD IT RIGHT THERE
IF YOU CARE
BECAUSE MY FOOTSTEPS ARE ON THE WAY

I've been long over do

And now I've come back to you

so oh Good God, HOLD IT RIGHT—

because IN A MATTER of minutes
I'll be right there
period
with all the love that I hold
mike
Oh Baby you've got, so much soul
period
so much soul, so much soul
mike          mike
mike
so much so oooooo oh Ah Do, Do whoop

THERE, IF YOU CARE, BECAUSE

MY FOOTSTEPS ARE ON THE WAY

oh I ran away because I didn't

WANT TO MARRY YOU, but now I've Changed

– My lifes been, rearrenged

So baby you've Got to, you're Got to

know, I'd wouldn't have come back

IF I, IF I Didn't love you so

So, oh HOLD IT, HOLD IT RIGHT THERE
IF YOU CARE
BECAUSE MY FOOTSTEPS ARE ON THE WAY yea

Ah, Ah DO DO whoop Do Do Do Ah DO De DO De Whoop
I              music

period I've been, I've been long, long over do

and now finaly baby I'mA, Ima Get next to you
together
(GOT TO GET NEXT TO the Real THING

Because don't you know that

BABY I'm in love with you

So Hold IT RIGHT THERE, Ah IF You CARE

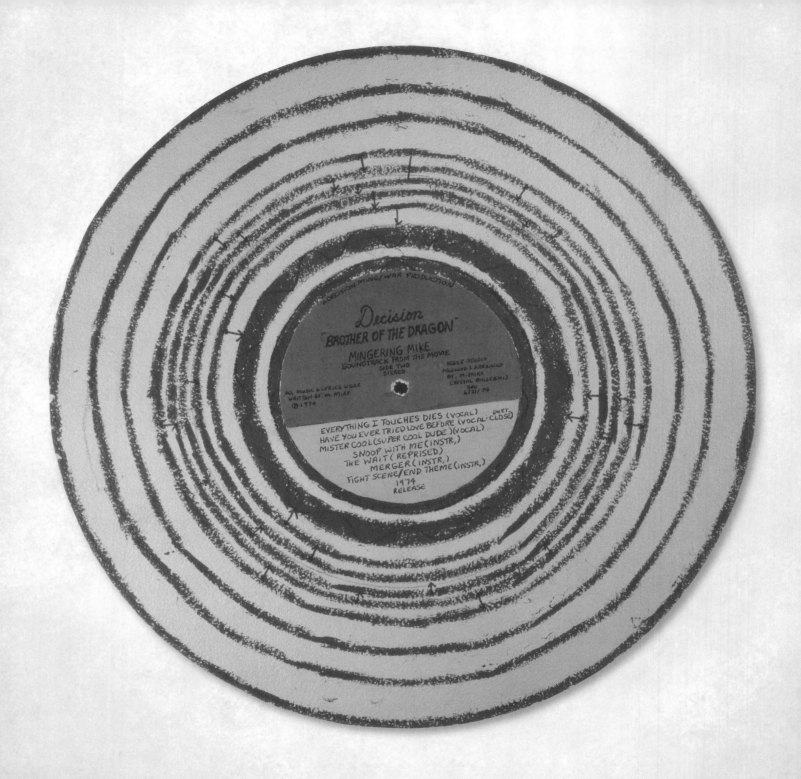

**MINGERING MIKE**
Brother of the Dragon (record)

Stevie Wonder—demonstrating their broad tastes in music and pop culture.

Another recording, "Nail in My Coffin," a song about the last straw in a relationship, typifies the passion the two shared in their work. Mike and The Big "D" holler and moan, belting out their frustrations over a pounding rhythm that truly sounds like someone trying to beat his way out of a coffin. Mike says the name was inspired by football commentator John Madden, who often claimed that one team had secured a win by "tacking a nail in [the other team's] coffin."

"Darlene," a song from the album *Darlene, Come on Back to Our Side of the Track*, was addressed to a wayward girl who made some bad decisions in the middle of hard times. Mike beat-boxes an introduction before dropping in with a bouncy vocal bass line and launching into song.

By this point, Mike had come up with his unique stage name.

"At first I was thinking 'Mingling Mike,'" he says. "But that didn't sound right." He thought the name sounded too Chinese. "So then I was in someone's car one day and I saw a sign that said 'merging traffic,' so I kind of combined 'mingling' and 'merging' and came up with 'mingering.' It just had a nice ring to it."

Mike kept his grandiose visions of stardom mostly to himself. While he was busy writing songs and meticulously working on his album covers, his family couldn't have realized how lost in his own world he truly was. Occasionally, if he felt really good about a song, he would play it for whoever was around, but for the most part the fantasy was between Mike and The

Big "D." Cathy, now in her late seventies, was shocked to see all of the albums together when she was shown the collection recently. She had no idea how extensive Mike's discography was.

His albums were the perfect and logical progression for his music and ideas. Creating them allowed him to express himself even further, tying his songs together into cohesive, thematic works. His lengthy liner notes (often made up of one very long sentence) allowed him to speak directly to his audience, elaborating on the messages of the albums. They also gave him the opportunity to have some fun. He often assumed the persona of a celebrity or one of his other acts, writing comical notes full of inside jokes.

One of the more common themes in Mike's music was love and relationships, often inspired by those close to him. "Sometimes people would come to me and say that they got a problem with a relationship... and I'd think, 'Hey, maybe I could make a song about that.' And then they might show it to their friend—how they feel, as interpreted by me, and maybe I'd patch up a relationship through something that I wrote."

Everything Mike created was a direct product of his day-to-day experiences or what he saw going on in other family members' lives. His albums can be seen as a diary of sorts—he wrote the date and sometimes even the time of day on each record, and they give an intimate look into what was going on in his life. Almost every detail has special significance to him.

"A lot of people go around everyday with thoughts in their mind that they can't express, and it stays locked up. I didn't want mine to stay locked up; I had to find some kind of way to express myself. So I started doing it

like that, with the songs. And after the songs came the albums.

"I learned a long time ago that in order to write something you got to have a beginning, a middle, and an end. I had thoughts, so that was like the beginning. The middle would be like developing that thought. The end would be the process of it being distributed. I had the beginning and the middle, but not the end. So that's what made me come up with the covers, it was like I was releasing my thoughts and views of the world. The album cover was really the final product."

"I used to draw all the time, whatever was around me," Mike says. "I used to try to copy the dollar bill and the front cover of the *Washington Daily News*, trying to make it look just like the original. I started drawing more when I started getting concepts in my mind for music. That was probably in 1967, when I was about seventeen."

Mike constructed his album jackets from posterboard that he bought from a local drugstore, carefully measuring the dimensions so that they would be exactly the right size. He always began his designs in pencil, jumping back and forth between albums and constantly making changes to make sure everything was just right.

Once satisfied, he would go over his drawings and text with either a felt or ballpoint pen, embellishing certain portions with paint. Because his creations were works in progress, some of his album covers were never completed and remain sketches. Everything was made by hand, aside from the cellophane, which he removed from real albums and pulled over his own. The call numbers that he wrote on the spines and covers of the albums were the actual dates that he started working on the albums.

The cardboard records were an afterthought; Mike made them because the covers were too flimsy. He liked to prop them up on a shelf he had constructed in his bedroom, but without something inside they wouldn't stand up correctly.

"I thought about putting old beat-up records inside of them and transposing my own labels on top of those, but then that wouldn't work because the bands on the record wouldn't correspond to the number of songs I had. So I decided to make my own."

Though never formally trained in art or music, Mike was obsessed with making his records as real as possible. In addition to making his own cardboard records, he added up the lengths of the songs to make sure they would fit on each side. He even painted the records with glossy paint that simulated the sheen of vinyl.

Though Mike dreamt of being an actual performing artist, the closest he got were his performances with his brothers and sisters at local hospitals and old-age homes. They put on shows around D.C. at St. Elizabeth's Hospital (a psychiatric institution), Cedar Knoll (a soldiers' home) and Children's Hospital. Together they staged circuslike revues, complete with musical performances and a magic show by Mike's brother Roland, aka The Incredible Steve-a-Reno. Mike would sing and dance, performing songs by James Brown and other favorites. Despite his great shyness, Mike was billed as "Mingering Rubber Legs Mike," and he boogied down with the latest dance moves.

"We'd take the receiver that the music would be playing on and adjust the reverb so that you only heard

the music," Mike says. "Then I'd sing over that, like karaoke. At first I was really shy, but after I saw that the people appreciated it I'd loosen up."

Mike's only other shot at stardom came when he once sent some lyrics to a company that had advertised in a magazine. He quickly discovered the ad was a sham and didn't pursue it further. "In the back of magazines they had a little advertising section, and in the back they had about 'we'll put your songs to music or we'll put your lyrics to music' like that, and they say $39.99. I said, 'I might try it out.' Then I said 'No, no, I know what I'll do. I'll write the most craziest, dumbest song I can think of and see if they'll tell me if it's good or bad.' So when I did send it off to them, they said, 'This is the most fantastic thing we ever heard in our life. We want your song! Send us more money and we'll get musicians and singers and...' I said 'Uh-huh, okay.' So I left that alone after that."

**Right**: Brainstorming on a Pampers box

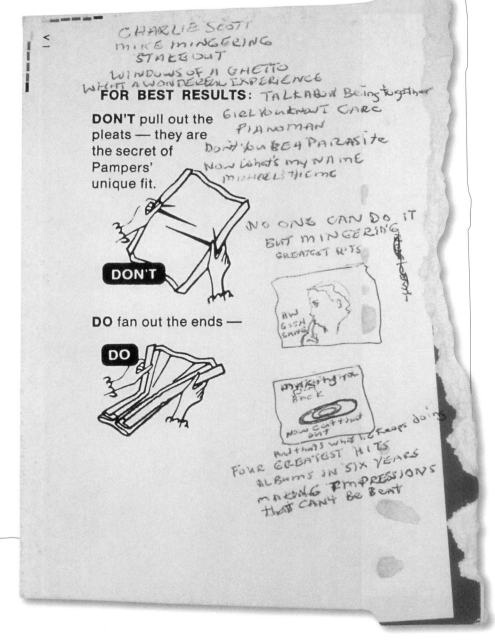

ROOTS

-EVILS

Picture By
M. Mike

"FOR FAN'S ONLY"

IF YOU WOULD LIKE TO
ENTER MINGERING MIKE'S
FAN CLUB SEND A
DOLLAR, FOR TWO PICTURE A
BUTTON, A PEN 2 BOOKCOVERS
AND A NOTE OF THANK
PERSONALLY FROM MIKE

SEND TO;
THE MINGERING MIKE
FAN CLUB P. O. 10100
WASHINGTON D.C. 200J0000

JUST ONE
DOLLAR

# Mingering Mike Enterprises

**MIKE WAS TRULY** a jack of all trades—in addition to singer, songwriter, and album designer, he took on the roles of record executive, talent scout, producer, manager, and promoter. With a multitude of imaginary acts under his wing, he was the Berry Gordy of his own musical empire.

"You know how a corporation has a team of idea men to come up with all the marketing ideas and stuff like that? Well, I didn't have that—I just had me. So I tried to make it like it was a corporate thing, and challenged myself to come up with different ideas. I came up with [the record label] Spooky after seeing that movie *Love at First Bite*, with George Hamilton and Sherman Hemsley from *The Jeffersons*. I thought, 'wouldn't that be good to have a movie about a British vampire that goes to the ghetto…and gets down!' I used that on a soundtrack I made called *Bloody Vampire*. And [the label] Hot'n Soulful Cookin', that was based off of Junior Walker's album *Home Cooking*, which was one of my favorite albums at the time."

Eventually Mike founded more than thirty record labels, each with its own logo: Mother Goose, Fake,

**Left: MINGERING MIKE:** Get'tin to the Roots of All Evils (detail)

Puppy Dogg, Decision, Ramit, Hot'n Soulful Cookin', to name just a few. He was masterful at branding and developing new musical entities. The concept for Sex Records, whose logo is the headboard of a bed, was actually The Big "D"'s idea. "Being young and all, all he could think about was booze and sex, so when I asked him what he wanted his label to be, he said 'Sex!'" Mike recalls.

"I looked at Motown, and Motown got a couple different labels. When you see the album or the label, you know who's on that particular record. So then I said, 'Well, that's a thought,' and I figured 'Well, me being all the artists and everything, gee, I'd better star on all the labels.' Then I said 'that's kinda crazy…' So I said 'Well, let me be more realistic and have various artists.'

"It was like I was a talent scout," he says. "I just had to do something with my creative juices, because I knew that if I ignored them I might get headaches or just bubble up and explode!"

Mike created a host of side acts, almost all of them based on members of his family. His cousin Warren, who was in the military, became Joseph War, one of his sisters morphed into Lora Landtree, and his cousin

Andre, the sound man at the family's shows, was crowned Audio Andre.

Mike's most amusing character was without a doubt "Rambling Ralph," based on his cousin, who was notorious for being stingy, especially when it came to food. The album *"In My Corner"* ridicules Ralph with some of the funniest song titles ever to grace an album cover: "What's Yours is Mine and What's Mine is Mine," "Sometimes I Get so Hungry I Can Eat a Light Bulb or My Chair or Even My Hair," and "You Don't Have to Wake Me Up, the Aroma Will do That."

Mike immersed himself in these characters, challenging himself to write songs from their perspectives and taking on their personas when writing their liner notes. On one of his earliest releases, *3 Footsteps Away from the Altar*, Mike wrote from both his own and The Big "D"'s perspectives:

The Big "D" is a find, find, talent and I believe if he would further his education, would make him even a better singer and song writer, he's just about the best, you see, his name is the big "D."

and:

Minger is a good singer and dancer and a find song writer but as you know it's hard for a singer to make hits after hits, and Minger has just about did this with his singing and writing, I may not like one song he records and if he knows that he'll try his best to do another one that haves me wishing I wrote it.

With so many talented and successful artists under his wing, Mike wanted to showcase them in the best way he could. *Live at the Howard Theater* was the perfect opportunity. He would have wanted to play at the place where he was raised, with a full bill "so that [he] could give the others a chance to shine," he says. The inside cover depicts a packed stadium with a caption proclaiming that the sold-out show grossed a total of $600,000.

In addition to his growing musical empire, Mike also delved into films, creating a number of soundtracks for films which he was also the director and star, including *Bloody Vampire*, *On the Beach with the Sexorcist*, and *You Only Know What They Tell You*. Most of his ideas were inspired by contemporary films.

"When I was doing movie themes I would see a movie and like it so much that I would try to come up with a concept close to it… So if someone didn't hear the original soundtrack then they'd hear mine and it would go along with the movie just as good as the original," he says. "I wanted to see if I was that versatile. I always wanted to keep fresh and come up with various different ideas, which was hard to do, because just about everything's been done. You can refine something, but you can't come up with a completely new concept, so it's challenging."

Some of Mike's soundtracks were undoubtedly inspired by the blaxploitation flicks that were so popular in the 1970s. In *Stake Out* (1972), which according to the cover was "a runaway 6 million hit," Mike played the part of a private investigator named Mike Mingering. The songs might have come right out of Curtis Mayfield's *Superfly* or Isaac Hayes's *Shaft*,

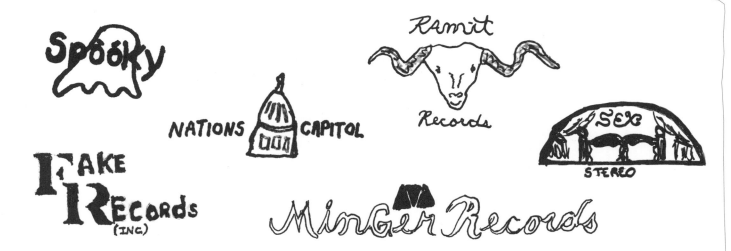

with titles such as "Final Trip," "The Hooker's Spot Check Walk," "Theme from Stakeout," and "Party Music." *Hot Rodd (Takes Revenge)*, from 1973, told the story of a club owner (again played by Mike) who is sent up the river on a bum rap and comes back seeking revenge. On the cover, next to a gun-slinging Mike in a flashy suit and platform shoes, are the words "They socked it to him—they must've not had known just what they were doing." The title is drawn in big block letters that are made of sticks of dynamite.

Like most musicians, in addition to their own chartbusters Mike and The Big "D" recorded their own versions of current hits. Mike remembers being blown away by Connie Stevens's rendition of the Bill Withers classic "Ain't No Sunshine" when he was young. Captivated by the idea of reinterpreting the songs in his own style, he showcased covers on nearly all of his albums, including classics such as Otis Redding's "I Can't Turn You Loose," Little Sister's "Somebody's Watching You," and Bobby Hebb's "Sunny."

The album *Fractured Soul* is composed entirely of other artists' songs, all performed in a soul fashion. The album cover states: "*Fractured Soul* is in part, for people who don't dig full rock and the people who don't dig full soul it's just as simple as that it's fractured soul." *The Big*

*"D" Sings Mingering Mike*, with a portrait of The Big "D" on the cover, is just what the title says—The Big "D" singing Mingering Mike songs in his own distinctive style.

With the huge number of songs Mike was releasing, it's no wonder that he put out his first greatest hits album in 1969, *Minger's Gold Supersonic Greatest Hits*, just over a year into his imaginary career. He would release two more volumes in the years that followed.

"Most of the time, the studio, they're the ones that come up with these concepts of what songs are gonna come out [on greatest hits albums]. Most of the time, the artists don't have anything to do with it. If they did there would be a better selection. So if I did it, I'd want it to be supersonic, I'd want to make sure everybody's getting their money's worth."

1972 was by far Mike's most prolific year, seeing the release of almost thirty best-selling albums and hit singles.

"When you're enjoying what you're doing, then you gotta let all the creative juices out before you forget it. Some albums I may not have finished because I was all of a sudden inspired by something else, and leaving them unfinished gave them a kind of mystique. I worked on lots of different albums at the same time because I was just so inspired all the time."

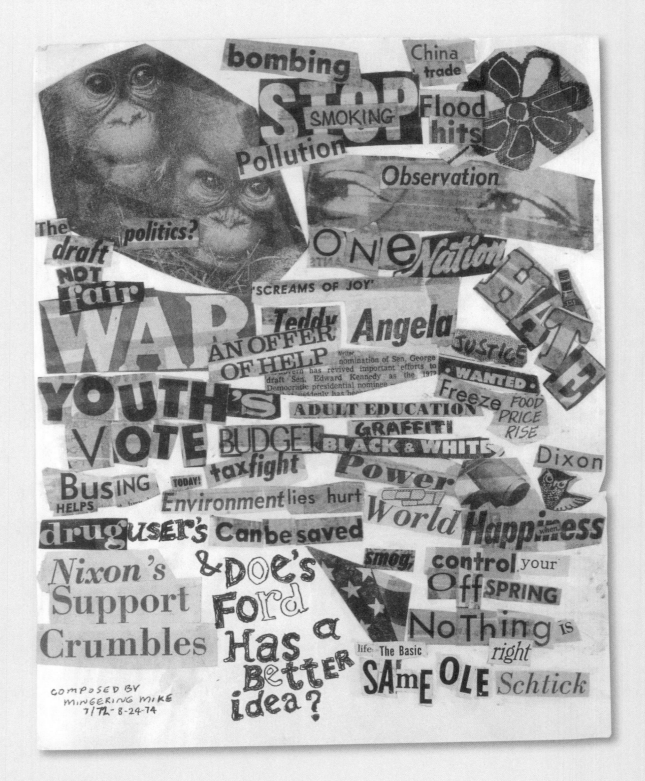

**MINGERING MIKE**

Darlene, Come on Back to Our Side of the Track

(original collage used for gatefold)

114

# But all I Can Do Is Cry

**IN 1969**, in the midst of the war in Vietnam and at the beginning of his musical career, Mike received the dreaded letter from the government. He was to report for military duty.

"I read it, and I couldn't believe it, so I read it over and over again. I started calling everybody in my family to try to see how I could get out of it. They said that it wasn't a big deal, and joked that if I pretended that I was gay that they wouldn't take me."

Mike had come up against a reality of the '60s: despite a supposedly universal draft, the war was being fought inordinately by the lower class and minorities. According to Myra MacPherson, in her book *Long Time Passing*, early on in the war, African Americans made up as much as fifty percent of companies on the front lines. Later, in response to protests by the burgeoning Black Power movement and other groups, that percentage would decrease. The drafting of Muhammad Ali sparked further war protests, and the cry "hell no, we won't go" became a symbol of anti-war sentiment.

Mike was horrified by the prospect of going to war. Unable to sleep the night before he was to report for duty, he wrote and recorded "But All I Can Do is Cry":

Never thought I could stoop so low
And to stand so tall and cry
But all I can do is cry
Oh, it hurts so to say goodbye
When you see the tears falling from my eyes
But the man told me to come on and take a ride
And kiss your family and friends goodbye
And what can I do
I can't do much
'Cause the tears are crowding my eyes
But all I can do is cry
'Cause when I get to war I might die
Kiss your family and friends goodbye
They understand and yet they still cry
Because they want to keep me here strong and alive
(me too)
But all I can do is cry.

For his induction Mike was to report to a military base near Baltimore in March of 1970. His aunt Agnes, now 91, remembers bringing Mike to the bus station. "He did everything he could to be late for that bus," she says. "But the buses waited around because they knew a lot of people would do that too."

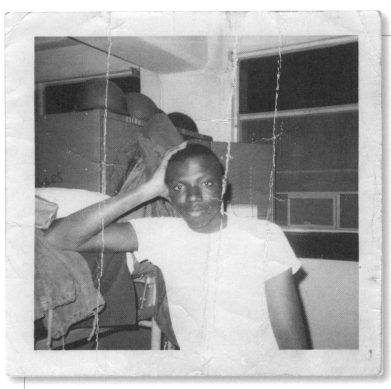

Mike in basic training, 1970

At the ceremony, Mike balked at his induction. "I wouldn't step forward. I was the only one. So they took me in the back and told me that I wouldn't have to fight, I could just perform for the soldiers since I was into music, that fighting was just a secondary thing. Then I went through the whole thing again at some other part of the process, and I wouldn't step forward again. But then they started telling me about the $10,000 fine and two years in jail. So that made me step forward. So I went to Fort Dix in New Jersey for training, and from there I was supposed to report to Seattle, Washington. When you go to Seattle, the next stop is Cambodia," Mike says. "I just went home."

"I was like, 'Man, they're trying to throw *me* up in this mess.' They tell you 'Just shut up and keep moving. Do what I say. You don't have any choice anymore.' It's like a person not being in control of their destiny. If

you go off to war you might just become a memory in people's minds. It's traumatic, trying to decide which side is right. Do I go this way or that way?"

When he returned to D.C., he began working on one of his most heartfelt albums—*The Two Sides of Mingering Mike*.

The cover depicts two self-portraits facing in opposite directions—one a soldier, the other a civilian. Underneath there are two hands—one reaching for a machine gun, the other a microphone. Small lettering below reads, "Which one would you want him to grab for—one is for the better and the other is for the 'worst.'"

The dichotomy appears again on the back, where Mike sings to a large audience of fans, while on the opposite side he stands in formation before a commander giving orders from a platform. A troubled Mingering Mike gazes out the window below.

Mike's brother Roland, who had been drafted a few years earlier, also went AWOL. He played a constant game of hide-and-seek with the military police who came looking for him.

"Every weekend he'd escape and come back home, and every weekend they'd come looking for him. One time he hid under the bed, but he busted out laughing and they found him. Another time, they came into the house and looked everywhere but couldn't find him. I happened to be sitting by the window and I saw him hanging on outside, saying 'Shhhh!' When they left the house he'd climb back in and taunt them. It was like a game for him," Mike remembers.

Lucky for Mike, no one ever came looking for him. But his AWOL status forced him to take precautions. For one thing, he couldn't get a legitimate job. Instead,

he earned some money by babysitting or through odd jobs. It wasn't until President Carter granted a blanket pardon in 1977 that Mike would truly be free again.

"After it seemed nobody was coming after me, then it made me a little calmer, and the creative juices started flowing without me having to worry all the time," he says.

Mike's desertion from the army allowed him to delve even deeper into his persona as Mingering Mike. Because he was afraid of being spotted, he mostly stayed indoors. His anti-war stance and the turmoil in the streets gave him a lot to work with.

His 1973 soundtrack to the film *You Only Know What They Tell You* picks up where *The Two Sides* left off. It was Mike's direct musical response to the war, which at that point was a complete disaster. Born from an idea he had for a film, the movie was to be based on Mike's being inducted and then sent off to war. Subtitled *The United States Puppet Force*, it was a damning criticism of the U.S. foreign policy that was sending young men overseas to die in a war that they had nothing to do with.

On the cover, a pensive Mingering Mike overlooks a puppet U.S. soldier fighting a Viet Cong guerrilla. His disdain for war is clear in the song titles—"Fight When I Say Fight," "G. I. Want to Go Home," "I've Got the Battlefield Blues," "But All I Can Do is Cry," and "You Only Know (What They Tell You)."

Inside the gatefold, Mike drew various scenes, from induction to combat to death, next to the words "induction then destruction, just who wants to die." His views on the war and the draft in general are clear in his liner notes:

Of course with so called statements like this, there should be two sides of the story, but I and only I and if you agree then that's your privilege to do so, but I don't think that in this day and age that if something was interfering with our right's that the people of our "fair" ah I mean country would really let us down, no, no, that can't be so, so there for I sincerely believe that theres no need for the unconstitutional drafting system.

While Mike was in hiding, his close cousin Joseph War was stationed overseas in Okinawa. The two kept in touch and Mike occasionally sent him some of his favorite recordings. Always looking for new ideas for songs, Mike based his song "I Found Peace in Saigon Sally" on a romance Warren had while overseas.

While he issued *You Only Know What They Tell You* on his socially conscious Together Records, whose logo depicts different colored hands coming together, other of Mike's labels specifically addressed the war and other timely issues. Decision Records was based initially on his inner conflict of having to choose between the music he loved and a war he both hated and didn't understand. He borrowed the imagery of the gun and microphone from the front cover of *The Two Sides* and used it as the logo. Later, as many soldiers returned home and fell into drug use, Mike sometimes replaced the gun with a syringe. Another of his labels, Division (a subsidiary of Decision), had a similarly minded but more global message—a wounded planet Earth is held together by a vise and supported by crutches.

While "make love not war" was soon being supplanted by "turn on, tune in, and drop out," Mike maintained an impassioned optimism in his work. Even after black neighborhoods burned during the riots in Chicago, Watts, and Washington, D.C., and inspirational figures such as Martin Luther King, Jr., President Kennedy, and Malcolm X were assassinated, Mike managed to keep a somewhat rosy view of the world.

Marvin Gaye's *What's Going On*, one of the early major-label soul albums to address social issues and challenge the status quo in a deep and meaningful way, was extremely influential when it was released in 1971. Written from the perspective of his brother Frankie, who had returned home after serving in Vietnam, the album reflected the growing discontent in America.

Social and political issues that were generally considered taboo (Motown balked at releasing Gaye's album, worried that it would be too controversial for its white audiences) were now being addressed openly in black music. Mike had been tackling these same issues all along, but as his career progressed he concentrated on them more and more.

A message inside the gatefold cover of *Can Minger Mike Stevens Really Sing* from 1969 shows his hopeful outlook during the country's turmoil:

Let Your Love Glow.
Let it show.
Let it feel your hearts.
Don't let it part.
Let's make it a better
World, Young men and
Little pretty Girls,

Who someday will be
The leaders of the
New World.

In his 1972 album *Darlene, Come On Back to Our Side of the Track*, Mike included a collage made from newspaper clippings. "I gathered images and put them together so that they had a significant meaning," he says. Phrases such as "the draft not fair," "one nation," and "control your offspring" are pieced together and juxtaposed over pictures of a pair of eyes, a band-aid, and other symbolic images.

Joseph War's debut album, *Introducing Joseph War "and What He Stands For"*, addressed similar issues. Songs like "Shame of the World" and "(And It's Happening) On the Street Where You Live" were about how distressing it could be to step outside your door with all of the horrible things that were going on. Still, Mike gives a humorous and upbeat characterization of his cousin in the liner notes:

War stands for peas and hominy
Mash potatoes and beef
Chicken and string beans
And "ah" lot of other stuff
But really he stands for peace and tranquility
I hope we all do.

The prevalence of drug use was steadily taking its toll on families and debilitating the black community. Mike had always shunned drugs and alcohol himself, but their presence on the streets was glaring. Alongside scenes of despair, he included thoughtful, hopeful

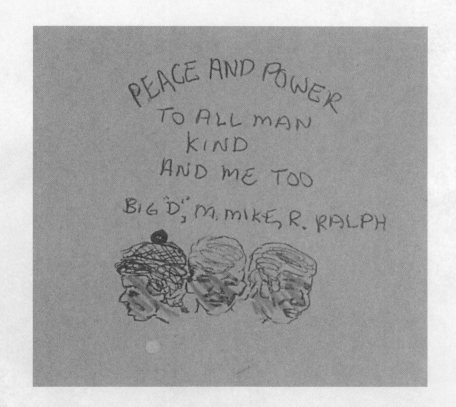

**MINGERING MIKE**

Get'tin to the Roots of All Evils (detail)

"JITTERING JACK"
5/4/71 - 6/13/72

"AH," SAY "JUNKIE," HA" YOU WANT SOME DOPE?
YOU WANT THE NEEDLE OR THE KIND, YOU SNIFF OR SMOKE?
    NOW LISTEN HERE JUNKIE
THE PUSHER DON'T CARE A HECK ABOUT YOU
    CAUSE HE MEETS HUNREDS A DAY, "JUST LIKE YOU",
    AND HE DON'T EVEN KNOW YOUR NAME
    BUT IT'S OBVIOUS YOU'RE A CUSTOMER
THAT'LL COME BACK AGAIN AND AGAIN, "WAITING FOR THE
    GOODS", SHAKEN AND FEVERING, "JUST THE SAME"
        "HEY," I THINK I'LL CALL YOU "AH", JITTERING JACK"
    CAUSE WHEN YOU CAN'T FACE THE WORLD
GOOD OR BAD, "AS IT IS", YOU'RE GOING TO COME BACK
AND AH AGAIN WE'LL HAVE SOME BUSINESS TO AH", TRANSACT,
AND "HA", I KNOW YOU CAN'T LIVE WITHOUT THE HELP OF ME
        SO HURRY, HURRY, "ON TO ME"
CAUSE YOU KNOW DAMN WELL THAT YOU CAN'T LET MY STUFF BE
        SO KEEP ON, "KEEPING ON
    TIL YOU'RE ALMOST OUT OF YOUR MIND
    BUT YOU'LL BE TOGETHER ENOUGH TO REACH DOWN
IN YOUR POCKET, TO SPEND YOUR LAST DIME
    IT MAYBE GOOD AND IT MAYBE BAD
    BUT YOU MUST DON'T CARE
BECAUSE THIS HAS BEEN THE UMPTEENTH TIME
    THAT YOU'VE BEEN HAD.

*Mingering Mike*

*The Drug Store* (detail)

messages in his liner notes, intended to dissuade people from falling victim to the evils that were destroying their community.

"[Drugs] were so abundant back then," Mike says. "I wanted to see if I could get through to people through my songs."

The album *The Drug Store*, subtitled *One of the Great "Shame's of the World,"* was his definitive anti-drug statement. Heroin and various pills are laid out across the cover, while the text states, "young or old 'the pusher ain't nobody's brother' (even though he's of all colors)." On the back are skulls, syringes, and a dedication: "for the one's that deserve to be noticed—the junkie."

Joseph War had a social conscience, too. His 1972 album *The Ghetto Prince* depicts a photograph of War alongside syringes, pills, and a mask. Inside, a menacing masked man on horseback (the Ghetto Prince) peddles drugs to children, while on the back cover a bloody spider web is captioned, "Do you get the point?"

Other albums, such as *Get'tin to the Roots of All Evils*, *"As High as the Sky,"* *Isolation*, and *Frustrations* all addressed the trials and tribulations of everyday life—poverty, inflation, the high price of food, racism, and incarceration, among others.

Even after his 1977 presidential pardon, when he stopped making albums and was able to work full time, Mike continued to write timely, relevant songs. "Better Git Hip and Come Off This Trip," written in 1993, again speaks to the social ills and worsening drug epidemic that plagued the nation's "murder capital":

**Left**: Lyric sheet for "Jittering Jack," June 1972

Better Get Hip and Come Off This Trip
Kill'in Your Own Kind
Poisoning Our Minds
Stealing Without Concern or feelings
Beating and raping our women
"where have we come?"
"Where have we been?"
"Where are we going?"
When every, everyday some what
We're living in sin
"PEOPLE! PEOPLE!"…"WELL…WE…"
Better get hip and come off that trip…

While D.C. was a racially divided city in the '60s—and still is, to a great extent—Mike's messages were universal. In *Frustrations* he depicts people of all colors and backgrounds—blacks, whites, Asians, and Hispanics. The album is about everyday people and their common frustrations, whether that person be a bum, a model, a big-time executive, or a police officer. Mike pleaded for everyone to come together to acknowledge each other's pain, and to help one another.

"Moon in the Ghetto," a song on his 1975 album *Isolation*, talks about the universality of life's hardships:

There's ah..."moon in the ghetto"
There's ah..."moon in the ghetto"
Looks like the economy's put'tin us all in the same mixing bowl
And every week there's a change in the weekly toll
I must have been blind to think just because their color's not like mines
That they should be doin fine
When the economy's really linking us all to the same chain
So I guess that's how it explains why
There's ah..."moon in the ghetto"
But it's alright
Ain't no need in makin' a scene
We all are human beings
We all have the same hopes and dreams
And we all have our will to live in the in betweens
We all shop at the same poor peoples rip
And when we get angry we all mouth the same lip
So dig it and don't forget it
That we're all in the same ole hole fillin' up
Instead of vacating the ghetto.

On only two albums did Mike express a dark side, and even then his hopefulness shines through. The cover of *Life is a Bitch* shows a dinner plate full of excrement and bears the message "sometimes I feel this way that its the pit hole of existence." At the time, Mike was miserable—he couldn't get a real job, and things seemed bleak. The liner notes state that "it was a mother putting this album together."

Another of his albums, *Sit'tin at Home with the Lowdown Blues*, depicts Mike in his living room listening to music while a menacing woman with horns stands by with a whip. The songs "Moneilessitus" and "Lowdown Blue's" hint at his financial woes while he was AWOL.

"Every once in a while we have our little ups and downs," Mike says. "So I thought I would do an album dedicated to that. But this is a rejoiceful kind of thing, too. Like when you see people feeling low, you get together to try to solve the low points to make them high points."

I'm very concern with the growing rates
of suicides, threats killings, alcolhalism, addicts
prostitutes, fake's, frauds, high cost of living
high cost for being sick, death arrangements
child education, adult education, poverty
prejudice, bigatry, the war, and the success
of this album

—Mingering Mike

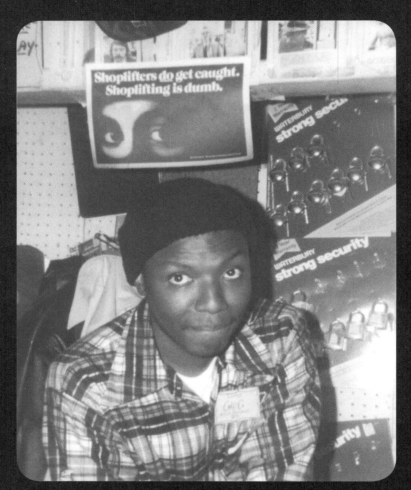

Mike at Sunny's Surplus, c. 1975

# The Return of the Magnificent Mingering

**MINGERING MIKE'S DREAM** lasted for almost ten years, but eventually he had to face reality; his imaginary career as a soul superstar wasn't going to pay the bills. When he received his pardon in 1977, he was required to do community service, and afterward, in need of money, he got a job as a security guard. The spectacular career of Mingering Mike had come to an end.

Since his rediscovery, however, the creative juices have started flowing once again. Though he barely has any spare time—he works two jobs—he has begun planning his triumphant return. Inspired by the interest in his lost art and music, Mingering Mike is back, ready once again to take on the world with his unique vision and infallible imagination.

He now looks at the loss of his albums as a blessing in disguise, though he still has trouble believing what has happened. No longer a private fantasy, Mingering Mike is now the stuff of legend. And though his dream had once been to be a star, he now prefers to remain in the shadows, concerned that his quiet personal life would be turned upside down from all of the attention. The anonymous Mingering Mike looks on while his cardboard alter ego lives out his dream.

At the time of this writing Mike has begun working on a new project: the construction of a portable cardboard record player for use in his next gallery showing. And he has plans for his comeback album—*The Return of the Magnificent Mingering*. On the cover, a rejuvenated Mingering Mike gallops in on horseback, the sun setting behind him.

## Bibliography

Battiata, Mary. "Radio, Roots and Rhythm," *The Washington Post*, February 11, 2001.

George Washington University, "U Street Jazz—Venues—The Howard Theater," George Washington University, http://www.gwu.edu/~jazz/venuesh.html (accessed June 14, 2005).

Layman, Richard, ed., *American Decades: 1960–1969*. Detroit: Gale Research, 1995.

MacPherson, Myra. *Long Time Passing: Vietnam & The Haunted Generation.* Garden City, NY: Doubleday, 1984.

Pascall, Jeremy and R. Burt. *The Stars and Superstars of Black Music.* London: Chartwell Books, 1977.

Ritz, David. *Divided Soul: The Life of Marvin Gaye.* New York: Da Capo Press, 1991.

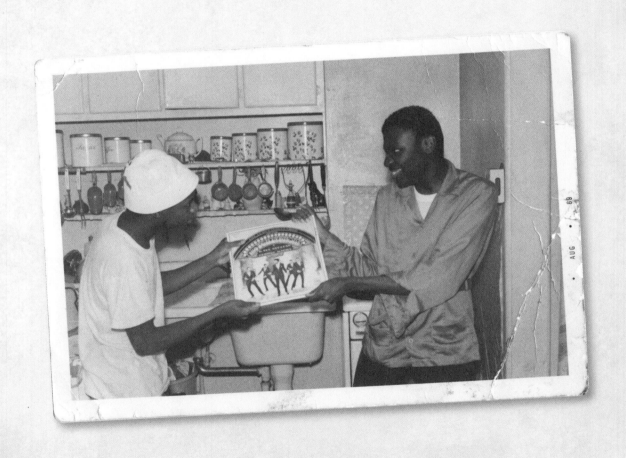

# A MESSAGE FROM MINGERING MIKE

Inspiration can come from any person,
at any place, at any time, And if you're
a very creative person, the mind is always
working, "You can be asleep," "Wake up from
a dream" or a nightmare, and record or
jot down a thought, a concept or an

Idea and capture a moment right then
and now, before it's lost forever. Because
if you don't record or memorize or jot it
down, the thought may never come back,

That way it's documented in the annals of time
for future or further use, luckily and unluckily
this kind of thing has happened to me, And
for this reason I dedicate this artistically
shaped and molded offering of mine, for all

Who have followed my work to see, at one time
the results of this finished product,
I dedicate this to: Dori Hadar & Frank Beylotte

"How the time and the moment"
came together is amazing and mysteriously
wonderful and I thank, "THY," for "them."

Forever gratefully yours

*Mingering Mike*

(2:20–2:50 a.m.)
2-16-04

p.s. Love & Kisses
Dawn & Lisa

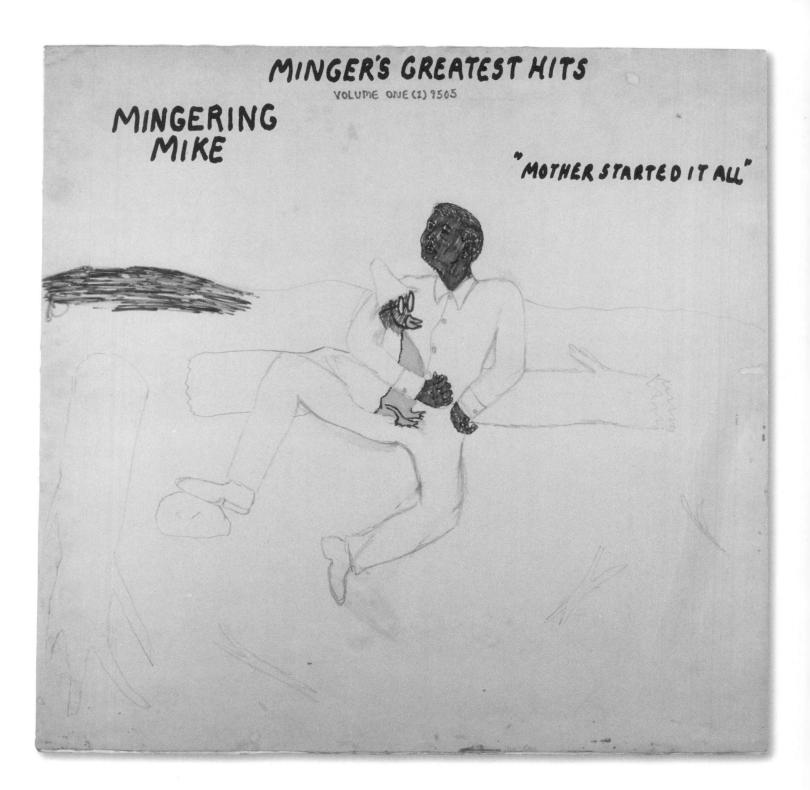

**MINGERING MIKE**
Minger's Greatest Hits (Volume 1)
(Mother Goose, June 1969)

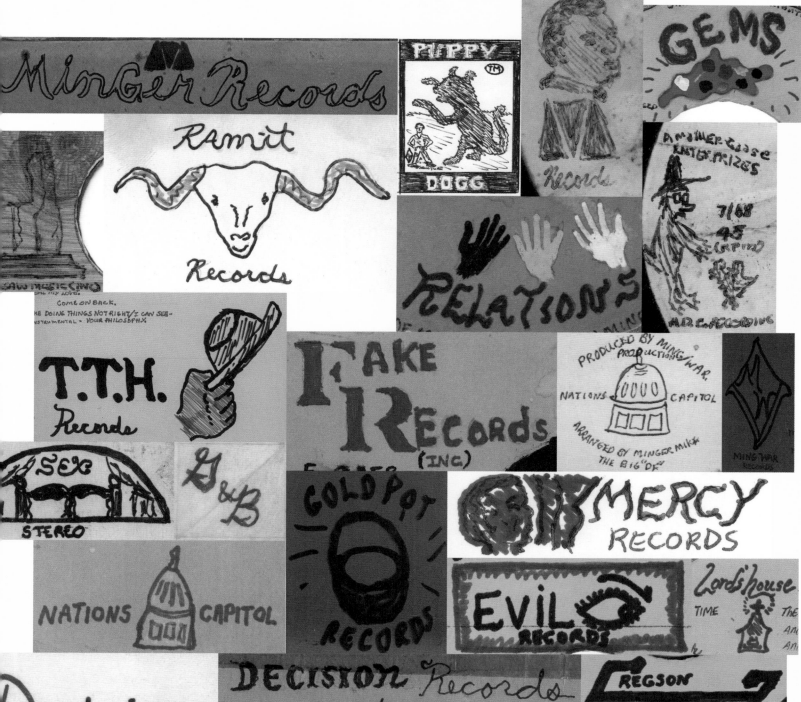

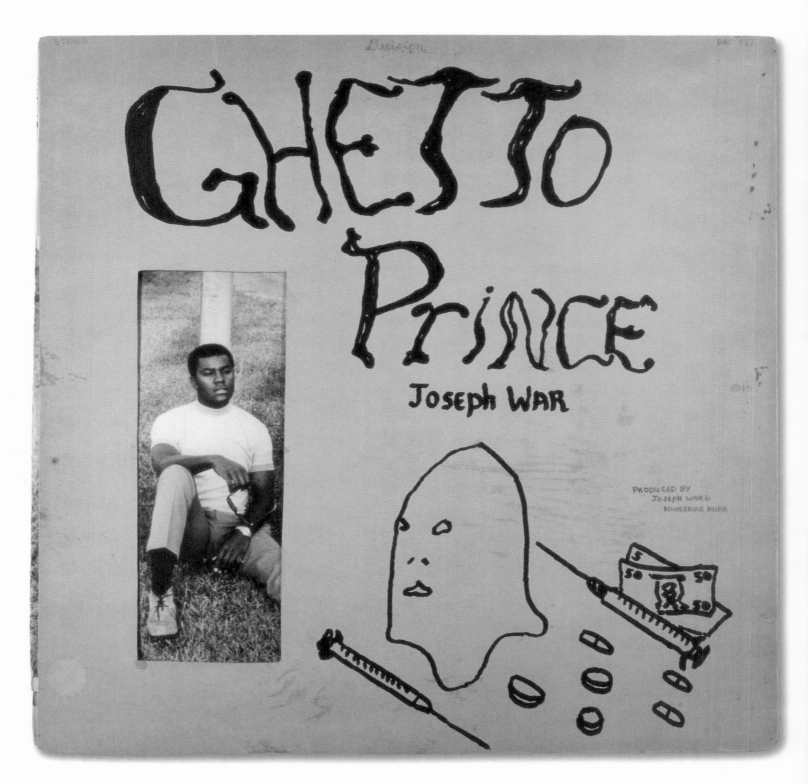

**JOSEPH WAR**
Ghetto Prince
(Decision, Aug. 1972)

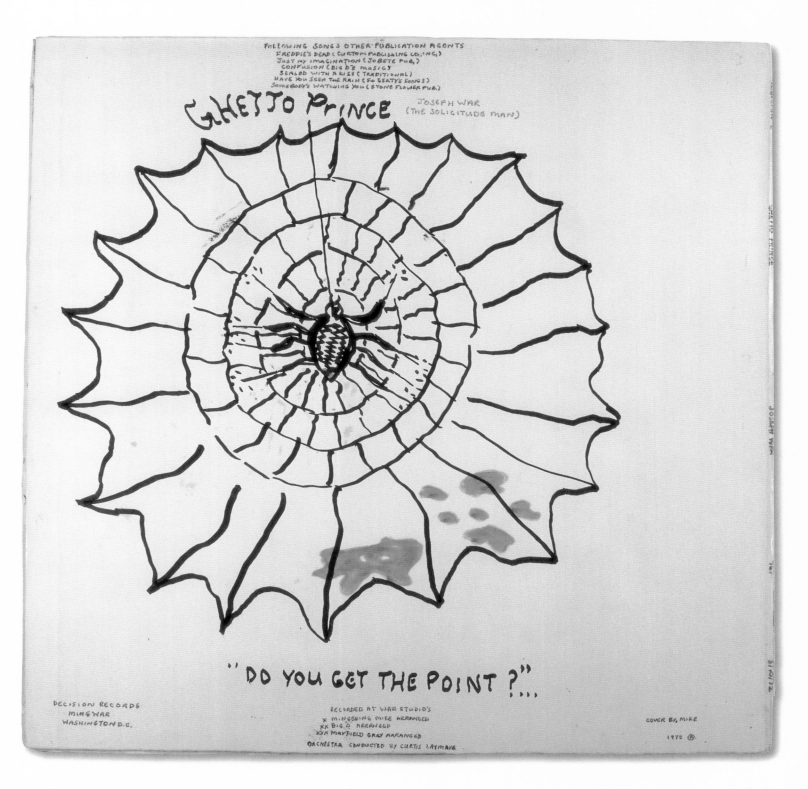

overleaf
**JOSEPH WAR**
Ghetto Prince (gatefold)

ONCE YOU START, IT'S HARD FOR YOU TO STOP.
ONCE YOU STOP...."STOP."

*Decision*
FOR LIFE

SIDE ONE

JUST MY IMAGINATION (Jobeta BMI)

HAVE YOU SEEN THE RAIN
(John Fogerty) Fogerty's

SEALED WITH A KISS
(Traditional)

SOMEBODY'S WATCHING YOU
(Sly Stone)

DON'T TRY AND TA TAKE IT ALL IN
(M. MIKE) Crystal Ball

SIDE TWO

"TRY IT," YOU'LL LIKE IT
(M. MIKE) Crystal Ball

FREDDIE'S DEAD
(C. Mayfield) Custom Pub.

CONFUSION
(Big "D")

GHETTO PRINCE
(M. MIKE) Crystal Ball

PASS...."IT AIN'T GOT NO THING ON ME."

This album is truly a collectors album
One that you don't mind spending the extra
Pennies that records are now costing
This album is fill of joys, hopes, love & sorrows
I dig it, and if I know people
They'll dig it too, there are a few songs that you
May have to have one or two gray hairs to remember
And even they sound just as good as they did
Long, long ago, enough of the small talk
I'll let you be the judge of whether
It's good or not, but if you don't want to chance
A brand new album from a sure to become
Regular artist then put it back down
And go to a friends home and hear it
Or wait until you hear some cuts or the 45
On the radio or in this store
If you don't buy it now then you're just
Going to be using up more time and money
Coming back down here when the selections
Blow your mind
As it did mines.

—Joseph War, President of Decision Records

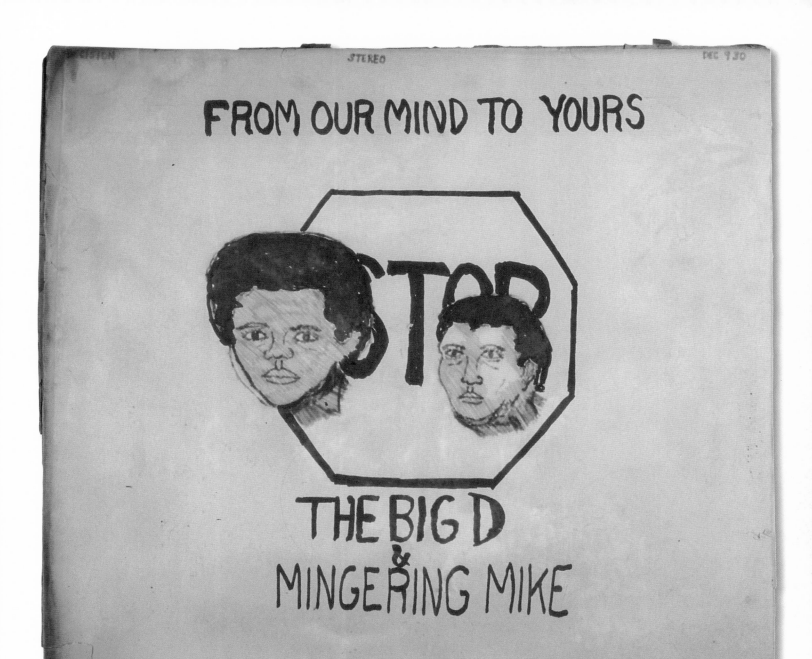

**THE BIG "D" & MINGERING MIKE**
From Our Mind to Yours
(Decision, Aug. 1972)

135

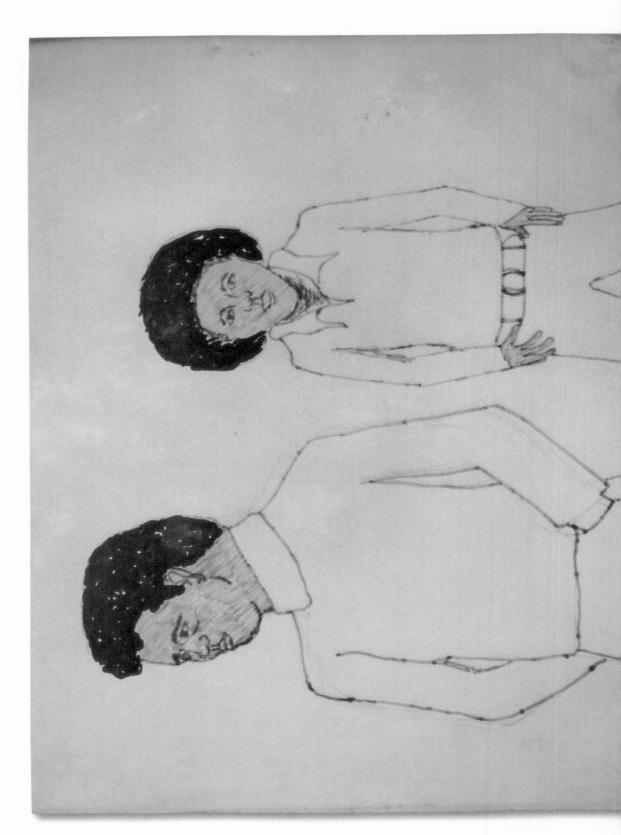

**THE BIG "D" & MINGERING MIKE**
From Our Mind to Yours (gatefold)

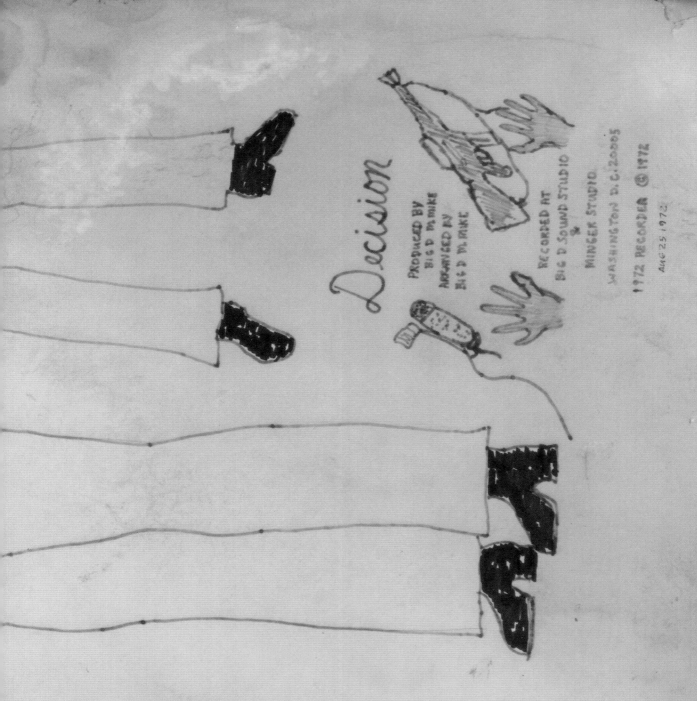

Decision

PRODUCED BY
BIG D. MIKE
ARRANGED BY
BIG D. MIKE

RECORDED AT
BIG D SOUND STUDIO
&
MINGER STUDIO
WASHINGTON D.C. 20005
1972 RECORDED © 1972

AUG 25 1972

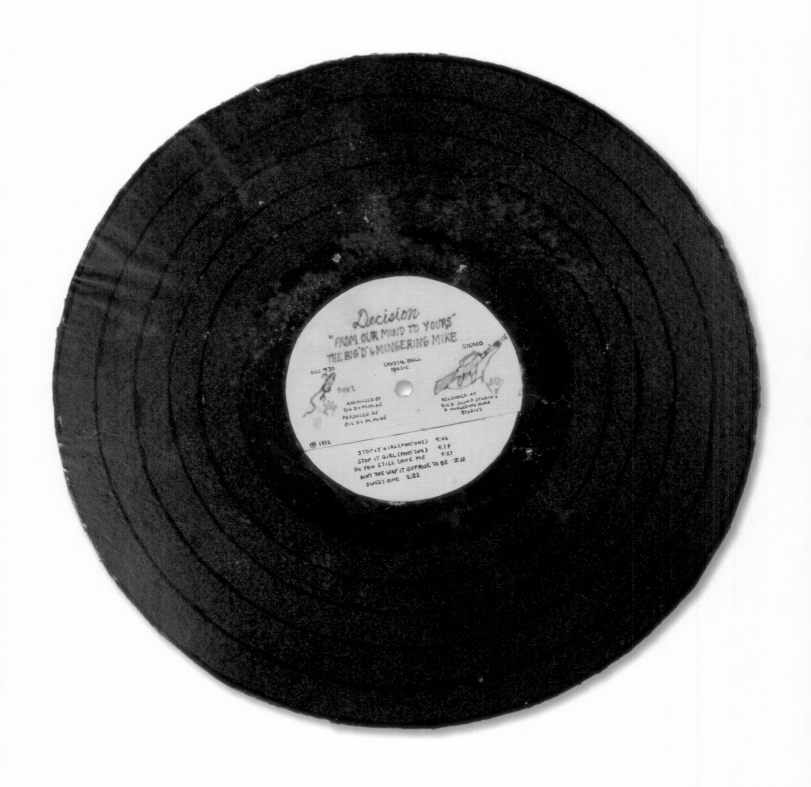

**THE BIG "D" & MINGERING MIKE**

From Our Mind to Yours (side 1)                    138

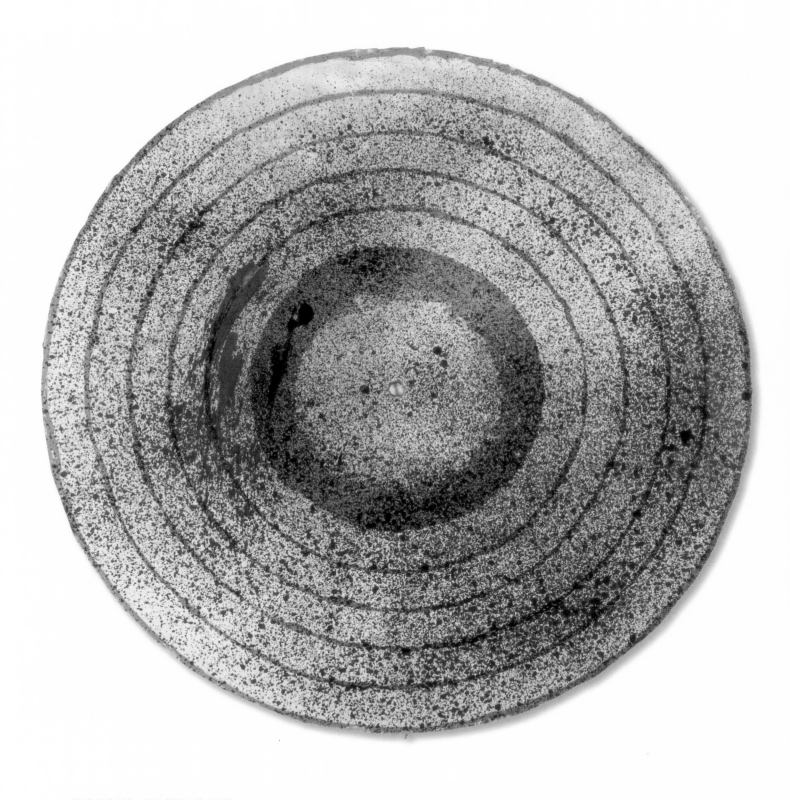

**THE BIG "D" & MINGERING MIKE**
From Our Mind to Yours (side 2) 139

**MINGERING MIKE**

Soundtrack from *"You Only Know What They Tell You"*

(Relations, May 1973)

MICHAEL'S MOOD
AND I LOVE HER
(AND I WANT HER BACK)
YOU KNOW ONLY WHAT THEY
(TELL YOU)
BUT DO YOU LOVE HIM

GIVE IT TO ME
OUR LOVE HAS SLIPPED AWAY
WHY YOU WANT TO DO THIS TO ME
MICHAEL'S THEME

FIGHT WHEN I SAY FIGHT
BABY, BABY, BABY
G.I. WANT TO GO HOME
MAY THE LORD WATCH OVER ME
I'VE GOT THE BATTLEFIELD BLUES

TROUBLE'S AH WAITING
BUT ALL I CAN DO IS CRY
EVERY STORY DOESN'T HAVE
(A HAPPY ENDING)

RE-RELEASE
8174

overleaf
**MINGERING MIKE**
Soundtrack from *"You Only Know What They Tell You"* (gatefold)

THE PIT OF MISERY

INDUCTION THEN

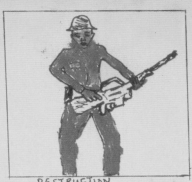

DESTRUCTION

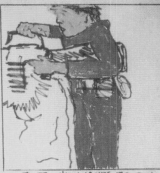

JUST WHO WANTS TO DIE.

OF COURSE WITH SO CALLED STATEMENTS
LIKE THIS, THERE SHOULD BE TWO SIDES
OF THE STORY, BUT I AND ONLY I
IF YOU AGREE THEN THAT'S YOUR
PRIVILEGE TO DO SO, BUT I DON'T THINK
THAT IN THIS DAY AND AGE THAT IF
SOMETHING WAS INTERFERING WITH
"OUR RIGHT'S THAT THE PEOPLE OF OUR
(FAIR) AH I MEAN COUNTRY WOULD
REALLY LET US DOWN, NO, NO THAT CAN'T BE SO
SO THERE FOR I SINCERLY BELIEVE
THAT THERES NO NEED FOR THE UNCONSTITIONAL
DRAFTING SYSTEM.

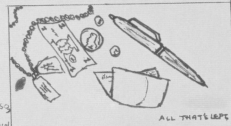

ALL THAT'S LEFT.

I SAY AND SING
ONLY WHAT I, AND
I ALONE BELIEVE.

I'VE JUST READ A FEW LINES
OF MARVIN GAYE, SAYING THAT
HE OR WHO EVER WROTE THE LINES
SAID THAT YOU HAD ENOUGH FAITH
OR BELIEVE THAT THE ALBUM THAT
YOU BROUGHT ISN'T WORTHLESS, SO
I'M NOT GOING TO CONTROL YOUR
MIND AND TELL YOU, WHICH SONES
TO TAKE INTEREST IN, OR WHICH
LYRICS TO PAY ATTENTION TO
SO I'LL LEAVE THE JUDGEMENT
UP TO YOU OF THE DOWN FALL
OR SUCCESS OF THIS ALBUM.

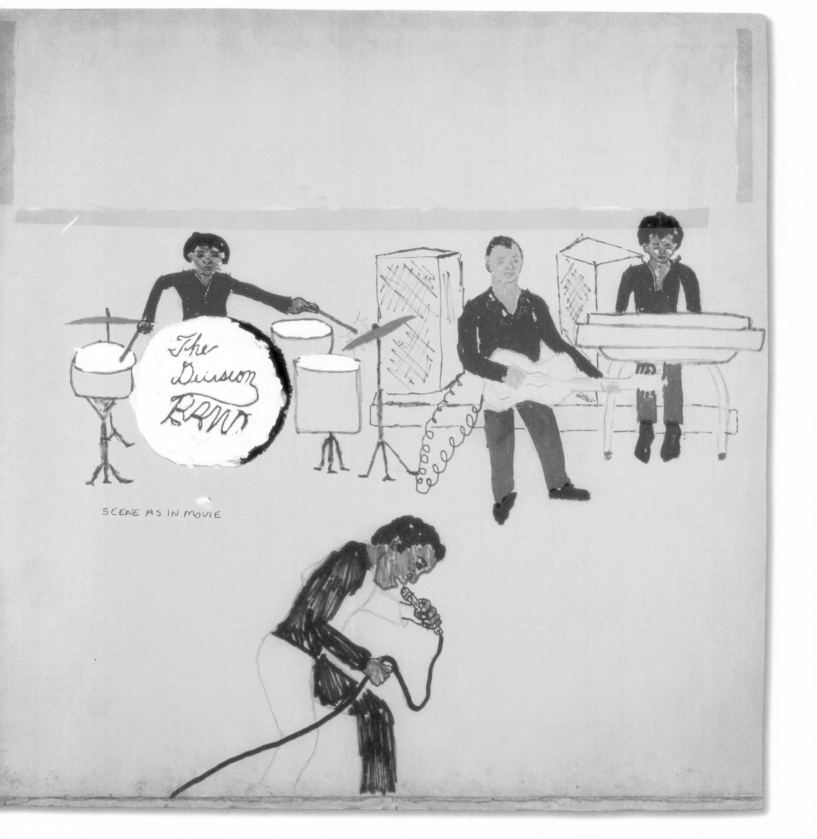

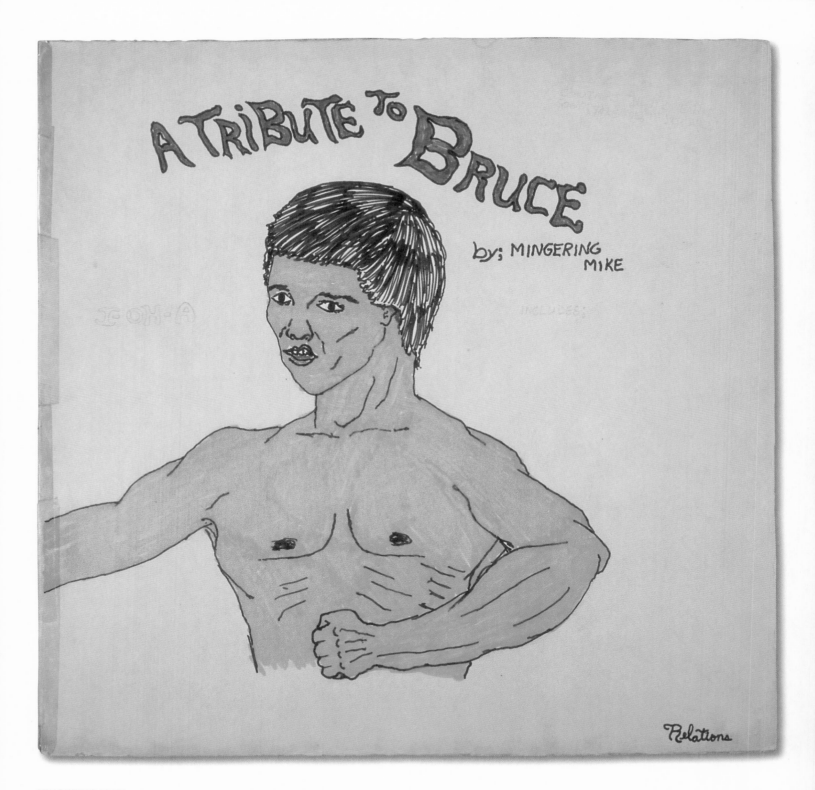

**MINGERING MIKE**
A Tribute to Bruce
(Relations, July 1973)

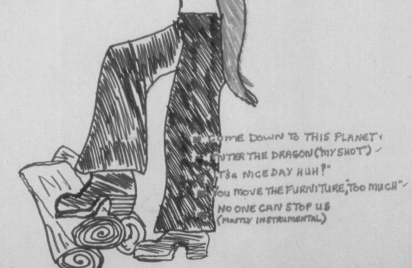

✳ "TAKE ME," IF YOU WILL"

✓ I'm COMING HOME

✓▪ NO ONE CAN STOP US NOW
(BECAUSE WE'RE TOGETHER)

▪ GET IN THE GROOVE

HE'S A SOLID TEMPO
THAT WILL JUST LIVE & LIVE & LIVE
IN MY MIND
IT'S a DAMN SHAME HE HAD TO DIE
IN SUCH A RISING TIME
IN HIS LIFE
AND THOUGH I DON'T KNOW THEM
I GIVE ALL MY LOVE & RESPECT
To HIS SON. DAUGHTER
AND I'M SURE SHE WAS To HIM
A VERY LOVING & A VERY
LOVLY WIFE.

m.mike

▪ COME DOWN TO THIS PLANET ✓

▪ ENTER THE DRAGON ("MY SHOT") ✓

▪ IT'S a NICE DAY HUH !"

▪ YOU MOVE THE FURNITURE, "TOO MUCH" ✓

▪ NO ONE CAN STOP US
(MOSTLY INSTRUMENTAL)

ALL SONGS WITH ▪ INDICATES; WRITTEN BY MINGERING MIKE
Published BY; CRYSTAL BALL MUSIC
℗ 1973 72773

145

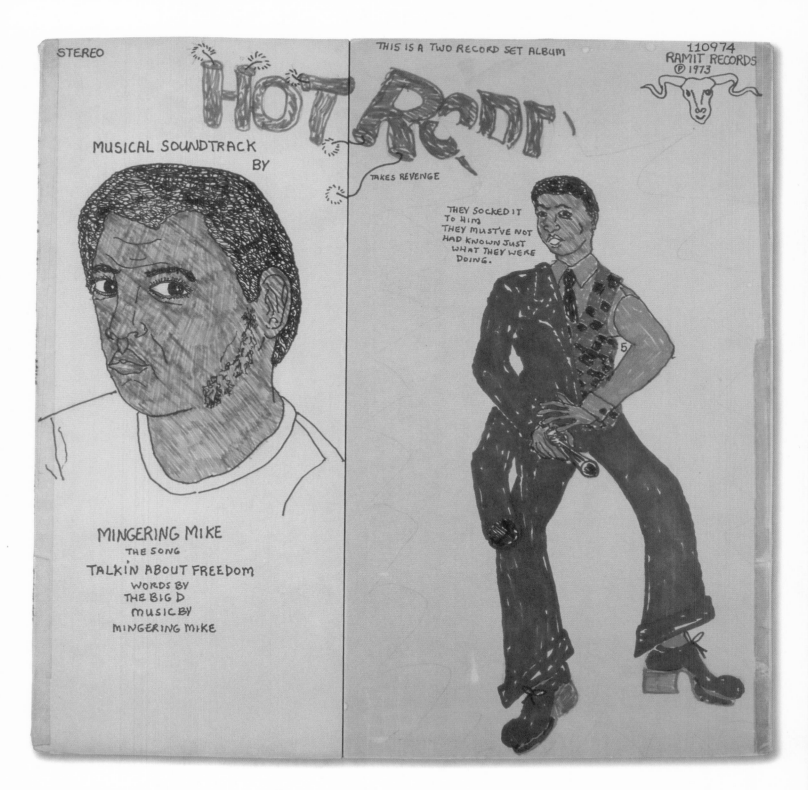

**MINGERING MIKE**

Original Soundtrack to *Hot Rodd (Takes Revenge)*

(Ramit, Nov. 1973)

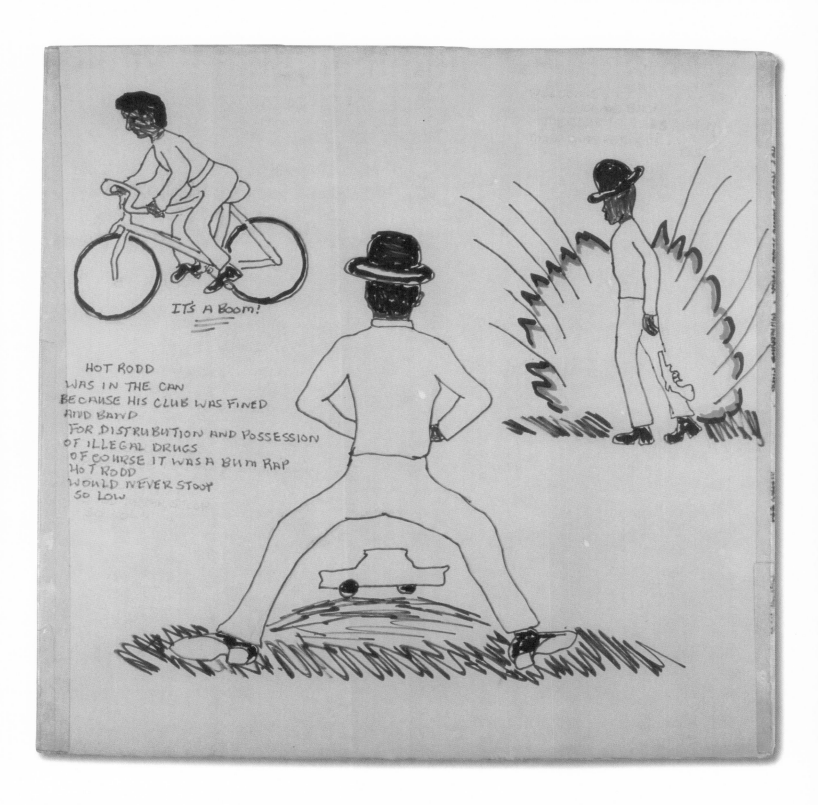

IT'S A BOOM!

HOT RODD
WAS IN THE CAN
BECAUSE HIS CLUB WAS FINED
AND BAND
FOR DISTRUBUTION AND POSSESSION
OF ILLEGAL DRUGS
OF COURSE IT WAS A BUM RAP
HOT RODD
WOULD NEVER STOOP
SO LOW

RAMIT RECORDS
IS DISTRIBUTED BY
DECISION MING/WAR
WORLD WIDE
1973 - RELEASE

SIDE ONE

HOT RODD (TAKES REVENGE)

BABY LOOK MY WAY (LOVE SCENE)
RUMBLE IN THE STREETS
① IT'S HIP WHEN YOU SLIP

SIDE TWO

WELCOME TO OUR PARTY
① SOMETHING IN GREEN
① E PITAH (BEFORE & AFTER)

SIDE THREE

MAN'S ONLY HOPE (POWER)
IT'S A BOOM
MAN'S ONLY DREAM

SIDE FOUR

① TALKIN ABOUT FREEDOM
(BIG D + M. MIKE)
SUDDENLY A MESSAGE
TRAIN RIDE (URGENT)
HOT RODD'S END

RECORDED AT:
WAR STUDIO'S
&
MINGER STUDIO'S

COVER & INSIDE PHOTO
BY, M. MIKE

ARRANGED BY M. MIKE
CONDUCTED BY JOE GRAM
PRODUCED BY; M. MIKE

THE SONG TALKIN ABOUT FREEDOM
WAS WRITTEN BY THE BIG D
THE MUSIC WAS WRITTEN BY
M. MIKE

**MINGERING MIKE**
Original Soundtrack to *Hot Rodd (Takes Revenge)*
(gatefold)                                    148

HOT RODD

TAKES REVENGE

STARRING

ROBERT KENTON & SUE JAMES

CO-STARRING

MINGERING MIKE, JACK BARODD, MARY COOK

WRITTEN BY

MINGERING MIKE

DIRECTED BY

MINGERING MIKE

PRODUCED BY

WARNERSISTERS & DECISION PRODUCTIONS

MUSIC BY: MINGERING MIKE

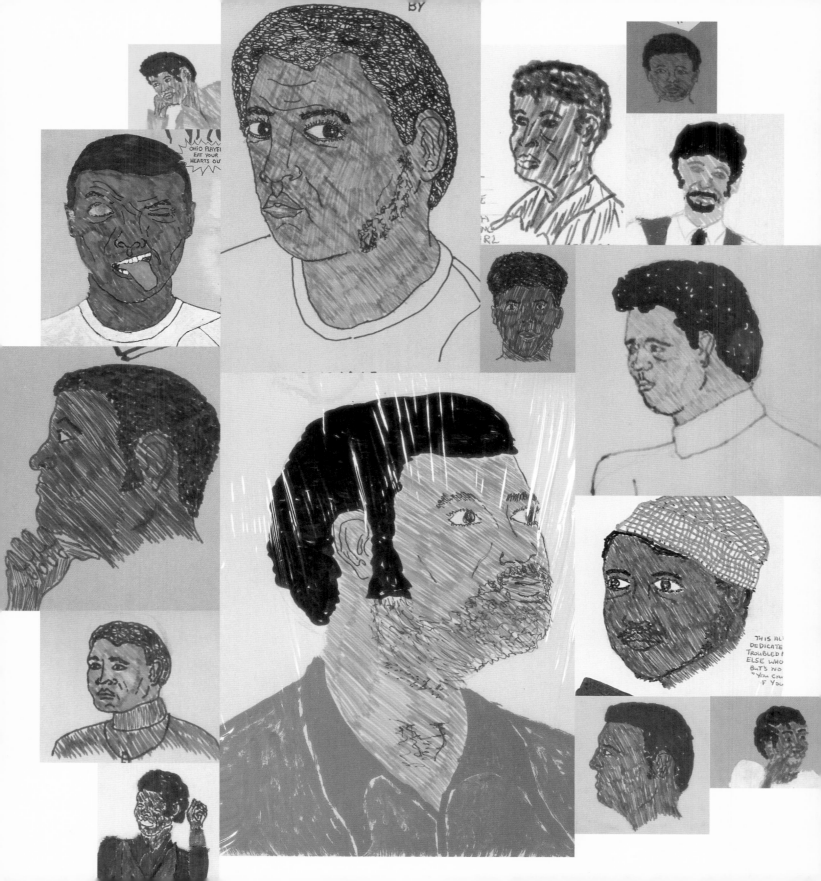

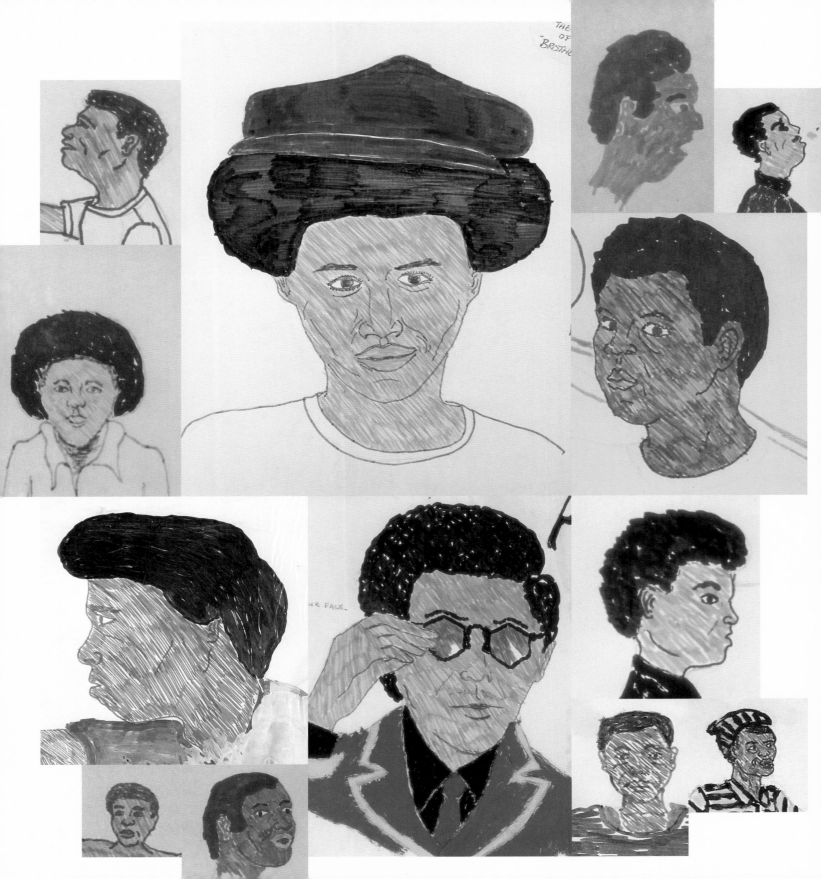

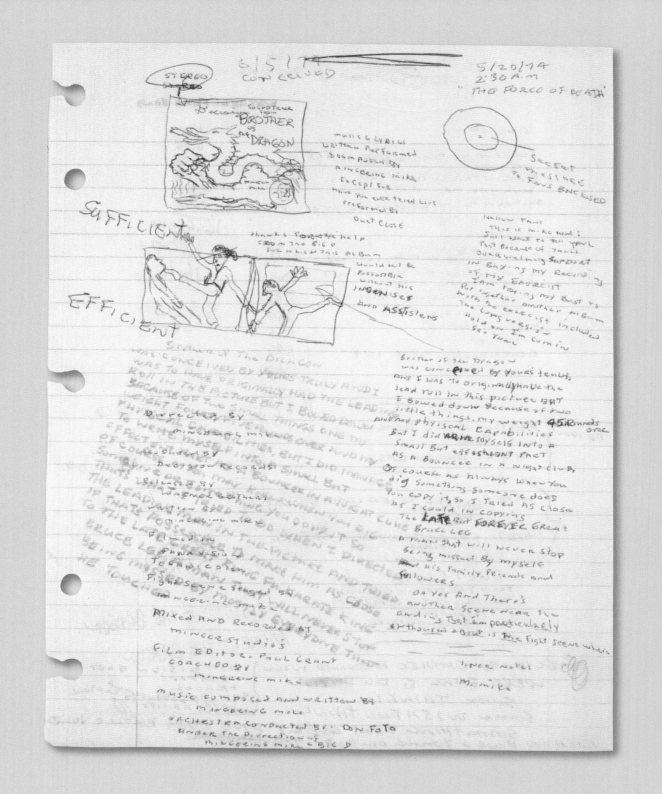

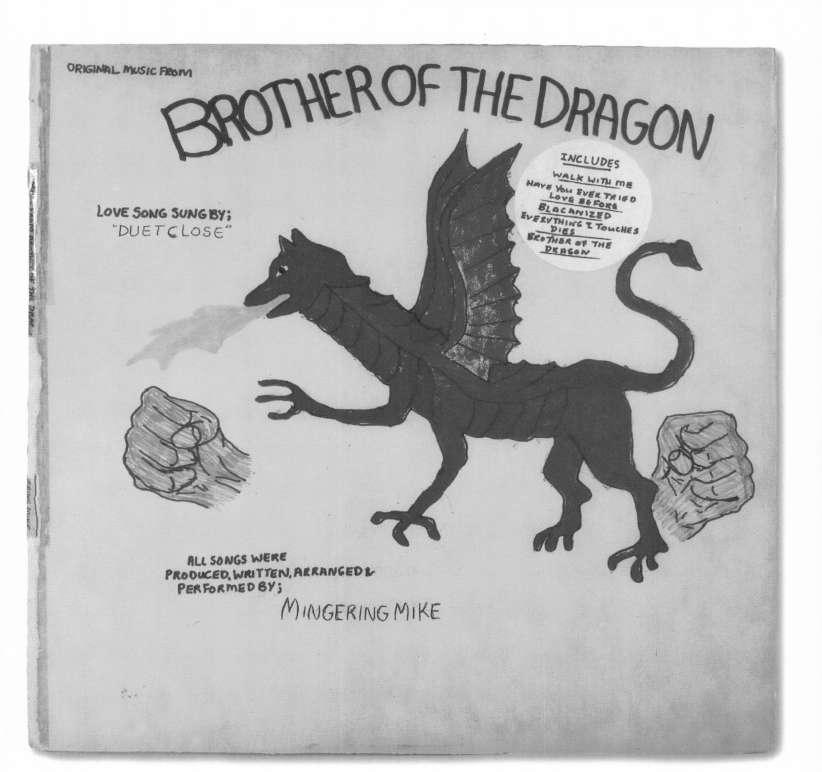

ORIGINAL MUSIC FROM

# BROTHER OF THE DRAGON

INCLUDES
WALK WITH ME
HAVE YOU EVER TRIED
LOVE BEFORE
BLACANIZED
EVERYTHING I TOUCHES
DIES
BROTHER OF THE
DRAGON

LOVE SONG SUNG BY;
"DUET CLOSE"

ALL SONGS WERE
PRODUCED, WRITTEN, ARRANGED &
PERFORMED BY;
MINGERING MIKE

**MINGERING MIKE**
Original Music from *Brother of the Dragon*
(Decision, June 1974)

overleaf
**MINGERING MIKE**
Original Music from *Brother of the Dragon* (gatefold)

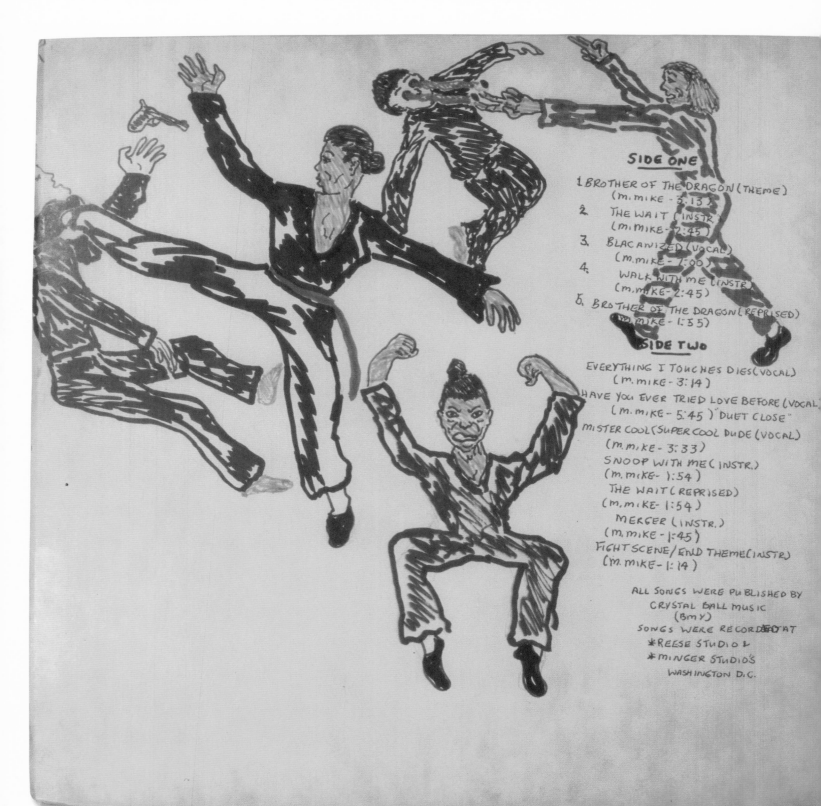

**SIDE ONE**

1. BROTHER OF THE DRAGON (THEME)
   (m. mike - 3:13)
2. THE WAIT (INSTR.)
   (m. mike - 7:45)
3. BLACANIZED (VOCAL)
   (m. mike - 7:00)
4. WALK WITH ME (INSTR.)
   (m. mike - 2:45)
5. BROTHER OF THE DRAGON (REPRISED)
   (m. mike - 1:35)

**SIDE TWO**

EVERYTHING I TOUCHES DIES (VOCAL)
   (m. mike - 3:14)
HAVE YOU EVER TRIED LOVE BEFORE (VOCAL)
   (m. mike - 5:45) "DUET CLOSE"
MISTER COOL (SUPER COOL DUDE (VOCAL)
   (m. mike - 3:33)
SNOOP WITH ME (INSTR.)
   (m. mike - 1:54)
THE WAIT (REPRISED)
   (m. mike - 1:54)
MERGER (INSTR.)
   (m. mike - 1:45)
FIGHT SCENE / END THEME (INSTR.)
   (m. mike - 1:14)

ALL SONGS WERE PUBLISHED BY
CRYSTAL BALL MUSIC
(BMY)
SONGS WERE RECORDED AT
✶ REESE STUDIO &
✶ MINGER STUDIO'S
WASHINGTON D.C.

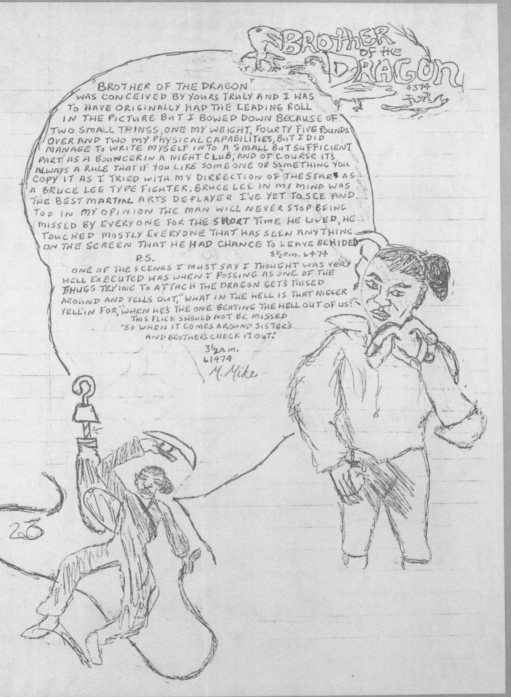

**THE LOVERS**

The Dark Side of Regan

(Sex, June 1974)

**SIDE ONE**   A.

1. THE DARKSIDE OF REGAN                                    7:11
2.     IT MUST BE THE DEVIL'S WORK              3:42
3.          BLOW IT AGAIN STEVE                       3:67
4. LORD KNOWS                                                      4:44
5. Jealous Eyes                                                          4:12

**SIDE TWO**

1.    I THINK I'M GOING OUT OF MY HEAD          2:70
2.    HOW DOE'S IT FEEL WHEN YOU KNOW       3:90
         (SHE DON'T LOVE YOU)
3.    I'M LOSING MY GIRL                                          2:80
4. NOTHING EVER GOE'S RIGHT FOR ME             3:54

B.     **SIDE THREE**

1. REGAN (WHY YOU DO THIS TO ME)              7:81
2. IF I COULD FIND A JOB                                      4:66
3. am YOUR SUPER man                                        3:47
4. I'M A STREET WALKER                                      3:22
5. I'M ONE OF THE LONELIEST MEN                 3:37
      (THAT EVER WALKED THE STREETS)

**SIDE FOUR**

1.                                                                                   3:13
     IT'S ALL OVER NOW                                          3:11
     (BIG D - M. MIKE)
2. START ALL OVER AGAIN                                    2:23
     (W. HART)
3. WE'LL MAKE IT                                                    3:69
4.   GET A BAG                                                          4:00
5. KALIMBA
     (M. WHITE)

THE LOVER'S;
      WE WANT TO JHANK
ALL THE PEOPLE OVER THE YEARS
FOR MAKING US ONE OF THE GREATEST
GROUPS AROUNDS

COVER ART WORK BY;
MINGERING MIKE

BIG D MUSIC (BMI)
RECORDED AT BIG D STUDIO
      1974 RELEASE
ARRANGED & PRODUCED BY
         THE BIG D
ALL SONGS WERE WRITTEN BY
THE BIG D WITH THE EXCEPTION
    OF THREE; IT'S ALL OVER NOW
(LYRICS BY; MINGERING MIKE MUSIC BY; BIG D)
START ALL OVER AGAIN (W. HART)
    KALIMBA (M. WHITE)

*How Can You loose*

*Where you Choose*

*"The Lover's?"*

**MINGERING MIKE**

On the Beach with the Sexorcist

(Decision, July 1974)

158

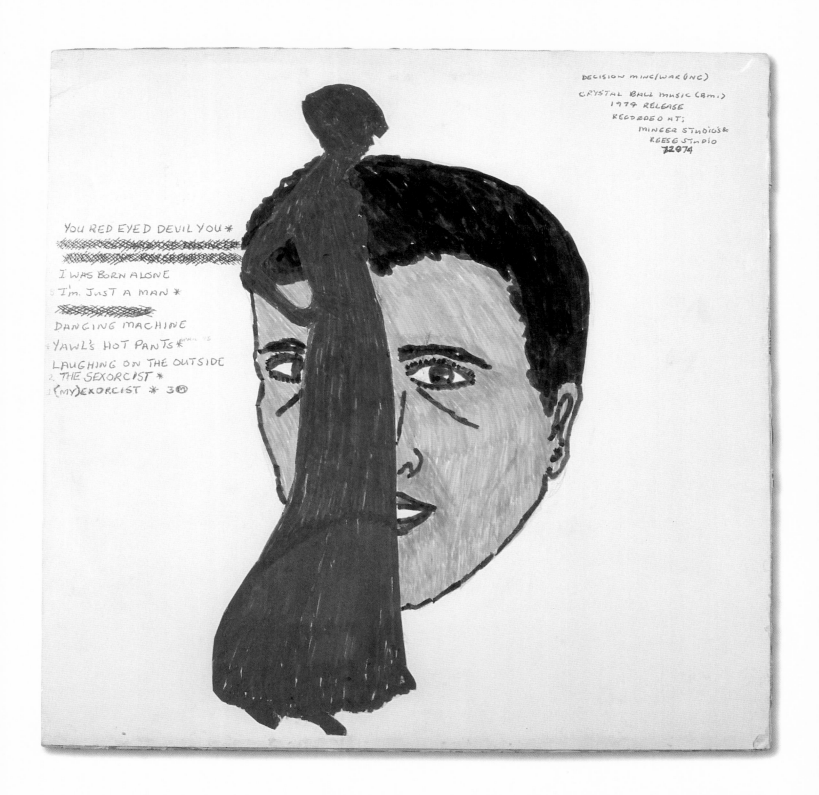

**JOSEPH WAR**

"Life is a Bitch"

(Green & Brown, Sept. 1974)

160

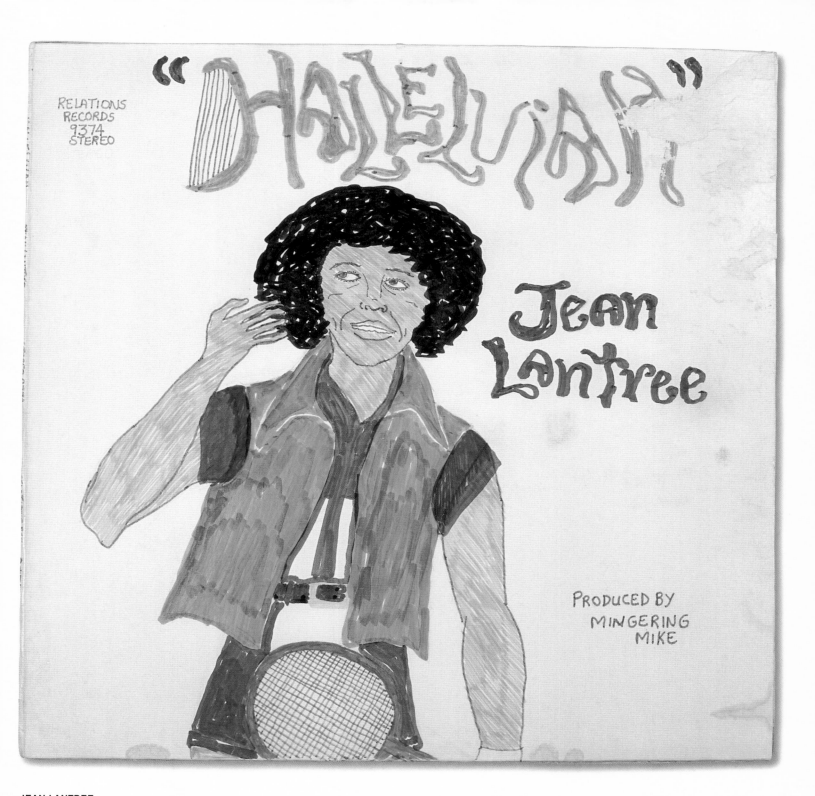

**JEAN LANTREE**
"Hallelujah"
(Relations, Sept. 1974)

THE MAGIC FINGERS
OF BIG D

- LET'S STAY TOGETHER
  I HOPE THAT I'D SEE YOU
  - (AND I DID)
- DO I LOVE YOU
  OH CAROLINE
  - (OH CAROLINE)
- DO YOU STILL LOVE ME
- IF I TAKE A OVERDOSE
- ANDRÉ
  (I FEEL SO GOOD)
- YOU YOU
- MINGERING MIKE
- LOOK AT YOURSELF

ARRANGED BY
MINGERING MIKE
BIG D

PRODUCED BY
MINGERING MIKE

RECORDED AT
BIG TIME STUDIOS

BACKGROUND    (PAID FOR BY
THE OUTSIDERS    BIG D)
AND SWEETMELONS
(SINGERS)
(PAID FOR BY MIKE)
PUPPY
DOGG RECORDS
NAME OF LABEL BY ANDRÉ
DESIGN BY MIKE

MUSIC
ACCOMPANIMENT BY
"INTO IT"

SIDE 1

LOOK AT YOURSELF : 1:50
DO I LOVE YOU : 2:33
OH CAROLINE : 2:37
MINGERING MIKE - 2:20
DO YOU STILL LOVE ME : 3:40

I WISH I HAD THE
FORCE TO MAKE MY
FINGERS MOVE AS HE.
    MIKE

SIDE 2

I HOPED THAT I'D SEE YOU
(AND I DID)    2:45
IF I TAKE A OVERDOSE  3:59
ANDRÉ
(I FEEL SO GOOD)    3:40
LET'S STAY TOGETHER 3:00
YOU, YOU    4:39

PUPPY

RELEASE DATE
3/4/73

"YOU, YOU" (INSTRUMENTAL
    &
DO I LOVE YOU (INSTRUMENTAL

Sketch for The Magic Fingers of Big D
(Mar. 1973)                162

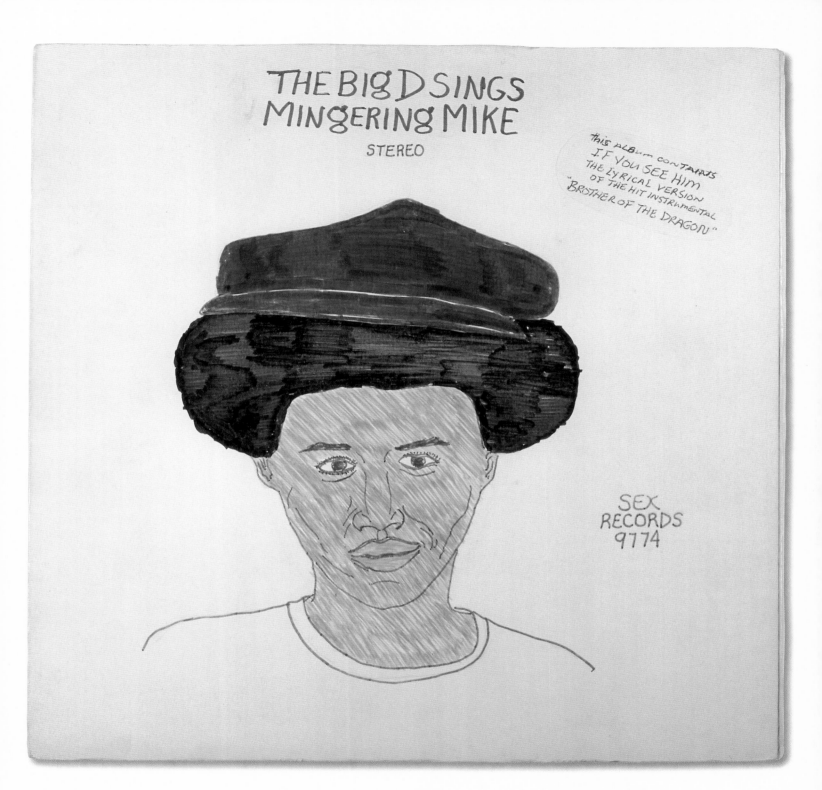

**The Big "D"**
The Big "D" Sings Mingering Mike
(Sex, Sept. 1974)

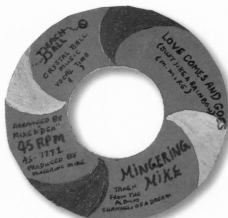

BEACH BALL
CRYSTAL BALL
MUSIC
VOCAL TIME
LOVE COMES AND GOES
(JUST LIKE A RAINBOW)
(M. MIKE)
ARRANGED BY
MIKE & DEA
45 RPM
45-7771
PRODUCED BY
MINGERING MIKE
MINGERING MIKE
TAKEN FROM THE ALBUM
CHANNELS OF A DREAM

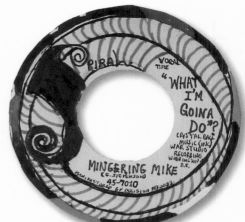

SPIRAL
VOCAL TIME
"WHAT I'M GOINA DO"?
CRYSTAL BALL MUSIC (INC)
WAR STUDIO
RECORDING
WASH INC. WASH
D.C.
MINGERING MIKE
(G. STEVENSON)
45-7010
MANUFACTURED BY DECISION RECORDS

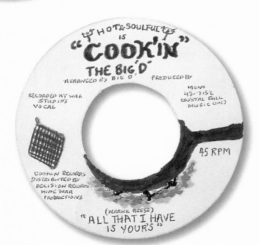

BLACK BALLED
JOBETE MUSIC
O MY TIME
ARRANGED BY
MOTOWN BAND
PRODUCED BY
M. MIKE
1972 RELEASE
© 1963
"WHERE DID OUR LOVE GO"?
(HOLLAND DOZIER HOLLAND)
MISS FLY DARLENE

BLACK BALLED

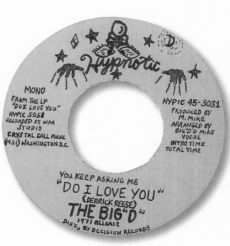

"HOT & SOULFUL IS
"COOK'IN"
THE BIG "D"
ARRANGED BY BIG "D"
PRODUCED BY
MONO
45-7152
CRYSTAL BALL
MUSIC (INC)
RECORDED AT WAR
STUDIO'S
VOCAL
45 RPM
COOK'N RECORDS
DISTRIBUTED BY
DECISION RECORDS
MINC WAR
PRODUCTIONS
(DERRICK REESE)
"ALL THAT I HAVE
IS YOUR'S"

Hypnotic
MONO
FROM THE LP
"DO I LOVE YOU"
HYPIC 5058
RECORDED AT WAR
STUDIO
CRYSTAL BALL MUSIC
(MSI) WASHINGTON D.C.
HYPIC 45-3031
PRODUCED BY
M. MIKE
ARRANGED BY
BIG "D" & MIKE
VOCAL
INTRO TIME
TOTAL TIME
YOU KEEP ASKING ME
"DO I LOVE YOU"
(DERRICK REESE)
THE BIG "D"
1971 RELEASE
DIST. BY DECISION RECORDS

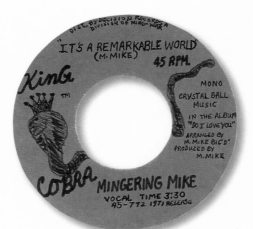

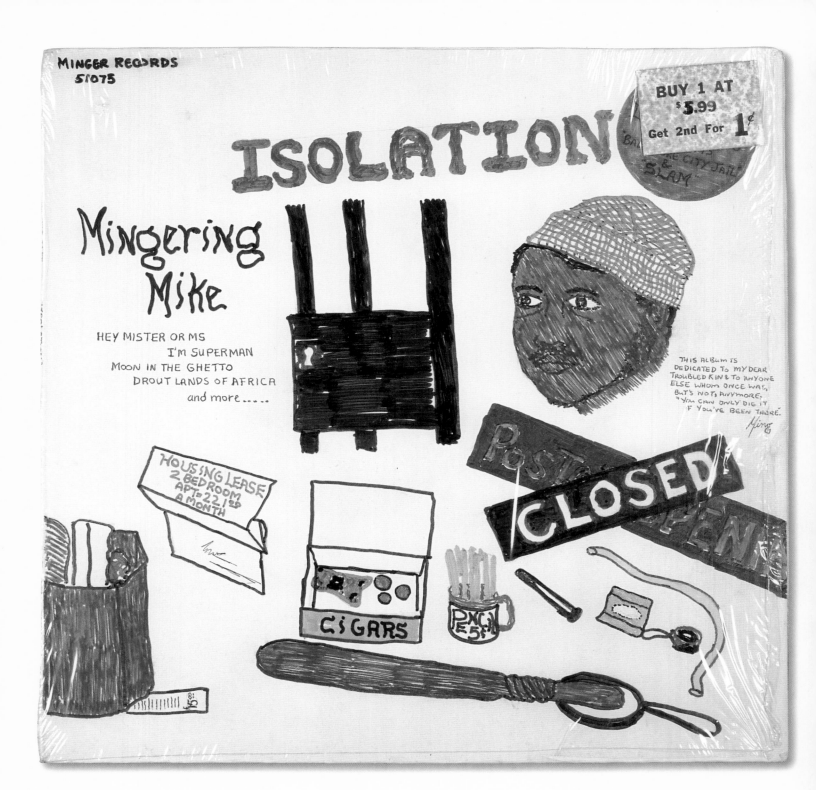

**MINGERING MIKE**
Isolation
(Minger, May 1975)

166

## "BLIND IN ONE EYE"

YOU'RE WORST THAN A PERSON
BLIND IN ONE EYE
AND CAN'T SEE OUT
   THE OTHER
YOU'RE WORST THAN A PERSON
BLIND IN ONE EYE
AND CAN'T SEE OUT
   THE OTHER
   I SAID
YOU'RE WORST THAN A PERSON
BLIND IN ONE EYE
AND CAN'T SEE OUT
   THE OTHER
   "YOU'RE HOPELESS"
YOU'RE HOPELESS, YOU'RE HOPELESS

YOU GO UPSTAIRS AND SHUT
   THAT DOOR, "YEAH!"

YOU STUMBLE DOWN STAIRS
   AND HIT THAT FLOOR, "YEAH"

YOU TRY TO OPEN THE DOOR AND YELL
   AND CATCH SOME AIR
   BUT YOU FIND THAT, THERE'S
      NONE THERE

YOU ASK SOMEBODY, TO HELP YOU PLEASE
HELP YOU PLEASE, WALK AROUND THE STREETS
   IF YOU WALK ALONE
   THE COPS MIGHT CATCH YOU
      PUT YOU IN JAIL
   AND THEN THROW AWAY THE KEY
   IT'S WORST THAN GOIN
   AND GIVE IT TO A RABBIT
   TYING IT TO HIS LEG
   AND LET HIM HAUL OFF
WORST THAN A PERSON
BLIND IN ONE EYE
AND CAN'T SEE OUT
   THE OTHER
YOU CAN'T REASON
   AT ALL
YOU CAN'T REASON
   AT ALL
YOU DON'T KNOW WHAT YOU'RE
   DOIN TO YOURSELF INSIDE
AND YOU'VE LOST ALL YOUR
   MONEY, WILL AND PRIDE
   AS MORE AND MORE
YOU TAKE THAT RIDE.

## "MAKES ME FEEL GOOD"

FOR ALL, HER LOVE, I'LL DO
ALL I CAN
MAKE ME FEEL GOOD
IT MAKES ME FEEL GOOD
THAT I'M HER MAN
AND I'M THE ONLY ONE
THAT WILL EVER
HOLD HER HAND
EVERY DAY, "I THANK HER"
MAMA AND DAD
CAUSE WITHOUT HER
MY WORLD WOULD BE
   TOTALLY
   SAD
TOTALLY SAD
OH, SO BAD
EVERY DAY I'D BE MAD
AND FOR HER,
   I'D DO ALL I CAN
BECAUSE I'M SO GLAD THAT
SHE'S MY WOMAN
AND I'M HER MAN OH

AND IT MAKES ME
FEEL GOOD TO KNOW
THAT I'M HER MAN

## "SLAM"

SLAM
AND WHEN
THAT DOOR CLOSE
   BEHIND YOU
IT'S LIKE A NIGHTMARE
ARMED GUARDS PATROLING
   DAY AND NIGHT
AND WHEN THE GUARDS NOT PATROLIN
   SENTRIES ON DUTY
WHY MUST PEOPLE DO THINGS
THAT GET EM PUT IN
   ALL THE SLAM
THERE'RE JUST TRYIN
   TO MAKE IT
THE BEST WAY THEY CAN
   AND THEN THEY
   END UP IN
   THE SLAM
AWAY FROM THEIR FAMILIES
AND WHEN YOU'RE ATTACHED
   TO THEM
YOUR INSIDES BLEEDS
   AND YOUR BODY
WANTS TO BE FREE
   AW SLAM.

## "BALTIMORE CITY JAIL"

WELL IT TOOK 40 MILES
TO GET THERE
SHE WENT WITH US
   BUT SHE
DIDN'T COME BACK
   WELL
WE'RE ON THE ROAD
   TO THE
BALTIMORE CITY JAIL
   ONE THIRTY
WE HAD TO APPEAR
   IN COURT
   BY SEVEN
WE WERE ON OUR WAY
   BACK HOME
BUT MY, DEAR KIN
SHE WAS IN A CELL
   ALL ALONE
   AND
SHE WAS GOING TO
   THE BALTIMORE
   CITY JAIL
      TOGETHER
WE COULDN'T
   MAKE BAIL
BALTIMORE CITY JAIL
   TIME AND TIME
WE TOLD HER
   NOT TO DO
CERTAIN THINGS
BUT YOU KNOW
HOW YOU GET
WHEN YOU'RE GROWN
   YOU DON'T WANT
NOBODY TO TELL YOU
WHAT YOU MUST DO
   ANYWAY
YOU AINT GONNA
   LISTEN
AND THAT'S WHY
   SHE'S AT
THE BALTIMORE
   CITY JAIL
LORD, BALTIMORE CITY JAIL
IT TOOK 40 MILES
TO GET THERE, YEAH
SHE WENT WITH US
BUT SHE, DIDN'T COME BACK
MAYBE, ONE DAY, SHE WILL
THEN ONCE AGAIN
MY HEART WILL BE FILLED
WITH JOY AND LAUGHTER
BUT FOR NOW
SHE WILL RESIDE
   AT THE
BALTIMORE CITY JAIL
HOLD ON GIRL
I KNOW IT'S HELL

## "MOON IN THE GHETTO"

THERE'S AH.."MOON IN THE GHETTO"
THERE'S AH.."MOON IN THE GHETTO"
LOOKS LIKE THE ECONOMY'S
PUTTIN US ALL IN
THE SAME MIXING BOWL
AND EVERY WEEK THERE'S AH
CHANGE IN THE CURRENT
   WEEKLY TOLL
I MUST HAVE BEEN BLIND
   TO THINK
   JUST BECAUSE
THEIR COLORS
NOT LIKE MINES
THAT THEY
SHOULD BE DOIN FINE
WHEN THE ECONOMY'S
REALLY LINKING US ALL
TO THE SAME CHAIN
   SO I GUESS
THAT'S HOW IT EXPLAINS
WHY, THERE'S AH
"MOON IN THE GHETTO"
BUT IT'S ALRIGHT
AINT NO NEED IN
MAKIN A SCENE
WE ALL ARE
   HUMAN BEINGS
WE ALL HAVE THE SAME
HOPES AND DREAMS
AND WE ALL HAVE
OR WILL LIVE
IN THE IN BETWEENS
WE ALL SHOP AT
   THE SAME
POOR PEOPLES RIP
AND WHEN WE GET ANGERY
WE ALL MOUNT
THE SAME LIP
   SO DIG IT
AND DON'T FORGET IT
   THAT
WE'RE ALL IN
THE SAME LE HOLE
FILLIN UP
INSTEAD OF VACATING
THE GHETTO.

MINGER
REC.
1975

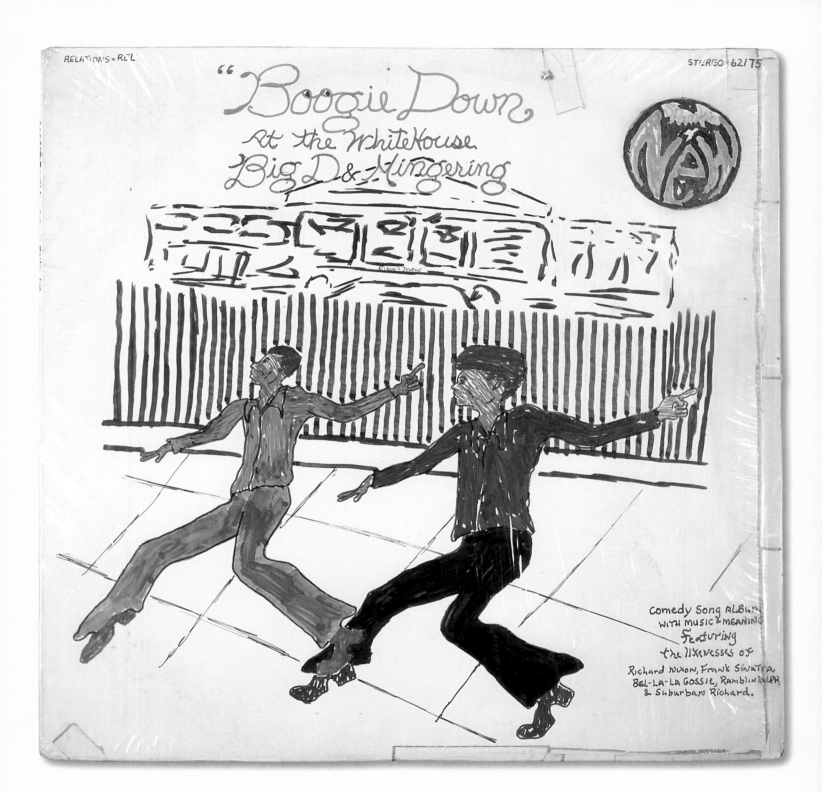

**THE BIG "D" & MINGERING**

Boogie Down at the White House

(Relations, June 1975)

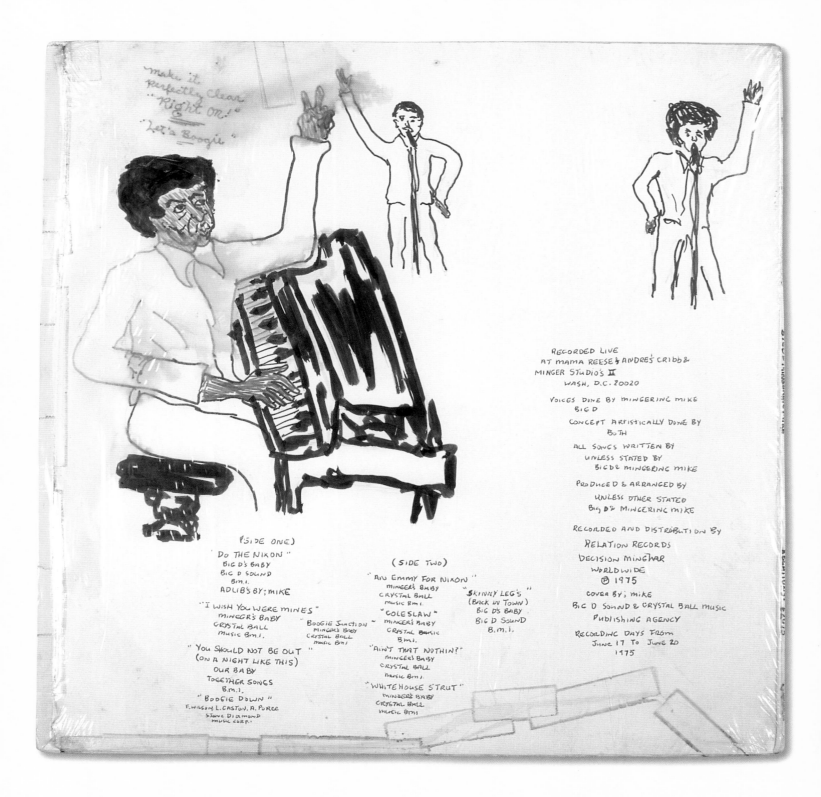

make it
perfectly clear
"RIGHT ON!"
"Let's Boogie"

RECORDED LIVE
AT MAMA REESE & ANDRE'S CRIBB &
MINGER STUDIO'S II
WASH, D.C. 20020

VOICES DONE BY MINGERING MIKE
BIG D
CONCEPT ARTISTICALLY DONE BY
BOTH

ALL SONGS WRITTEN BY
UNLESS STATED BY
BIG D& MINGERING MIKE

PRODUCED & ARRANGED BY
UNLESS OTHER STATED
BIG D& MINGERING MIKE

RECORDED AND DISTRIBUTION BY
RELATION RECORDS
DECISION MINEWAR
WORLDWIDE
℗ 1975

COVER BY; MIKE
BIG D SOUND & CRYSTAL BALL MUSIC
PUBLISHING AGENCY

RECORDING DAYS FROM
JUNE 17 TO JUNE 20
1975

(SIDE ONE)

DO THE NIXON "
BIG D'S BABY
BIG D SOUND
B.m.i.
ADLIB'S BY; MIKE

" I WISH YOU WERE MINES "
MINGER'S BABY
CRYSTAL BALL
MUSIC B.m.i.

" YOU SHOULD NOT BE OUT "
(ON A NIGHT LIKE THIS)
OUR BABY
TOGETHER SONGS
B.m.i.
" BOOGIE DOWN "
F. WILSON L. CASTON, A. PORCE
STONE DIAMOND
MUSIC CORP.

" BOOGIE JUNCTION "
MINGER'S BABY
CRYSTAL BALL
MUSIC Bmi

(SIDE TWO)

" AN EMMY FOR NIXON "
MINGER'S BABY
CRYSTAL BALL
MUSIC B.m.i.
" COLESLAW "
MINGER'S BABY
CRYSTAL BASIC
B.m.i.
" AIN'T THAT NOTHIN? "
MINGER'S BABY
CRYSTAL BALL
MUSIC B.m.i.
" WHITEHOUSE STRUT "
MINGER'S BABY
CRYSTAL BALL
MUSIC BM1

" SKINNY LEG'S "
(BACK IN TOWN )
BIG D'S BABY
BIG D SOUND
B.M.I.

169

**MINGERING MIKE**

"I'm Superman"

b/w "Blind In One Eye"

(Minger, June 1975)

500,000

"I'm Superman"

I'm Superman
I can
change the course
of mighty rivers

Bend steel
in my
bare hands
"Ha!"

"I'm Superman"

And now
I need
"Ah"
Superwoman
Because

"I'm Superman"

I want to have
some super kids
To carry on
my Supername.
"Let's face it"

Even Superman's
got ta get old

Trying ta fly
over all his
wrinkles

Tryin to go foreward
when he's
going backward
Aww
"I'm Superman"

Bend steel
with my bare hands
And now I need
some kids
To carry on
my super name
"Yeah Ho!"

I need ah woman
Yawl.

℗ 1975

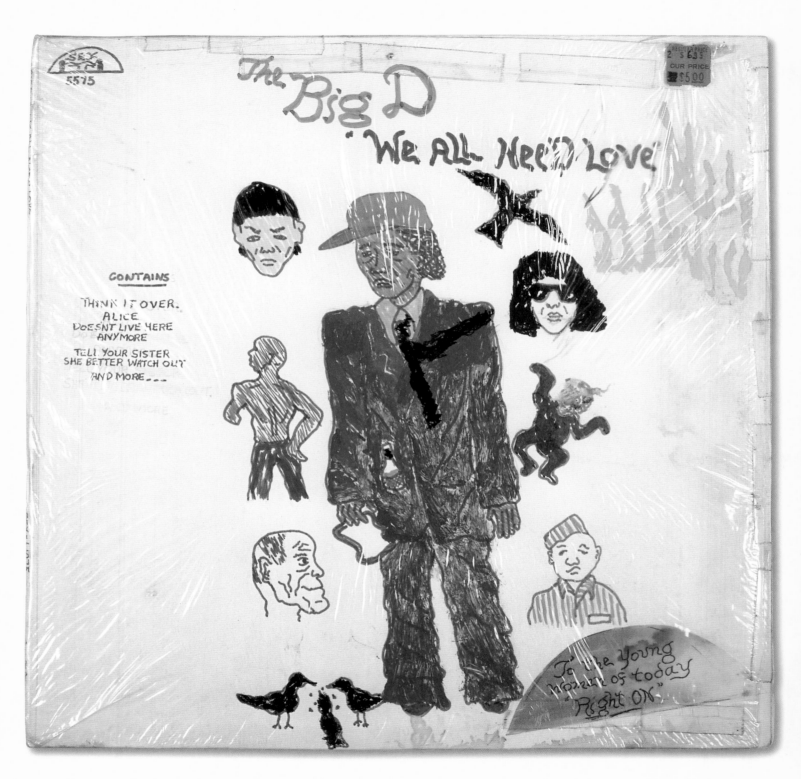

**THE BIG "D"**
We All Need Love
(Sex, June 1975)

172

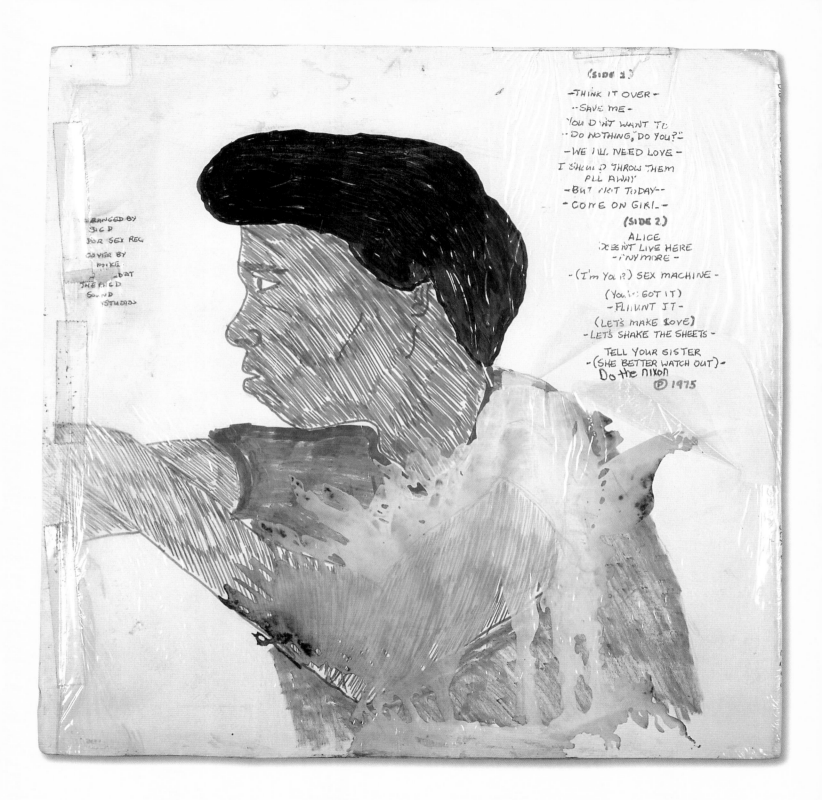

(SIDE 1)
-THINK IT OVER-
--SAVE ME-
YOU DON'T WANT TO
"DO NOTHING, DO YOU?"
-WE ILL NEED LOVE-
I SHOULD THROW THEM
ALL AWAY
-BUT NOT TODAY--
- COME ON GIRL-

(SIDE 2)
ALICE
DOESN'T LIVE HERE
- ANY MORE -

- (I'm YOUR) SEX MACHINE -

(YOU'VE GOT IT)
- FLAUNT IT -

(LET'S MAKE LOVE)
-LET'S SHAKE THE SHEETS -

TELL YOUR SISTER
-(SHE BETTER WATCH OUT)-
Do the nixon
Ⓟ 1975

ARRANGED BY
BIG D
FOR SEX REC
COVER BY
MIKE
BAT
THE BIG D
SOUND
STUDIOS

173

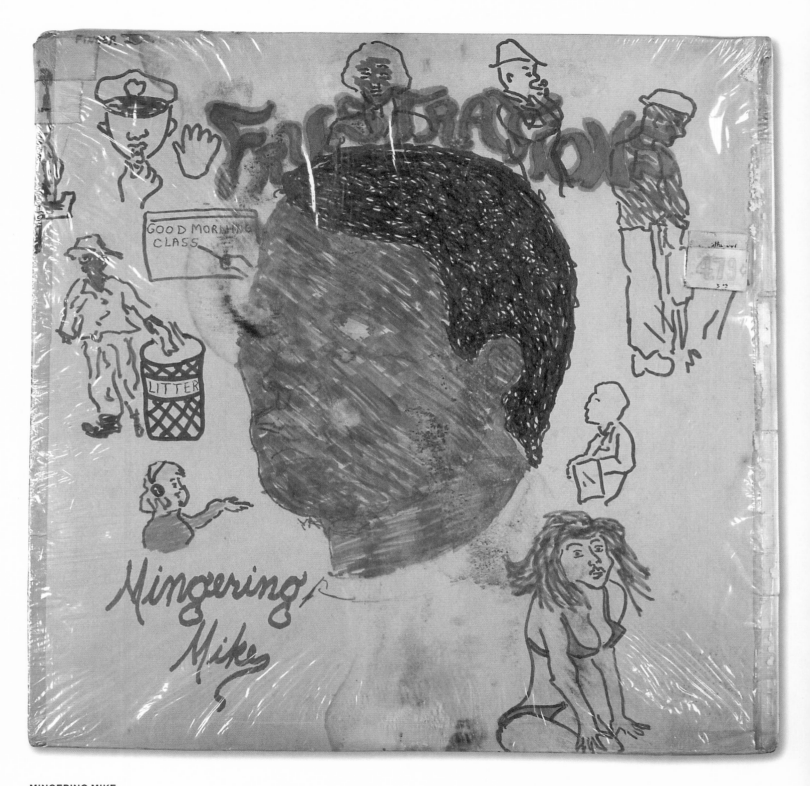

**MINGERING MIKE**

Frustrations

(Finger, Sept. 1975)

SIDE A

SUPERNATURAL THING
"I CAN", STRIKE
SUNN,
POOCHIE

SIDE B

"LET'S NOT FIGHT"

"DOCK OF THE BAY"

"GREGORY"

"HIS GIRLS A WOMAN NOW
(YOU BETTER BELIEVE)

THE WINTER SONG.

"LET'S NOT FIGHT"
IS DEDICATED TO
THE UNREST IN BOSTON &
TO THE PEOPLE OF P.G. COUNTY
WHO'VE DESTROYED
A BLACK COUPLES
CAR AND THRETENED
THEIR LIVES

"HEY YAWL"
WHAT'S WRONG WITH YAWL
LET'S LOVE MORE
AND HATE LESS.

Mingering
Mike

9-4-75
2:35 A.M.

"RIGHT ON" TO POOR PEOPLE
"POSTAL WORKERS"
"PAINTERS"
"FAIR COPS"
"CLERGYMEN"
"TEACHERS"
"CONSTRUCTION WORKERS"
"WAITERS"
"CASHIERS"
"WAITRESSES"
"OLD PEOPLE"
"YOUNG PEOPLE"
"TEENS"
"GARDENERS"
"FARMERS"
"DOCTORS"
"SALE'S PEOPLE"
"FIREMEN"
"CAB DRIVERS"
AND PEOPLE OF THE WORLD
IN GENERAL.

PRODUCED BY; MINGERING MIKE
ARRANGED BY; MINGERING MIKE
RECORDED AT; MINGER STUDIO'S II
WASHINGTON D.C.
ENGINEER; MINGERING MIKE
MANAGEMENT
JOSEPH WAR
CREATIVE PACKING, DIRECTION
& COVER DESIGN
ALSO BY
MINGERING MIKE

ALL SONGS EXCEPT FOR; SUPERNATURAL THING
DOCK OF THE BAY & SUNNY
WERE WRITTEN BY; MINGERING MIKE

PUBLISHED BY
SAVE THE WORLD MUSIC

FINGER RECORDS IS DISTRIBUTED BY
; DECISION MINGWAR WORLDWIDE
℗ 1975

MUSIC SUPLIED BY
THE MINGERING MIKE ORCHESTRA
& THE NATURAL FUNK BAND

MIKE GIVES HIS THANKS TO ALL THAT HELPED IN
MAKING THIS AND ALL OF MINGERINE'S
PREVIOUS ALBUMS POSSIBLE.

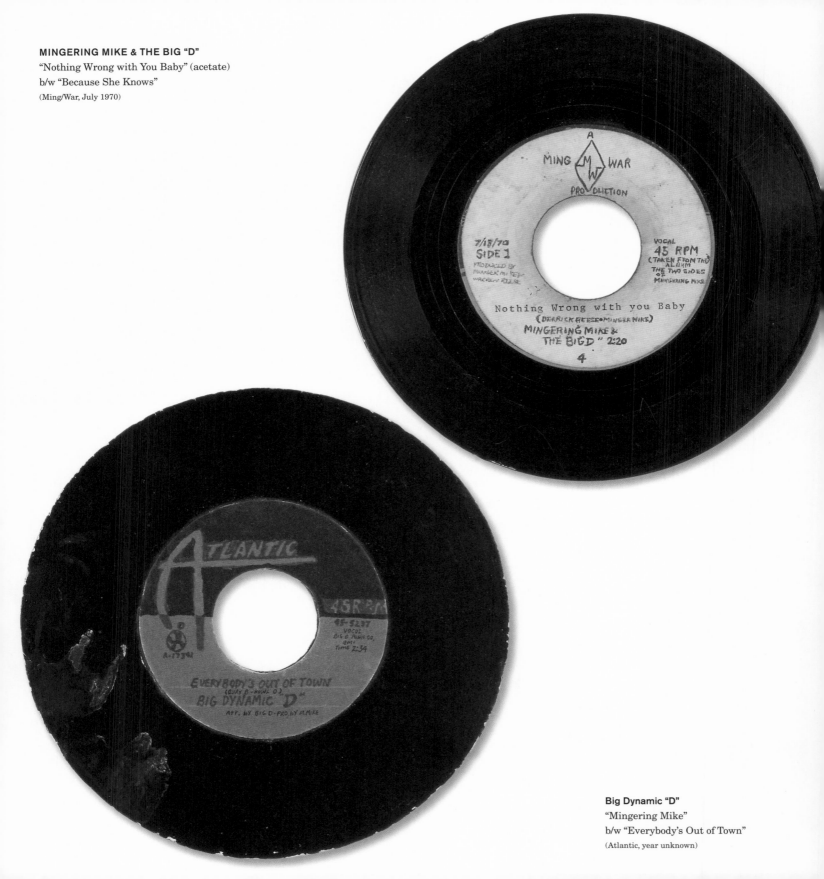

**MINGERING MIKE & THE BIG "D"**
"Nothing Wrong with You Baby" (acetate)
b/w "Because She Knows"
(Ming/War, July 1970)

**Big Dynamic "D"**
"Mingering Mike"
b/w "Everybody's Out of Town"
(Atlantic, year unknown)

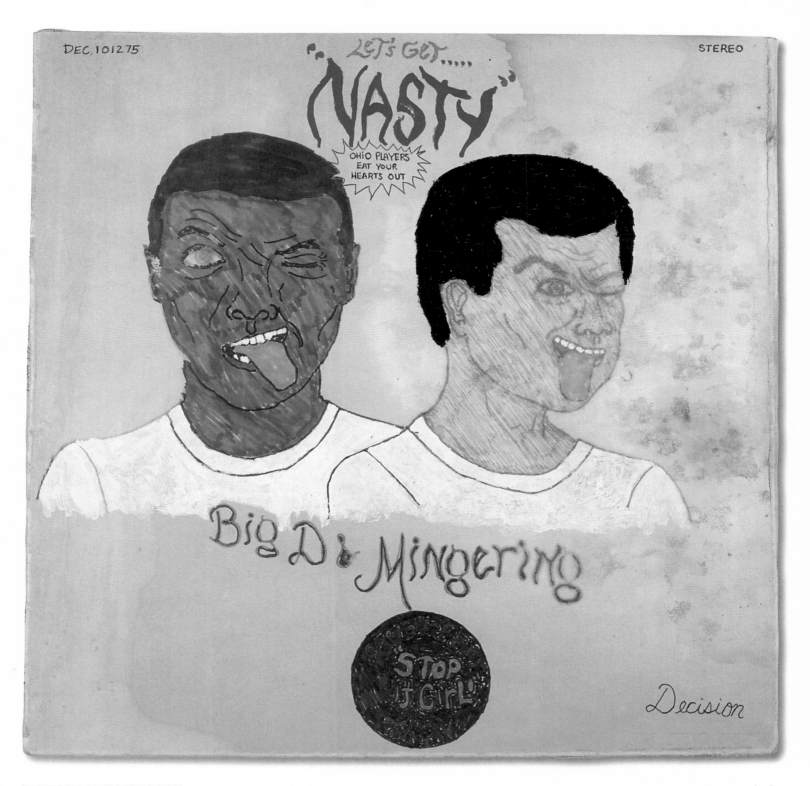

**THE BIG "D" & MINGERING MIKE**
Let's Get "Nasty"
(Decision, Oct. 1975)

overleaf
**THE BIG "D" & MINGERING MIKE**
Let's Get "Nasty" (gatefold)

LET'S GET "NASTY"

Big D & Mingering

"Doin it Again"

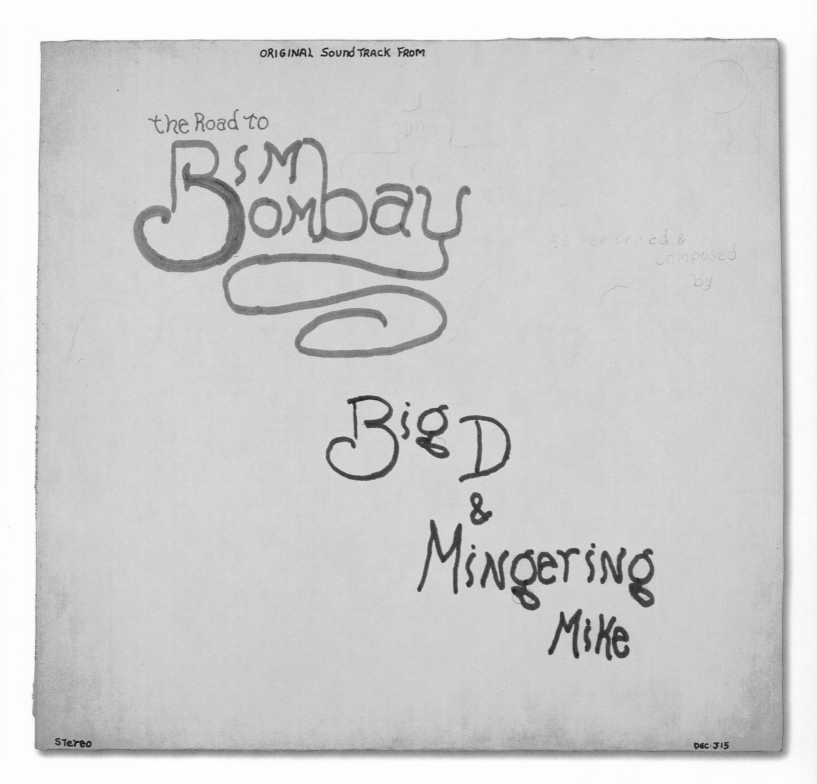

**THE BIG "D" & MINGERING MIKE**

Original Soundtrack from The Road to BimBombay

(Decision, Feb. 1976)

180

Ⓑ Road to BimBomBay · Mirage ✳Ⓑ
Ⓑ Interlude to Love
Can't stop a Man in Love
What I'm gonna do

"Hey!"

Starring
MINGERING MIKE
&
BiG D

All Other Selections
Written By:
MINGERING MIKE

Ⓜ Whisper What You Whispered
last night ✳

Desert Heat Ⓑ

AUDiO'S AMigo

Ⓜ Star in the eyes of Man Ⓑ

BomBay/Reprised Ⓑ

Recorded AT
MINGER STUDIO'S Ⅱ
FEB, 6 To 17
(1976)

ARRANGED BY M.MIKE
BiG D
✳ LYRiCS BY
BiG D
MUSIC BY
M. MIKE
Ⓜ
WRITTEN TOGETHER
Ⓑ

181

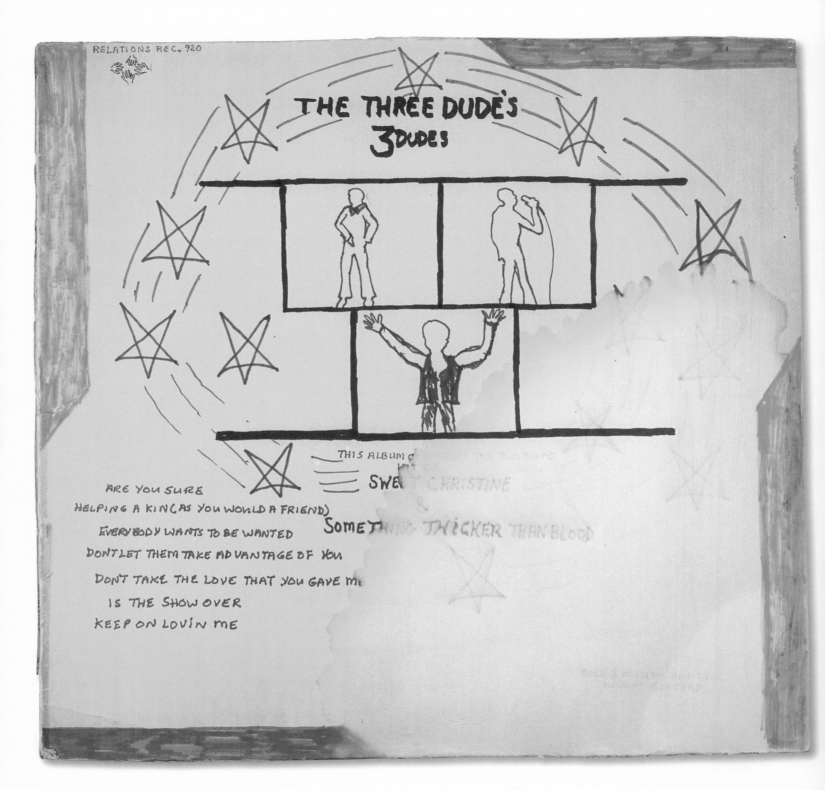

**THE THREE DUDE'S (The Big "D," Mingering Mike, and Joseph War)**

s/t

(Relations, year unknown)

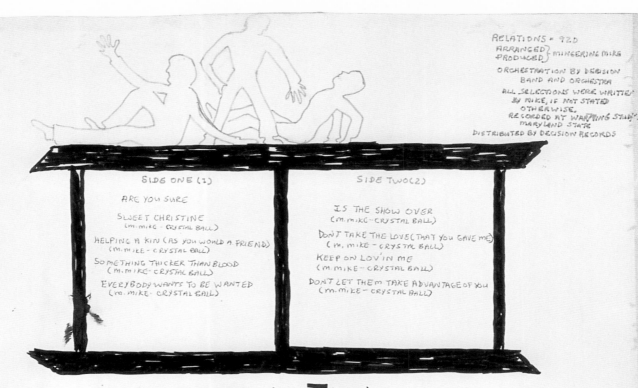

RELATIONS = 920
ARRANGED }
PRODUCED } MINGERING MIKE

ORCHESTRATION BY DECISION
BAND AND ORCHESTRA

ALL SELECTIONS WERE WRITTEN
BY MIKE, IF NOT STATED
OTHERWISE.
RECORDED AT WARPPING STUDIO'S
MARYLAND STATE
DISTRIBUTED BY DECISION RECORDS

**SIDE ONE (1)**

ARE YOU SURE

SWEET CHRISTINE
(m. mike - CRYSTAL BALL)

HELPING A KIN (AS YOU WOULD A FRIEND)
(m. mike - CRYSTAL BALL)

SOMETHING THICKER THAN BLOOD
(m. mike - CRYSTAL BALL)

EVERYBODY WANTS TO BE WANTED
(m. mike - CRYSTAL BALL)

**SIDE TWO (2)**

IS THE SHOW OVER
(m. mike - CRYSTAL BALL)

DON'T TAKE THE LOVE (THAT YOU GAVE ME)
(m. mike - CRYSTAL BALL)

KEEP ON LOV'IN ME
(m. mike - CRYSTAL BALL)

DON'T LET THEM TAKE ADVANTAGE OF YOU
(m. mike - CRYSTAL BALL)

# THE THREE DUDE'S 3 DUDE'S

## "HEY!" WHO WROTE THIS LINER NOTE AND SQUEALED?"

BOY WERE THE FANS SURPRISED TO SEE
THREE OF THEIR MOST FAVORITE SINGING STARS
ALL UNDER THE SAME ROOF AND THE SAME STAGE
THE PEOPLE MUST HAVE EITHER HEARD
THEIR NEW RECORD OR THEY WERE JUST ANXIOUS
TO SEE JUST WHO WERE THE THREE DUDES
THAT SUNG THEIR NEWLY HIT SONG
PUT OUT BY DECISION RECORDS, ONE OF THE MOST
ENVIED RECORD COMPANY'S IN THIS THE UNITED STATES
THE LABEL JUST SAID SIMPLY "BLAH-BLAH"
BY THE THREE DUDE'S THE FANS WENT WILD
AS THEY CAME ON THE STAGE (BIG D-MINGERING MIKE AND JOSEPH WAR)
AS THEY SAID, "GOOD EVENING SOUL BROTHER'S AND SISTER'S AND
EVERYBODY **ELSE** WE'RE THE THREE DUDES"
*The Phantom*

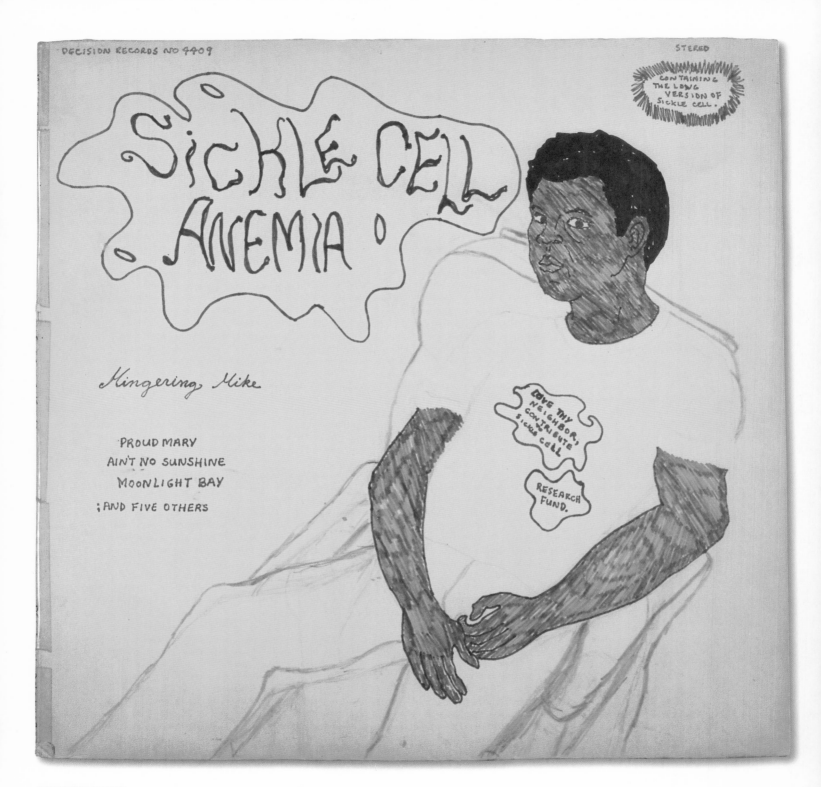

**MINGERING MIKE**

Sickle Cell Anemia

(Decision, May 1972)

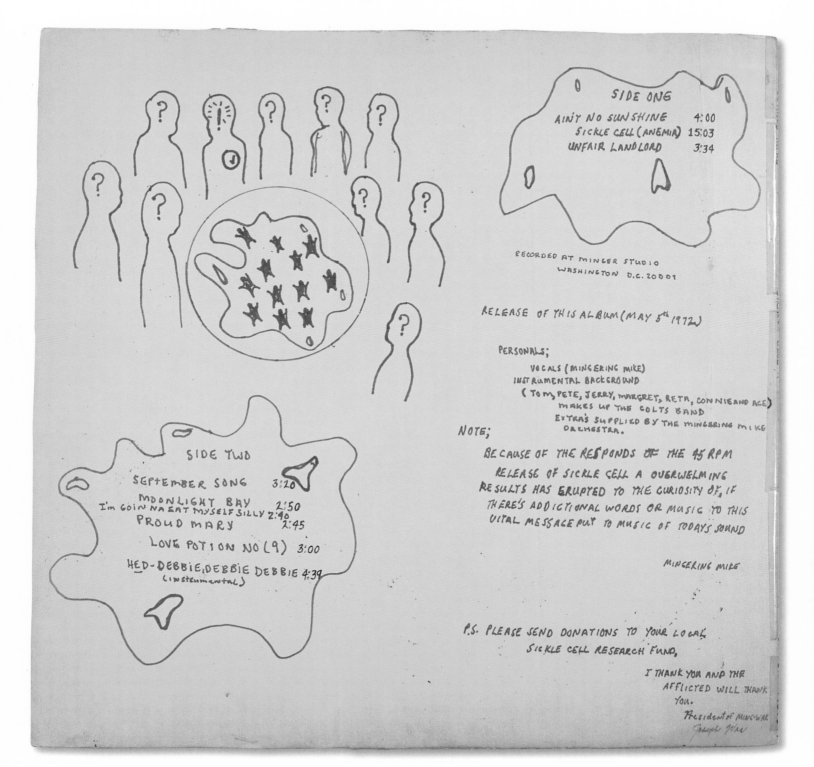

SIDE ONE

AIN'T NO SUNSHINE 4:00
SICKLE CELL (ANEMIA) 15:03
UNFAIR LANDLORD 3:34

RECORDED AT MINGER STUDIO
WASHINGTON D.C. 20001

RELEASE OF THIS ALBUM (MAY 5th 1972)

PERSONALS;
          VOCALS (MINGERING MIKE)
     INSTRUMENTAL BACKGROUND
          (TOM, PETE, JERRY, MARGRET, RETA, CONNIE AND ACE)
               MAKES UP THE COLTS BAND
               EXTRA'S SUPPLIED BY THE MINGERING MIKE
               ORCHESTRA.

NOTE;

     BECAUSE OF THE RESPONDS OF THE 45 RPM
     RELEASE OF SICKLE CELL A OVERWELMING
     RESULTS HAS ERUPTED TO THE CURIOSITY OF, IF
     THERE'S ADDICTIONAL WORDS OR MUSIC TO THIS
     VITAL MESSAGE PUT TO MUSIC OF TODAYS SOUND

                              MINGERING MIKE

P.S. PLEASE SEND DONATIONS TO YOUR LOCAL
     SICKLE CELL RESEARCH FUND.

                    I THANK YOU AND THE
                    AFFLICTED WILL THANK
                    YOU.
                    President of MINGWAR
                    Joseph War

SIDE TWO

SEPTEMBER SONG        3:20
MOONLIGHT BAY         2:50
I'm GOINNA EAT MYSELF SILLY 2:40
PROUD MARY            2:45
LOVE POTION NO (9)    3:00
HED-DEBBIE,DEBBIE DEBBIE 4:39
     (INSTRUMENTAL)

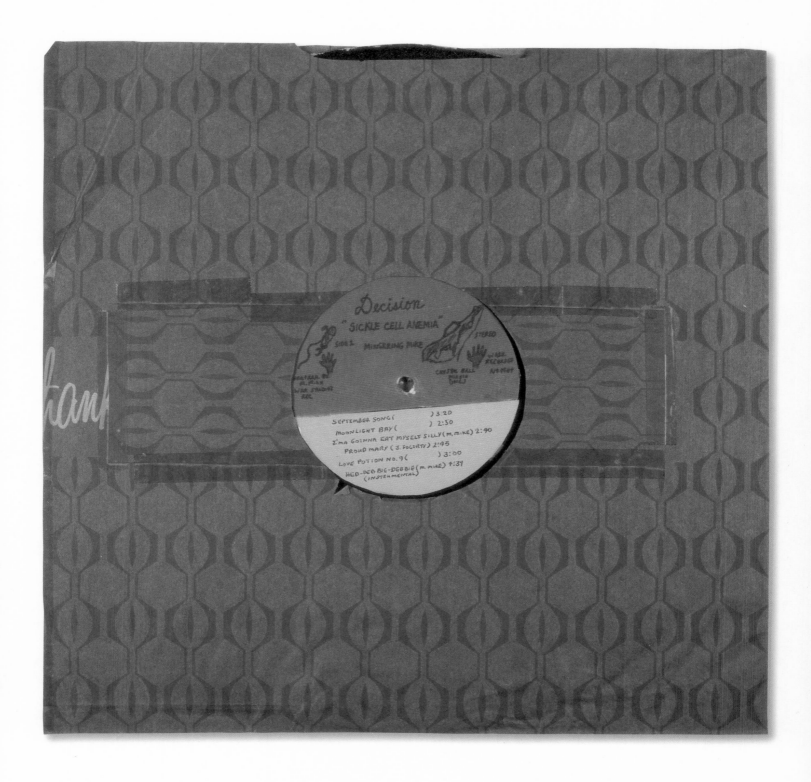

**MINGERING MIKE**
Sickle Cell Anemia (inner sleeve)                186

Jane Livingston

# Afterword

Mingering Mike's story is one of those late-to-be-discovered triumphs that combine elements of celebration and sadness, though the former, in his case, far outweighs the latter. His experience might stand for the creative impulses of three generations of self-taught artists and musicians in recent American history. Some of the richest visual imagery, to say nothing of popular music, in our culture has poured forth from the private yearnings of just such as Mike—African Americans in the South who turn to art-making in the name of personal survival. Often even the most powerful creators in this vein have been slow to be validated. Mike belongs to a long and rich tradition of artists, such as Bill Traylor, William Edmundson, Sister Gertrude Morgan, David Butler, and James Hampton, whose achievements have taken their place in the pantheon of the great artists of the twentieth century.

Mingering Mike's contribution could seem a little tangential to the "purely visual" art of these other African-American artists, in that he seems to derive his creative drive from a deeply private, even secret, ambition. He hasn't really seen himself as an artist and probably couldn't tell us where he gets his painterly inspiration. His visual achievement came out of an elaborately imagined career as a popular musician, and it is fair to speculate that he sees himself not as an accomplished illustrator, much less a gifted painter, but rather as a hobbyist in the world of pop-culture dreaming. It is ironic—and, one hopes, for him rewarding—that he may turn out to be a full-fledged member of a visual lineage whose existence, much less his membership in it, he never imagined.

Starting in the late 1970s, while serving as chief curator of the Corcoran Gallery of Art in Washington, D.C., I became aware of a phenomenon in the culture of the South that I felt had to represent the tip of some iceberg. I had recently come to Washington from Los Angeles; the Corcoran, it soon became apparent, represented a kind of artistic mecca for artists from Louisiana and Mississippi and Alabama and Georgia. It was to the old and new South what the Whitney Museum or the Museum of Modern Art were to artists in the Northeast and Midwest. On visits to New Orleans, I was introduced to Sister Gertrude Morgan, whose small house served as her church and was opulently decorated with her extraordinary paintings and writings, and to David Butler, whose small yard was filled with the snipped metal sculptures he spent many decades crafting

for the delight, it seems, of the neighborhood children who were never far from this beneficent old man.

In the course of a mere eighteen months, starting in 1979, my colleague John Beardsley and I were able to discover and present Black Folk Art in America: 1930–1980, the first exhibition and publication documenting the remarkable phenomenon of self-taught, southern African-American artists. The show opened at the Corcoran in 1982 and subsequently traveled to Houston, Brooklyn, and Los Angeles.

Meeting and working with the artists—out of twenty, some twelve were still living at the time of the show—became a definitive event in my life. It wasn't just the art, but the personalities of the artists, that added up to such an inspiring experience. Along with the joy of it, however, was a distinct sadness; I felt somehow that these individuals, and the visual tradition they embodied, was endangered. It seemed likely then that the popular culture of the 1980s and '90s would swallow up the fragile artistic impulse, born of a paradoxical combination of isolation from mainstream culture and a wealth of communal folkloric and religious subjects. I wondered if the next generation of southern African-American artists, especially those in rural communities, could possibly keep the inventiveness alive. But by the year 2000, it had become clear that there is indeed a new generation of artists in the South who are inheriting and evolving the tradition. With the likes of the Alabamans Ronald Lockett, Lonnie Holley, and the quilters of Gee's Bend; the Tennessean Joe Light; and the Floridian Purvis Young—all members of the baby boomer era—a vibrant extension of the older tradition continues to thrive. Perhaps most consummately, the amazing Thornton Dial, of Bessemer, Alabama, though now in his late seventies, is working at the very top of his form, staking out his own claim to genius within this creative matrix.

It was evident to those of us pioneering in the scholarship of this artistic phenomenon that the much more recognized and celebrated realm of southern black music needed to be taken into account as a counterpart, or parallel universe, to that of the visual art. Indeed, a few of the artists in the Black Folk Art exhibition were musicians, including the Mississippi Delta blues singer and guitarist James "Son Ford" Thomas. Sister Gertrude played the piano and sang the gospel; Sam Doyle played hymns daily on his piano at home and in his church on Sundays; and the great ladies of Gee's Bend often sing nearly as beautifully as they design their textile masterpieces. But a literal intertwining of musical and visual ambition and talent in a single individual has not, so far, seemed to occur. Mingering Mike, if only as an example of a musician whose ambition has been to embrace every aspect of the musical world, and to elevate its visual aspects to a high art form, seems to be a unique character.

Many artists like Mingering Mike use Biblical or popular-culture-inspired imagery as subjects for their work. It strikes me that Mike operated on an even deeper level of imaginative force than is implied by adopting commonly understood symbols or narratives; he finds his inspiration in his own lyrics, his own song titles, his own obsessions. In order to parse the imagery in most of his album covers, one needs to know a little bit about the songs they illustrate. The process can become quite complex and layered. On the other hand, Mike shares with his compatriots among this visual tradition in one fundamental way: he is often teaching or

commenting on moral and spiritual issues. In his case, these preoccupations center on his pacifism, which arose in him during the Vietnam era, and his anti-drug sentiments. Mike was able to avoid shipping out to Vietnam, but not without his own kind of trauma in connection with the episode. He has clearly known the depredations wrought from both the horror of conscription and its frequent aftermath in bottomless addiction. His instinct is always to empathize with others' troubles, even while maintaining his satiric edge. What other Motown or pop musician can we think of who would use sickle-cell anemia as a subject for an album? In person, Mike shows himself to be palpably sensitive, a somewhat wary and fragile soul, and his innate compassion shows itself not only in his personality, but in the messages conveyed in much of his work.

Another way in which Mingering Mike reminds me of some of his fellow artists is in the sly humor that is never too far beneath the surface of his words and images. *3 Footsteps Away from the Altar*, and *The Return of the Magnificent Mingering* and "Do I Love You" are inspired jokes; and even when his messages are sobering or sad, they often have a slyly ironic or self-deprecating undertone.

Two artists whose works on paper are especially akin to Mingering Mike's are the late Luster Willis and the late Sam Doyle. Both of these formidable artists—one a native of Holly Springs, Mississippi, the other a lifelong resident of Frogmore, South Carolina—created their own worlds of memory and message with pen and ink and paint and crayon. Compared to them, in whose work one senses a certain formal ambition, Mike's visual style is usually straightforwardly illustrational. He uses flat, iconic images freely, as in the fire-spouting, winged

creature on *Brother of the Dragon*, or the bat in *Bloody Vampire*. But he is also capable of rather sophisticated depictions of the human figure, a difficult challenge for any artist. His gestural vitality can be prodigious— the two dancing figures illustrating *Boogie Down at the White House* jump off the page, and his portrait of the slick *Tuxedo Styled* Audio Andre is as evocative, and funny, as it gets.

When I asked Mike about his visual influences, he immediately told me about a visit to the National Gallery in his home town in the early 1990s, at the moment they were exhibiting a series of four heroic, mythic landscapes by the nineteenth-century American painter, Thomas Cole. Mike was riveted by these huge canvases, representing four stages in the "Voyage of Life": Childhood, Youth, Manhood, and Old Age. These four canvases, painted in 1842 and all using the metaphor of boat journeys on water, show a man guided by angels into his different destinies. Their intent is largely to teach, to communicate from a perch of experience, and to moralize. Cole wanted to help create specifically American mythology, and while he is looking back at the neoclassical French painters, he is clearly advancing his case using a pointedly American landscape and style. Cole's romantic, dreamlike depictions of states (or seasons) of life were conceived as an instrument of public instruction. In a way, public instruction is not so different from what Mingering Mike is doing, in his own miniaturized and somewhat eccentric domain. It is this impulse to communicate what he has learned, and what he feels about the power of visual art to express, that links him not only to other African-American visionary artists of his own and earlier generations, but to the very mainstream of American art.

# Discography

## ALBUMS

**Audio Andre**
*Tuxedo Styled* (Puppy Dogg, 1972)

**The Big "D"**
*The Big "D" Sings Mingering Mike* (Sex, 9/1974)
*We All Need Love* (Sex, 6/1975)

**The Big "D" & Mingering Mike**
*3 Footseps Away from the Altar* (Nations Capitol, 12/1969)
*The Two Sides of Mingering Mike* (Ming/War, 7/1970)
*Channels of a Dream* (Decision, 9/5/1970)
*Fractured Soul and Other Wise* (Decision, 4/30/1971)
*(You Keep Asking Me) "Do I Love You"* (Hypnotic, 12/10/1971)
*From Our Mind to Yours* (Decision, 8/1972)
*Boogie Down at the White House* (Relations, 6/27/1975)
*Let's Get "Nasty"* (Decision, 10/12/1975)
Original Soundtrack from the Motion Picture *The Road to BimBombay* (Decision, 2/1976)

**The Duet Close**
*Hit 'Em Where It Hurts* (3 Footsteps, 1972)

**Jean Lantree**
*"Hallelujah"* (Relations, 9/3/74)

**Joseph War**
*Introducing Joseph War "and What He Stands For"* (Green & Brown, 1970)
*"Into It"* (Green & Brown, 10/20/1971)
*Ghetto Prince* (Decision, 8/1972)

*"As High as the Sky"* (Decision, 6/15/1972)
*"Life is a Bitch"* (Green & Brown, 9/1974)

**The Lovers**
*The Dark Side of Regan* (Sex, 6/1974)

**Mingering Mike**
*Sit'tin by the Window* (Mother Goose, 6/1968)
*Can Minger Mike Stevens Really Sing* (Fake, 3/1969)
*Minger's Greatest Hits (Volume 1)* (Mother Goose, 6/6/1969)
*What I'm Going to Do* (Nations Capitol, 11/1969)
*Grooving with Mike* (Minger, 10/1970)
*Minger's Gold Supersonic Greatest Hits (Vol. 3)* (Minger, 5/20/1971)
*Get'tin to the Roots of All Evils* (Minger, 8/1971)
*Slow "N" Easy* (Decision, 10/1/1971)
*Galveston* (Finger, 1972)
*Pianoman* (Hypnotic, 1972)
Soundtrack from the Motion Picture *Stake Out* (Ming/War, 11/1972)
*Homecoming / "But When You Drink"* (T.T.H., 2/5/1972)
*Just in Time for Easter* (Lord's House, 3/1972)
*Sit'tin at Home with the Lowdown Blues* (Relations, 4/17/1972)
*Sickle Cell Anemia* (Decision, 5/1972)
*The Drug Store* (Minger, 5/9/1972)
*Darlene, Come on Back to Our Side of the Track* (Minger, 7/4/1972)
Original Soundtrack to *Bloody Vampire* (Hypnotic, 2/1973)
Original Soundtrack to *Hot Rodd (Takes Revenge)* (Ramit, 11/1973)
Soundtrack from *You Only Know What They Tell You* (Relations, 5/1973)

*A Tribute to Bruce* (Relations, 7/1973)
Original Music from *Brother of the Dragon* (Decision, 6/14/1974)
*On the Beach withthe Sexorcist* (Decision, 7/20/1974)
Original Soundtrack to *Tight Squeeze* (Mercy, 2/20/1975)
*Isolation* (Minger, 5/10/1975)
*Frustrations* (Finger, 9/4/1975)
*Positive Impiety* (1976)

**Mingering Mike, The Big "D" & The Colts Band**
*"Super Gold" Greatest Hits* (Ming/War, 7/1970)

**The Mingering Mike Singers & Orchestra**
*Instrumentals and One Vocal* (Ming/War, 8/1971)

**The Outsider's (featuring The Big "D")**
*The Outsider's Are Back* (Sex, 1971)
*Get Onboard (The Friendship Train)* (Sex, 1972)
*"Mercy the World"* (Sex)

**Rambling Ralph**
*"In My Corner"* (Ramit, 1/23/1972)

**The Three Dude's (The Big "D," Mingering Mike, and Joseph War)**
*The Three Dudes* (Relations)

**Vangoes**
*On The Road* (Ramit, 1972)

**Various Artists**
*The Mingering Mike Revue All Decision Stars—Live from Paris* (Goldpot, 1/15/1972)
*The Mingering Mike Show—Live from the Howard Theater* (Nations Capitol, 6/1969)

## SINGLES

**Audio Andre**
"Evil Ways" b/w "Three Footsteps Away from the Altar" (Puppy Dogg, 1972)

**The Big "D"**
"Do I Love You" (Hypnotic, 1971)
"What Becomes of a Broken Heart" b/w "If You See Him" (Sex, 3/8/1975)
"All That I Have is Yours" (Cookin')
"It Feels Good" (Sex)

**Big Dynamic "D"**
"Mingering Mike" b/w "Everybody's Out of Town" (Atlantic)

**The Duet Close**
"A Love Song for Minger" b/w "A Brand New Key" (3 Footsteps, 1972)
"And I'm Loosing Weight" (3 Footsteps, 1972)
"Eat Myself Silly" (3 Footsteps, 1972)
"Have You Ever Tried Love Before - Part 1" (3 Footsteps, 6/18/1974)

**The Freedom Stompers**
"What's Going On" b/w "There's Nothing Wrong with You Baby (Part 2)" (Green & Brown, 11/1969)
"I Heard it Through the Grapevine" (Bird Tree)

**The Freedom Stompers / Mingering Mike & The Big "D"**
"There's Nothing Wrong with You Baby" b/w "What's Going On" (Green & Brown / Puppy Dogg, 8/1971)

**Joseph War**
"Trapped Between Two World (Of Love)" (Green & Brown, 1972)
"Got ta Keep Trying" b/w "The Soothing Sea" (Green & Brown, 8/21/1974)
"You Ignite (A Flame in Me)" b/w "Blue Monday" (Gem, 3/5/1975)

**Main Vein (Instrumental Group With Background)**
"Do Your Thing" (unknown label)

**Mike & Derrick**
"Good Sweet Woman" (Hypnotic)

**Joseph War & Mingering**
"I've Fort Battles in Saigon Now I've Got to Fight in Washington" b/w "I Found Peace in Saigon Sally" (Gems, 1972)

**Mingering Mike**
"Sittin by the Window" b/w "Angie" (Mother Goose, 6/1968)
"It's A Boy's Life" b/w "Two Way Traffic" (Mother Goose, 7/1968)

"Channels of a Dream" b/w "I Heard It Through the Grapevine" (T.T.H. / Minger Records, 1969)
"Sing A Song/Any King Of Song" b/w "I Can't Turn You Loose" (Fake, 1969)
"Me and My Shadow" (Minger, 1970)
"She Looked into My Eyes" b/w "Don't Try and Take it All In" (Minger, 1970)
"It's a Remarkable World" (King Cobra, 1971)
"O-Sole-Mio" (Minger, 1971)
"But a Girl Can Make You Change" (Minger, 1972)
"But a Girl Can Make You Cry" (Minger, 1972)
"Come on Back" (T.T.H, 1972)
"I Need You So—Part One" b/w "I Need You So—Part Two" (Hypnotic, 1973)
"The Exorcist—Part 1" b/w "The Exorcist—Part 2" (Evil, 1974)
"Moon River" b/w "This is Where it All Started" (Motherland, 10/12/1974)
"We're Gonna Make it Baby (Yeah)" (Mercy, 3/12/1975)
"Gregory" (long version) b/w "Gregory" (edited version) (Finger, 8/27/1975)
"I'm Superman" b/w "Blind in One Eye" (Minger, 6/1975)
"But All I Can Do is Cry" b/w "I'll Get It Together" (Minger/Decision)
"Just Not Made for One Another" b/w "Be Yourself (And Nobody Else)" (Mother Goose)
"Keep on Loving Me" (Minger)
"Love Comes and Goes (Just Like a Rainbow)" (Beach-Ball)
"Love Comes and Goes (Just Like a Rainbow)" b/w "Don't Try and Take it All In" (Green & Brown)
"Loving Eyes" (Finger)
"Our Love Has Slipped Away" (Relations)
"She's Back" (Minger)
"Sweet Woman of Mine" (Gold Pot)
"What I'm Goina Do" (Spiral)
"With a Little Bit Of Luck 'We Can All Have a Very Find Christmas'" (Minger)
"Yawl's Hot Pants—Part 1" (Evil, 1975)
"You Only Know What They Tell You" b/w "Michael's Theme" (Relations)

**Mingering Mike & His Fractured Soul Band**
"Dig It" b/w "Well She Loves Me" (Mercy)
"Something Thicker than Blood" (Mercy)

**Mingering Mike & The Big "D"**
"Three Footsteps (Part 1)" b/w "Baby I'm In Love With You" (Minger, 2/12/1970)
"I'll Get it Together" b/w ""Look At Yourself" (Decision)
"Baby Don't Go" b/w "The Seven "OO's" (Of Love)" (Minger, 2/27/1970)
"I Can See it in Your (Eyes)" b/w "Three Footsteps (Away From The Altar) (Minger 5/20/1970)
"Nothing Wrong With You Baby" b/w "Because She Knows" (Ming War, 7/18/1970)

**Mingering Mike & The Vangoes**
"Michael's Theme (Blue & Cheerful)" b/w "Are You My Woman (Tell Me So)" (Ramit / Relations, 2/11/1972)
"Let The Music Take Your Mind (The Brain Scramblers)" (Mercy 3/12/1975)

**Mingering Mike / The Supreme Choice**
"Bangla-desh" b/w "Sittin by the Window" (3 Footsteps)

**Mingering Mike Singers & Orchestra**
"It's a Remarkable World" (Ming/War, 7/5/1975)

**Miss Fly Darlene**
"Where Did Our Love Go" (Blackballed, 1972)

**Natural Funk Band**
"Tone Death" b/w "Walk with Me" (Gregson, 6/19/1974)

**One Plus One**
"Good Sweet Woman" (Together, 11/22/1971)

**Rambling Ralph**
"I'm Sorry Mike, You Were Only Following in My Footsteps, ('How'd You Know Not to be Cheap to Me, but to Everybody Else')" b/w "Forgive Me Son" (Ramit, 1970)
"T.V. Dinners of Mines" b/w "Eat Now and Eat Later" (Ramit, 1972)

**Rambling Ralph / The Underdoggs**
"222 Love Avenue" b/w "'I'll Kill' for Peace" (Decision / Jigsaw, 1971)

**Roadman Steve**
"I Can't Get Started (Without You)" (Hypnotic)

**Roadman Steve & "Black Klan"**
"Jungle Call (O-La-La)" (Hypnotic)

**Steve Frightened And His Nightmares**
"Last Night I Thought I Was Bruce" b/w "It's a Good Thing Big D & Mike Weren't Here Because They Both Would Have Been Wasted" (Spooky, 1/1974)

**Unknown Artist**
"It Feels Good" b/w "She's Back"
"Stop It, Girl (Part 1)" b/w "Stop It, Girl (Part 2)"

## 8-TRACKS

V/A (mix tape) "Now Really Greg"
V/A (mix-tape) Mike's Mixes: More…"Out of the Blue Hits" (Volumes 3&4) (5/2/1976)

# Biographies

**DORI HADAR** is a criminal investigator by day and DJ by night. He lives in Washington, D.C.

**NEIL STRAUSS** is the author of four New York Times bestselling books, including *The Game: Penetrating the Secret Society of Pickup Artists*. He writes for *Rolling Stone* and lives in Los Angeles.

**JANE LIVINGSTON** is an independent curator and author living in rural Virginia. Her exhibitions for the Corcoran Museum include Black Folk Art in America (1920–1980) and The New York School: Photographs, 1936–1963. She has also organized exhibitions and written books on Richard Avedon, Richard Diebenkorn, and Joan Mitchell for the Whitney Museum of American Art.

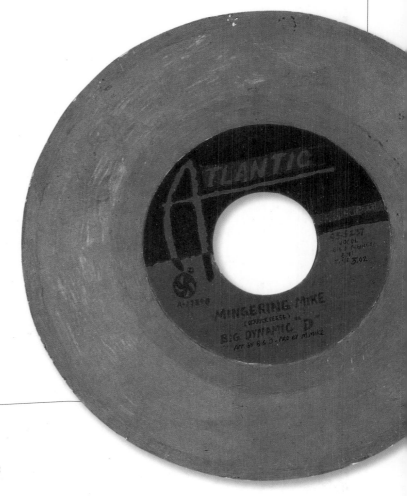